Jasper Johns to Jeff Koons: Four Decades of Art from **the Broad Collections**

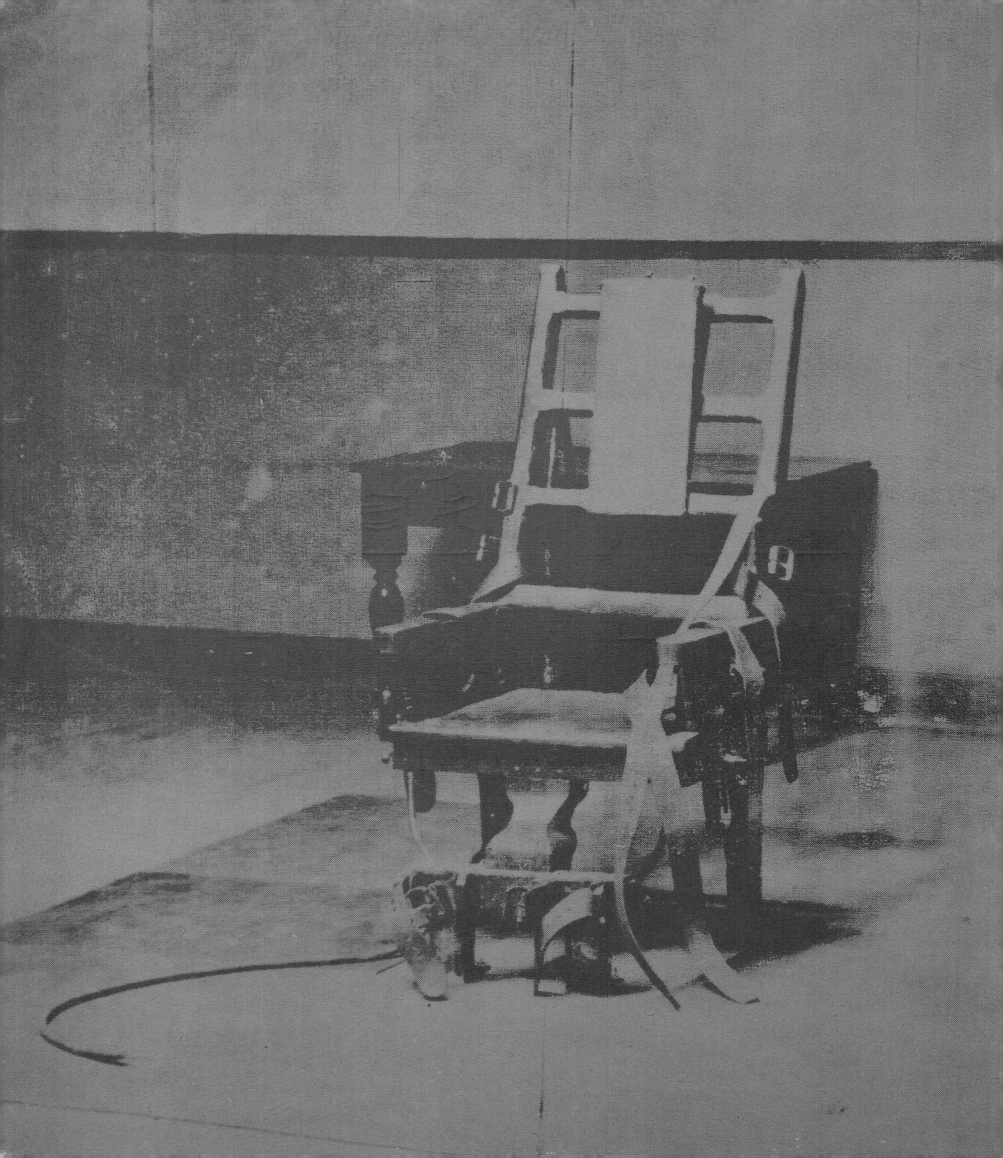

4 Jasper Johns to Jeff Koons: Four Decades of Art from the Broad Collections

Stephanie Barron and Lynn Zelevansky

with essays by

Thomas Crow

Sabine Eckmann

Joanne Heyler

Pepe Karmel

Los Angeles County Museum of Art in association with

Harry N. Abrams, Inc., Publishers

First published in the United States in 2001 by the Los Angeles County Museum of Art, 5905 Wilshire Boulevard, Los Angeles, California 90036, and Harry N. Abrams, Inc., 100 Fifth Avenue, New York, NY 10011, in conjunction with the exhibition *Jasper Johns to Jeff Koons: Four Decades of Art from the Broad Collections*. This exhibition was organized by the Los Angeles County Museum of Art.

Itinerary of the Exhibition:

Los Angeles County Museum of Art
October 7, 2001–January 6, 2002

Corcoran Gallery of Art, Washington, D.C.
March 16–June 3, 2002

Museum of Fine Arts, Boston
July 21–October 20, 2002

LIBRARY OF CONGRESS CATALOGING-IN-PUBLICATION DATA:

Barron, Stephanie, 1950–
Jasper Johns to Jeff Koons : four decades of art from the Broad collections / Stephanie Barron and Lynn Zelevansky ; with essays by Thomas Crow ... [et al.].
 p. cm.
ISBN 0-8109-0612-0
1. Art, American–20th century–Exhibitions. 2. Broad, E i–Art collections–Exhibitions. 3. Broad, Edythe–Art collectiors–Exhibitions. 4. Art–Private collections–California–Los Angeles–Exhibitions.
I. Zelevansky, Lynn. II. Crow, Thomas E., 1948–
III. The Broad Art Foundation. IV. Title.
N6490 .B2595 2001
709'.73'07479494–dc21

 200˙001607

Harry N. Abrams, Inc.
100 Fifth Avenue
New York, N.Y. 10011
ww.abramsbooks.com

Frontis page:

Andy Warhol, *Big Electric Chair* (detail), 1967

Title page, top to bottom:

Photograph of Eli and Edythe Broad

Cy Twombly, *Nini's Painting* (detail), 1971

Andy Warhol, *Self Portrait* (detail), 1966

Jeff Koons, *Michael Jackson and Bubbles* (detail), 1988

Bernd and Hilla Becher, *Typology of Water Towers* (detail), 1972

Page 224:

Jeff Koons, *Jim Beam-J.B. Turner Train*, 1986

Director of Publications: Garrett White **Managing Editor:** Stephanie Emerson **Editor:** Margaret Gray
Book Design: Tracey Shiffman **Production Coordinator:** Karen Knapp **Supervising Photographer:** Peter Brenner
Rights and Reproductions Coordinator: Cheryle T. Robertson **Rights and Reproductions Assistant:** Giselle Arteaga-Johnson Printed in Japan

contents

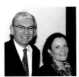

foreword

The Los Angeles County Museum of Art takes great pride in organizing and presenting *Jasper Johns to Jeff Koons: Four Decades of Art from the Broad Collections*. Both personally and through The Broad Art Foundation, Eli and Edythe Broad have lent and donated important works to museums worldwide. They have also been leading patrons of cultural and educational institutions across the United States. LACMA has benefited from their commitment and generosity for nearly thirty years.

Jasper Johns to Jeff Koons: Four Decades of Art from the Broad Collections is the first large-scale exhibition of significant works of postwar art from the Foundation and the Broads' personal collection, and this exhibition seeks to capture the breadth, depth, and quality of those collections. It was organized for the museum by Stephanie Barron, Senior Curator of Modern and Contemporary Art and Vice President of Education and Public Programs, and Lynn Zelevansky, Curator and Department Head, Modern and Contemporary Art. They have selected works by twenty-five of the 173 artists included in the Broads' holdings. Most are represented by several objects; some, such as Jasper Johns, Roy Lichtenstein, Cy Twombly, Jeff Koons, and Cindy Sherman, are represented by a great range of work. The exhibition spans the years 1954 to 2000, from an important untitled red painting by Robert Rauschenberg to the most recent works of John Baldessari.

The exhibition is organized in five sections, beginning with the work of three artists, Rauschenberg, Johns, and Twombly. Their art is characterized by the use of found materials and vernacular forms. Their approach led to the development of Pop art, which is represented by the paintings of Roy Lichtenstein and Andy Warhol. Ed Ruscha's work forms the bridge between Pop and the more conceptually based art of Baldessari and Hans Haacke. The exhibition offers examples of German art of the last four decades, as well as an opportunity to reflect on the art historical contributions of U.S. artists associated with the 1980s. It ends with works by younger Los Angeles artists Charles Ray and Sharon Lockhart.

It is particularly appropriate that LACMA has organized this exhibition, because it reflects the avid interest and keen eye of collectors who are so essentially part of the leadership of Los Angeles and the Southern California region. In the cultural arena, in addition to serving as a member of LACMA's board of trustees, Eli Broad was the founding chairman of the board of trustees of The Museum of Contemporary Art in Los Angeles. In 1984 Eli and Edye Broad established The Broad Art Foundation in order to focus on contemporary art and to make their collection available to art institutions. Since its inception, it has lent works to more than 325 museums and university galleries throughout the world.

As a businessman, Eli Broad is Chairman of SunAmerica Inc. and serves on the board of its parent company, American International Group, Inc. He is founder and Chairman of KB Home. Broad is a builder of major business enterprises. His wide-ranging curiosity and laserlike focus have made him a leader in every area to which he has turned his attention. Together Eli and Edythe Broad have assembled one of the finest collections of contemporary art in the world.

Eli and Edythe Broad and their collections are integral to the establishment of Los Angeles as an international cultural capital. I would like to thank my colleagues Malcolm Rogers, Director of the Boston Museum of Fine Arts, and David Levy, Director of the Corcoran Gallery of Art in Washington, D.C., for their enthusiastic participation in bringing the Broad collections to a wider public. We are honored to have the opportunity to share the Broads' collections, a reflection of their vision and vitality, with the nation and the world.

Andrea L. Rich
President and Director

Ed Ruscha *Sunset-Gardner Cross*, 1998–99

building a collection and more

Talking with Eli and Edythe L. Broad

Jasper Johns to Jeff Koons: Four Decades of Art from the Broad Collections *draws from two impressive groups of works that Eli and Edythe (Edye) Broad have assembled over the last thirty years: their personal collection and the holdings of The Broad Art Foundation. These collections span four decades and include some of the most iconic works in the history of postwar art. Classic examples by Jasper Johns, Andy Warhol, and Roy Lichtenstein are among their greatest strengths. The exhibition features paintings such as Johns's* Flag, *1967, and the first crosshatch painting of 1975; Warhol's depictions of Marilyn, Jackie, and Elvis; and Lichtenstein's* I . . . I'm Sorry, *1965–66, his five-part* Rouen Cathedral Set III, *1969, and examples from several other of his series inspired by art history. Another important aspect of the collections is their concentration on major figures from the 1980s, such as Jean-Michel Basquiat, Jeff Koons, Julian Schnabel, and Cindy Sherman. Since it takes approximately twenty years to form a historical perspective on an era and its art, this exhibition offers one of the first opportunities to assess the achievements of that decade.*

Over the last century, active and discerning individuals in Los Angeles have assembled significant art collections. Some have comprised a small group of objects of exceptional quality. Others are defined by a concentration of work of a specific genre or by a particular group of artists. Only a few, however, are distinguished by the quality of their objects, the depth of their holdings in the work of specific artists, and their sheer volume: for example, the collections of Walter and Louise Arensberg, formed in Los Angeles in the 1930s and now in the Philadelphia Museum of Art, and of Norton Simon, housed in the museum that bears his name in Pasadena.

The collections of Eli and Edye Broad belong to this exceptional category. Great art collections, both public and private, are essential to the life of a great city. Today, the Broad collections, with their mix of renowned and younger artists, are unique in Los Angeles for their combination of quality, depth, and quantity. They are especially important to the cultural life of this city and to an understanding of art in our time.

The Broads began to collect seriously in the early 1970s. Edye had an interest in modern and contemporary art from childhood, but once Eli became involved, he began to build the collection actively. Although consumed with the expansion of his business interests, Broad found, in the pursuit of recent art and the creation of a collection of the highest quality, a complement to the rigors of his business life. For him collecting has been an engagement with ideas as much as an accumulation of objects. Fascinated with the unconventional ways in which artists think, he has valued art's ability to expand his intellectual horizons. Eli and Edye Broad have approached collecting in an atypical manner. Politically active and socially concerned, they have collected art for purposes beyond the aesthetic. As a response to escalating art prices, they formed The Broad Art Foundation as a lending institution in 1984. Public museums here and abroad, which found it difficult to compete for works of art in the marketplace, were able to turn to the Foundation for generous loans. While the desire to possess coveted objects has driven many, the Broads have tempered this impulse with civic concern, forming these collections with the idea that the works they contain will ultimately be donated to public institutions.

Although in these collections U.S. artists predominate, there is also a strong representation of contemporary German work. The personal and Foundation holdings overlap to a certain degree; however, the former comprises largely more established artists, while the latter has specialized in work by younger people. Eli Broad has also formed two corporate collections specializing in emerging art from Southern California, one belonging to KB Home and the other to SunAmerica Inc.; together they contain more than 400 works of art by 147 artists.

The text that follows combines two interviews conducted by Stephanie Barron and Lynn Zelevansky in January 2001, with Eli and Edye Broad.

Q: Where did you grow up?

Eli: I was born in New York City and raised in the Detroit suburbs.

Q: What was your family background?

Eli: My parents were very liberal Lithuanian immigrants who went through the Great Depression. My father started as a housepainter and then became a merchant, and my mother was a dressmaker. At the beginning of World War II, Detroit was the arsenal of democracy with lots of opportunities, so they moved there in 1940, when I was six.

You should understand that the maternal side of my family are all academics. I'm an only child and the only cousin that has only one degree. So here's the maternal side of my family, they're all very educated with multiple degrees, and not very aggressive people. They came from the countryside of Lithuania and were in the timber business. But my father was poor, from the ghetto, and he was very aggressive; he hustled to get ahead; that's what he had to do. I'm a mix of the two. I think I'm aggressive, but I've always had a great curiosity for things.

Q: Edye, what is your background?

Edye: I was born and raised in Detroit, Michigan. My parents were born in Canada. They both came from very poor, large families. If their friends needed help, they were there. My dad, who was a chemist, was especially interested in community service. My parents always gave to major charities. I think Eli's parents had a little bit more of an immigrant experience. I don't think my parents were as politically involved as his.

Q: Where did your interest in art come from? Did your parents like or collect art? Were you exposed to much art as a child?

Eli: I can't say I was exposed to a great deal of anything culturally. My parents didn't drag me to museums. We went to concerts on occasion.

Edye: My parents liked art, but I don't remember them going to the art museum in Detroit. I think my interest came from school. I went to a school that took a lot of field trips. We went to the Young People's Symphony, to the theater, and to art exhibits every year. I liked all of those activities, but I especially liked art. It's hard to explain. My response is kind of visceral. I get it when I see certain paintings. We went to the Detroit Institute of Arts.

Q: What do you remember about the museum?

Edye: The Diego Rivera murals; that they had a mummy. You know, in Detroit that was a very exotic thing. The other thing the museum had that I loved was a Colonial house that you could go into and see the rooms and all the furniture. It was beautiful.

Q: Did you collect anything as a child?

Edye: I bought my first print on a field trip when I was twelve, on my twenty-five-cent allowance. I saw a Picasso print at the University of Michigan bookstore and thought, "I'd really like to have that," so I bought it.

Eli: Stamps. I probably started when I was eight or nine. I was quite a collector. In fact, at age thirteen I became a dealer in postage stamps and advertised in various collectors' journals.

Q: There's a wonderful article on collecting by Jean Baudrillard.[1] He says that boys collect between the ages of seven and twelve. The instinct to collect then lies dormant until men are in their forties. How long did your interest in stamp collecting last?

Eli: Until I discovered girls. [Laughter] I was thirteen or fourteen when I stopped.

Q: Were the aesthetics of stamps important to you?

Eli: I didn't collect them for their beauty. I thought it was a great way to learn about world geography and history. So it wasn't just a collection of objects. I wanted to know things like where the Cape Verde Islands were. Where was Trinidad?

fig 1

fig 1 Eli and Edye Broad on their wedding day, 1954

1. Jean Baudrillard, "The System of Collecting," in John Elsner and Roger Cardinal, eds., *The Cultures of Collecting* (Cambridge: Harvard University Press, 1994), 7–24.

2. Eli Broad and Donald Kaufman founded Kaufman and Broad Home Corporation (recently renamed KB Home) in Detroit in 1957. The company expanded into Arizona in 1962 and into California in 1963.

Q: Did you enjoy school?

Eli: I was a terrible high school student as far as my teachers were concerned, because I questioned anything and everything, but I blossomed in college. You could ask more questions there and the professors would enjoy a dialogue.

Q: Did you study art in college?

Eli: I really didn't get involved in art until about 1971 or 1972, which got me to age forty, I guess.

Q: There you go, just as Baudrillard suggests. Where did you two meet?

Edye: In Detroit. I was in my last year of high school and Eli was in his last year of college. We got married over Christmas vacation in December 1954 and lived in Detroit until we moved to Arizona.

Q: When did you move to Arizona?

Edye: It was in 1960. Eli was expanding his business.[2] I think he probably felt more comfortable expanding in a smaller place. We ended up in Arizona.

Q: How long were you there, and what brought you to California?

Edye: We were in Arizona about two and a half years. By then Eli's business was in California, too. He was in Michigan, Arizona, and California. He was spending less time in Arizona, so he suggested that we move to California. We had visited California, and it just seemed so big. I thought the people were strange. I said I didn't like it, and he said, "Well, try it for a year," so we moved for a year. At the end of the year I said, "I'd like to go back," and he said, "Try another year." Then I knew we weren't going back! Now I wouldn't want to live anyplace else. I like living in California, since we can travel the world. I like the freedom and the climate.

Q: Edye, you were the one who originally had an interest in art?

Edye: I always did. I can't remember not being interested in art. When I moved to L.A., I was reading a lot, learning my way around, looking in the Calendar section of the paper, and so on. The first thing I bought was by Betye Saar. That was before anyone knew her. She was at a little gallery, showing works on paper. I bought two works, and then went to visit her.

Q: Did you know other collectors then? Did you visit galleries?

Edye: It was in the early sixties. I didn't know other collectors yet. I remember going to the Ferus Gallery.[3] I used to go to the La Cienega galleries on Monday nights when they were open late. When we first moved here, I used to go exploring in the Hollywood area. I loved books and bookstores. They had great bookstores in Hollywood. One day on the way home, I found Nick Wilder's gallery.[4]

Q: Did you buy anything from the Ferus Gallery or Nick Wilder?

Edye: No. Wish I had.

Q: Did you take Eli with you to the galleries?

Edye: No, he really wasn't around enough. He was traveling between three cities. Visiting galleries was one of the things I liked doing on my own time. I would've liked him to go with me, but he didn't have the time to devote to it. And as you know, he's not the kind of person who does anything lightly. He would always say, "That's Edye's hobby." Every time he'd go out of town, I'd buy something. He was fine with that, until he started recognizing the names; then he got nervous. I was buying prints and works on paper. I bought a little Braque,[5] and then I bought a Lautrec poster. When Eli came home and saw it hanging, recognizing the name, he said, "Well, how much was it? Where did you get it? What do you know about it?" Up until then, it had been my thing, my hobby.

Q: Did you think of yourself as a collector?

Edye: I don't know if I ever thought of myself as a collector. Probably once Eli got more serious about it, because then the acquisition budget went up.

Eli: You know Edye's a more normal person than I am. I don't do much in moderation. She doesn't become addicted to things the way I do.

Q: Eli, who introduced you to the art world?

Edye: I would like to say it was me, but it wasn't.

Eli: I was introduced to the art world by Taft Schreiber.[6] I met him through politics, even though he was an avid Republican, and I was a Democrat.

Alan Cranston was defeated in 1966.[7] At that time I was active, but not that active, in politics. Cranston joined Kaufman and Broad as head of a subsidiary. He decided in 1967 that he wanted to run for the Senate and asked me if I'd be his campaign chairman. I told him I didn't know anything about running campaigns, but he said that I was smart and would figure it out. So I went to the library, got every book I could find on campaigns, and did it. That was an active year.

I met Taft along the way. He tried to make a Republican out of me. He didn't succeed, but when he and John Connally formed Democrats for Nixon, I became vice chairman.[8] I was distressed with the Democratic choice for president—George McGovern.[9] Frankly, I could not imagine him dealing with the Soviets, who were very tough at the time.

Q: How did Schreiber encourage you to become an art collector?

Eli: Taft was kind to me. He'd tell me about every picture, about artists and how they thought, and about how he collected. He was a great hunter of great pictures. He told me how he got pictures from Leigh Block during a recession, when Bloch thought the world was going to end.[10] He was truly a hunter, as compared with a collector like Joseph Hirshhorn,[11] who would buy lots of things. For me, Taft was sort

3. Ferus Gallery (1957–66) was founded by curator Walter Hopps and artist Edward Kienholz. In 1958 Irving Blum became director of the gallery, which, in addition to its other activities, supported young Southern California artists and mounted the first exhibition of Andy Warhol's work in 1962.

4. Nick Wilder (1938–1989) ran a gallery in West Hollywood from 1965 to 1979.

5. Georges Braque, *Quatre Oiseaux*, n.d., lithograph.

6. Taft Schreiber (1908–1976) was vice president of the Music Corporation of America. He and Eli Broad met in 1971. Beginning in the 1940s, Schreiber and his wife Rita Bloch Schreiber collected nineteenth- and twentieth-century European and American art. The collection was not limited to specific movements or schools but aimed to include the finest examples from each movement or period. Schreiber was a member of the LACMA board of trustees from 1964 to 1974.

7. Alan Cranston, a Democrat, served two terms (1959–67) as California state controller. In 1967 he became president of Homes for a Better America, a Los Angeles building company and a subsidiary of Kaufman and Broad Home Corporation. In 1968, with Eli Broad as his state campaign chairman, Cranston was elected to the U.S. Senate, where he served four terms.

8. John Connally (1917–1993) served three terms as governor of Texas from 1962 to 1968. He was Secretary of the Navy under President John F. Kennedy and Secretary of the Treasury and special advisor to the president in the Richard Nixon administration.

9. George McGovern, Democratic candidate for president in 1972, lost to Republican Richard Nixon. As Senator from South Dakota, McGovern had been highly critical of President Johnson's escalation of the war in Vietnam. He was reelected to the U.S. Senate in 1974 and served until 1980.

10. Leigh B. Block (1905–1997) and his wife, Mary, were Chicago collectors who began to collect nineteenth- and twentieth-century European art in the late 1920s. The Blocks later added twentieth-century American art to their holdings, much of which is today in the collection of the Art Institute of Chicago.

11. Joseph H. Hirshhorn (1899–1981) was a successful businessman. He amassed a collection of twentieth-century European and American works, with a particular emphasis on the work of living artists. In 1966 Hirshhorn donated his collection to the Smithsonian Institution in Washington, D.C. In 1974 the Hirshhorn Museum and Sculpture Garden opened on the Mall in Washington, D.C.

12. Paul Rosenberg (1881–1959) opened a branch of his Paris art gallery at 20 East 79th Street in New York in 1940. His son Alexandre managed the gallery, which specialized in contemporary French painting, until the 1980s. Klaus G. Perls and his wife, Dolly, ran an art gallery at 1018 Madison Avenue in New York from 1937 to 1995, specializing in European modern art. His brother Frank Perls had a gallery in Beverly Hills from 1939 to 1977.

13. The Broads acquired van Gogh's drawing *Cabanes à Saintes-Maries* (Two Cottages at Saintes-Maries-de-la-Mer), 1888, from a Sotheby Parke-Bernet sale in New York in October 1972. The work previously belonged to the Ritter Collection, New York, which included a number of nineteenth- and early twentieth-century French paintings.

14. Charles Laughton (1899–1962) and his wife, Elsa Lanchester, were actors and collectors in Los Angeles. They were primarily interested in nineteenth- and twentieth-century European art.

15. In 1967 Kaufman and Broad became the first U.S. home-builder in Europe and is today one of the largest home-builders in France. In 1971 Kaufman and Broad acquired SunAmerica Life Insurance Company, which, through strategic restructuring, became SunAmerica Inc. in 1989. Eli Broad is chairman and cofounder of SunAmerica Inc., a financial services company, and also served as its president and CEO until January 2001. He is a member of the board of directors of SunAmerica's parent company, American International Group.

of a bridge. He was kind enough to introduce me to various people: dealers like Paul Rosenberg, Klaus Perls, museum directors.[12] I first was interested in Impressionism and Postimpressionism. Pretty pictures.

Edye: Taft was a successful businessman, somebody Eli could relate to. He was able to explain what art meant and did for him, that it chronicled history. Eli must have told Taft that I was interested in art, and that he was a *little* bit interested. Taft said that we had to go to New York and spend a lot of time there looking, going to museums, and visiting dealers. We had to look for a long time before we bought. He wrote the dealers on our behalf saying, "When the Broads come into the gallery, please treat them as if it were me. They're my friends." He couldn't have known what would happen at the time, but he told them that we were going to become prominent collectors.

Q: So Schreiber was a kind of model of a way to collect as opposed to somebody like Hirshhorn?

Eli: I'm not sure I'm a good student of his model, but yes. I looked at every picture he had, a Jackson Pollock over the couch, or any of his other things. Every single piece was well thought out, and he bought from everybody. It wasn't just buying objects. He knew what he was doing.

Q: What was your first acquisition?

Eli: The first thing of any import we bought was a van Gogh drawing (fig. 2) that we got from the Ritter Foundation collection, I think in 1972.[13] We bought it at auction.

Q: That's a pretty serious first acquisition.

Eli: It was $95,000 at the time. I wanted to buy something of quality. I talked to a lot of people about it beforehand. I'm not sure Taft counseled me on it, but I was impressed with the way he collected and with his description of how he had learned from Charles

fig 2

Laughton.[14] Taft instilled in me the notion of quality. You know a lot of collectors look for bargains, and sometimes I do, too, but he convinced me that you can't overpay for a good work of art.

Edye: We both liked the van Gogh drawing; it wasn't something you saw a lot. Afterwards I think Taft said we paid too much. Eli said, "I'll listen to your advice about quality, but not about price." Taft's collection had been built earlier. He had wonderful things, but the art market was going up.

Taft taught us a lot. I think he was delighted that Eli got so involved, and I was thrilled to pieces. I would've bought everything, but we didn't. We weren't ready to buy. As I look back, there were so many things, but we didn't have unlimited funds. It was exciting and fun. I loved having that van Gogh drawing. I used to just look at it and think, "I can't believe it."

Q: At that point, were you going to museums regularly?

Eli: Oh, yes. I started about 1970 or so. The whole experience of collecting was not simply about buying objects. It was about learning. It was going to museums wherever I was, wherever we had businesses—in France, Germany, Canada.[15]

Q: What kind of reading were you doing when you began collecting?

fig 2 **Vincent van Gogh** *Cabanes à Saintes-Maries* (Two Cottages at Saintes-Maries-de-la-Mer), 1888, reed pen and brown ink over pencil, 12³/₈ x 18³/₄ inches (31.4 x 47.6 cm), The Thaw Collection, The Pierpont Morgan Library, New York

fig 4

fig 3

Eli: I got the art magazines about then, and I'd read museum and auction catalogues. Before we bought the 1933 Miró painting (fig. 3) from Harold Diamond,[16] I got all the Miró books. I couldn't decide between that one and a Miró that Beyeler had, which he sent over from Basel.[17] We had it on our wall and we thought about the two and ended up with this one.

Edye: The Miró has always been one of my favorites. It hangs in my office. I love it, and I wish I could've had the other one, too. It was beautiful, but we couldn't have both; we had to choose.

Q: What else did you buy in the early days? When did you start to think of yourselves as collectors?

Eli: We bought a 1923 Matisse ink drawing (fig. 4) and a Modigliani caryatid at Sotheby's auction house.[18] The Matisse drawing is the earliest work still in our collection today. Then we bought the Unesco commission of Henry Moore.[19] I thought I was a collector of sorts at that time. Did I think I was one of the top five collectors . . .? I wasn't in Taft's league. But collecting becomes a compulsion and an addiction. I loved the whole thing. It wasn't just the objects. It was meeting the people, the curators, the directors, the dealers, and the artists, as we moved forward.

Q: Did you get to know the prominent Los Angeles collectors of the sixties, Fred and Marcia Weisman,[20] or Joann and Gifford Phillips?[21]

Eli: I didn't meet them until later. I wasn't aware of that scene. I didn't know who Irving Blum was.[22] I don't remember how I got to know Marcia, but it was after Taft Schreiber.

Q: How did you start to collect contemporary art?

Eli: For me it was a progression, really. At the time we started I didn't appreciate contemporary art at all. I saw Henry Geldzahler's show at the Metropolitan in 1971.[23] Before that, I was not interested in pictures where, as Taft said, "The paint isn't quite dry yet." The first postwar picture we bought may have been an early Rothko.[24] We also had a Morris Louis.[25] We've exchanged things; for example, an early Frankenthaler called *Yellow Caterpillar*.[26]

Edye: I liked contemporary as well as earlier twentieth-century work. That's what I was interested in.

16. The Broads acquired Joan Miró's *Painting 1933*, 1933, in January 1974, from Harold Diamond, who was a private art dealer in New York from about 1960 until his death in 1983. Diamond specialized in late nineteenth- and early twentieth-century European art, including the work of Picasso, Matisse, Miró, Braque, and Léger.

17. Ernst Beyeler has been an art dealer in Basel since 1945 and a major collector of European Modernism. He cofounded Basel's International Art Fair in 1971. In 1982 he created the Beyeler Foundation, and in 1997 his museum opened in the Berower Park in Riehen, a suburb of Basel.

18. The Broads purchased Henri Matisse's pen-and-ink drawing, *Nu Couché*, 1922–23, in 1973. They bought the Amedeo Modigliani painting *Caryatid*, c. 1913–15, in 1975.

19. The Broads purchased Henry Moore's working model for the UNESCO Commission, *Reclining Figure*, 1957, a 94-inch-long bronze, in 1974. They sold the piece in 1993.

20. Los Angeles collectors Frederick R. (1912–1994) and Marcia (1918–1991) Weisman began collecting twentieth-century art in the mid-1950s. Eventually they built one of the finest collections of American contemporary art in Los Angeles. Fred Weisman served as trustee of LACMA from 1975 to 1994.

21. Joann and Gifford Phillips are collectors of modern and contemporary European and American art. Gifford Phillips was the first chairman of LACMA's Contemporary Art Council (1961–63).

22. Irving Blum became director of the newly established Ferus Gallery in Los Angeles in 1958. The Ferus Gallery closed in 1966, and in 1974 Blum opened a gallery in New York that specialized in contemporary American art.

23. *New York Painting and Sculpture, 1940–1970*, The Metropolitan Museum of Art, New York, 1970. The show included the work of Jasper Johns, Ellsworth Kelly, Roy Lichtenstein, Morris Louis, Robert Motherwell, Robert Rauschenberg, Mark Rothko, and Andy Warhol.

24. The Broads acquired Mark Rothko's *Orange, Yellow, Orange*, 1949, from the Marlborough Gallery in May 1980 and sold it at Sotheby's in November 1987.

"Artists and people at the academy—in higher education—have a different view of the world than people who spend all of their time in business. They view societal changes differently…. In a way, artists are ahead of us in how they view what's going on in society and the world. I enjoy listening. I don't always agree, but it's interesting." ELI

fig 3 Joan Miró *Painting 1933*, 1933, oil on canvas, 51¼ x 77 inches (130.2 x 195.6 cm), The Eli and Edythe L. Broad Collection
fig 4 Henri Matisse *Nu Couché*, 1922–23, pen and ink on paper, 11 x 15½ inches (27.9 x 39.4 cm), The Eli and Edythe L. Broad Collection

25. The Broads purchased Morris Louis's *Castor and Pollux*, 1962, from the Andre Emmerich Gallery in 1980 and sold it in 1987.

26. The Broads purchased Helen Frankenthaler's *Yellow Caterpillar*, 1961, in 1977 and sold it in 1990.

27. The Broads acquired Robert Motherwell's *The Sicilian Door*, 1972, in 1976 and sold it in 1983.

28. Albert Elsen (1928–1995) was a professor of art at Stanford University from 1968 to 1995. A Rodin scholar, he specialized in modern sculpture and was particularly influential in the development of the sculpture collection of Harry W. and Mary Margaret Anderson, in San Francisco.

29. German artist Joseph Beuys became involved with Josef and Anna Froehlich of Stuttgart as they were beginning to form their collection of modern and contemporary art.

30. The artist Sol LeWitt introduced New York collectors Dorothy and Herbert Vogel to the young artists who would form the core of their collection of minimal and conceptual art. In 1992 the Vogels promised their collection to the National Gallery of Art in Washington, D.C. In 1994 the National Gallery hosted *From Minimal to Conceptual Art: Works from the Dorothy and Herbert Vogel Collection*.

31. Michele De Angelus began to work with the Broads in 1980. She was curator of The Broad Art Foundation, The Eli and Edythe L. Broad Collection, and the corporate collections of SunAmerica Inc. and KB Home until 1995.

32. Leo Castelli (1907–1999) opened his New York gallery in 1957. He was a preeminent dealer and supporter of Pop art.

33. Longtime contemporary art dealer Larry Gagosian opened a print gallery in Los Angeles in 1976. By 1980 he was showing the work of New York artists such as Eric Fischl, Richard Serra, and David Salle. He now has galleries in Los Angeles, New York, and London.

Q: We understand that, at some point, you made a decision to sell the van Gogh drawing and buy the red Rauschenberg.

Eli: I'll tell you how that happened. We had a red Motherwell that didn't do much for me, which we put up for auction.[27] I was sitting at Christie's. To my right were David Whitney and Philip Johnson. They had consigned the red Rauschenberg, and we had consigned the Motherwell. We were kidding around, saying that it was an evening of red pictures. I was the successful bidder for the Rauschenberg—and I joke about the term, "successful bidder." It means that you're stupid enough to pay more than anyone else in the world would pay for the object! But we got it. And then—not having unlimited funds—we sold the van Gogh. I was willing to do this because, while I loved the drawing, it had to be in a drawer for six months; there was all that conservation stuff.

Edye: I wish we could've kept it, but as Eli said, because it was a drawing it had to be kept out of the light. We couldn't look at it all the time. I think in the beginning, if you can't have everything and have to choose, you make a tighter selection of works. If you can just buy a lot of things, it's not the same. I like the way Taft collected. He only wanted the best. He studied. He knew what was really good.

Q: The Rauschenberg's a tough picture. What was it that drew you to that painting?

Eli: I thought it was the beginning of Pop art. I don't know now if it's Pop art or not, but I was a student of the contemporary, and somehow I was attracted to the work of Rauschenberg. Not early enough.

Q: Did you see that as the beginning of a more serious collection? Did it set the bar higher for future acquisitions?

Eli: I'm not sure I was conscious of it, but I think it actually did set the bar higher.

Q: For a number of collectors, an artist, a dealer, or an art historian has served as a guide in the development of the collection: Albert Elsen for the Andersons,[28] Joseph Beuys for the Froehlich Collection,[29] Sol LeWitt for Dorothy and Herbert Vogel.[30] Did anyone play a role like that for you?

Eli: No, not really. I made all my own decisions. Shelley would scout things.[31] She'd provide me with lots of things to think about, but I'd make the decisions. With Leo Castelli, for example, I listened to him, but I didn't say, "You make the decision."[32] I've been a client of Larry Gagosian's since he started selling posters in Los Angeles.[33] Larry's more of a friend now, but there were times when he would be very honest in his opinion, and there were times when he would be a dealer, because he wanted to make a sale. Any artist we buy, I think it's fairly safe to say that,I've looked through all the books of the artist's work; I've seen it in exhibitions; and so on. I'll make my own decisions. I'm not saying the decisions are perfect, but they're mine.

Q: I think of yours as predominantly an eighties collection.

Eli: We became far more active in the eighties than we were in the seventies.

Q: And you continue to collect a lot of the artists who emerged in the eighties.

Eli: Yes. We keep buying. For example, we continue to acquire Eric Fischl's work, which we've collected since the beginning of the Foundation, along with work by David Salle, Cindy Sherman, Peter Halley, and many others.

16.

"Any artist we buy, I think it's fairly safe to say that I've looked through all the books of the artist's work; I've seen it in exhibitions; and so on. I'll make my own decisions. I'm not saying the decisions are perfect, but they're mine." ELI

fig 5

34. Metro Pictures gallery, run by Janelle Reiring and Helene Weiner, opened at 169 Mercer Street in Soho in 1980, showing the work of Cindy Sherman and Sherrie Levine, among others.

35. James Corcoran, a dealer in contemporary art, has had a gallery in Los Angeles since 1974.

36. The exhibition *Andy Warhol: A Retrospective,* curated by Kynaston McShine, was shown at The Museum of Modern Art, New York, from February 6 to May 2, 1989.

37. Marian Goodman opened her gallery at 24 West 57th Street in October 1977. She introduced U.S. audiences to many contemporary European artists, including Anselm Kiefer, whose work she first showed in early 1980.

38. Barbara Gladstone opened her first gallery at 152 Wooster Street in New York in 1983.

Q: In your collecting in general, did you take a conscious, scholarly approach?

Eli: Well, we didn't want to collect everything. I had a theory that the great collections of the world were made when the art was contemporary—you can't go back and create a great Impressionist or Post-impressionist collection today. I remember how we started with Cindy Sherman in the basement at Metro Pictures on Mercer Street.34 It was about 1980 or 1981. Then we just followed her, and now we have about a hundred of her works.

Q: Was Sherman the first artist you bought in depth?

Eli: Yes, we kept following her career. With Johns we bought whatever we could, but it wasn't easy to acquire Johns pictures because there were lines of collectors waiting for the work.

Q: Did you buy Johns soon after you bought the Rauschenberg?

Eli: I didn't buy Johns early enough. I bought the crosshatch painting (p. 64) in 1978 from James Corcoran.35

Q: What about Warhol?

Eli: We were late coming to Warhol. An appreciation for Warhol came when I saw the retrospective at MoMA.36 I find retrospectives very educational. My understanding of Warhol's work came when I saw it all at one time.

Edye: Eli likes Warhol more than I do. I appreciate him, but I like some things more than others.

Q: Is getting to know the artists an important part of the collecting process?

Eli: It has been, in many cases, the most important part. I mean, I loved spending time with Roy and Dorothy Lichtenstein and still enjoy seeing Dorothy. The works, for me, were an acquired taste. The first

work of his we bought was *Green and Yellow Apple* from the Castelli Gallery. I remember being in his studio around 1986 when he was making *Imperfect Painting* and *Perfect Painting.* We got to know one another, and I would see him out at Southampton. We bought from every show once we started buying Lichtenstein. Then we went back to acquire *Blang!* (p. 68) and other paintings, mostly at auction.

Q: Eli, you've often said that an artist's way of thinking appeals to you.

Eli: Artists and people at the academy—in higher education—have a different view of the world than people who spend all of their time in business. They view societal changes differently. In a way it's like politics: When you have third-party movements, they're generally way ahead of the major parties. If you go through American political history, you find that a decade or so after the third parties emerge, the major parties adopt some of their ideas. In a way, artists are ahead of us in how they view what's going on in society and the world. I enjoy listening. I don't always agree, but it's interesting.

Q: I assume that your taste has changed over the years. Are there artists you now collect who were difficult for you to understand earlier?

Eli: Sure. Warhol was tough to understand. Lichtenstein was tough to understand. They were all tough. You've got to be exposed to it. You've got to learn about it. You've got to see more of it. We were not into contemporary European pictures until about ten or fifteen years ago. I still remember seeing Marian Goodman about European artists;37 we also got a list from Barbara Gladstone.38 I liked Kiefer; Balkenhol came later. Early on we bought a fracture painting by Baselitz (p. 169). I wish we had bought Richter earlier.

18.

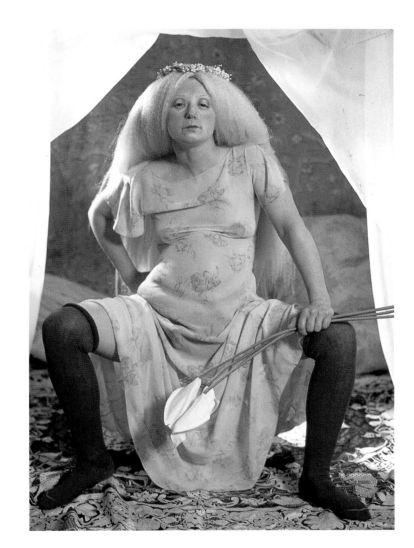

Eric Fischl *Untitled*, 1982
Cindy Sherman *Untitled #94*, 1981
Cindy Sherman *Untitled #276*, 1993

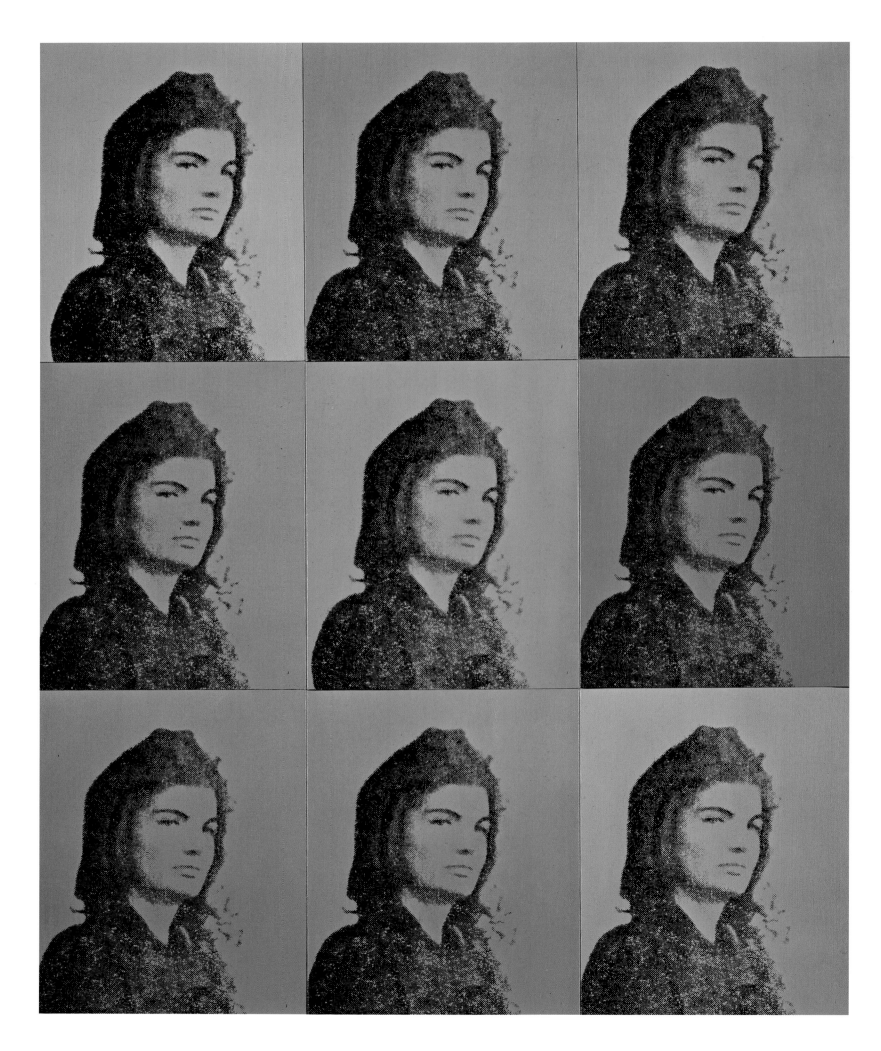

20.

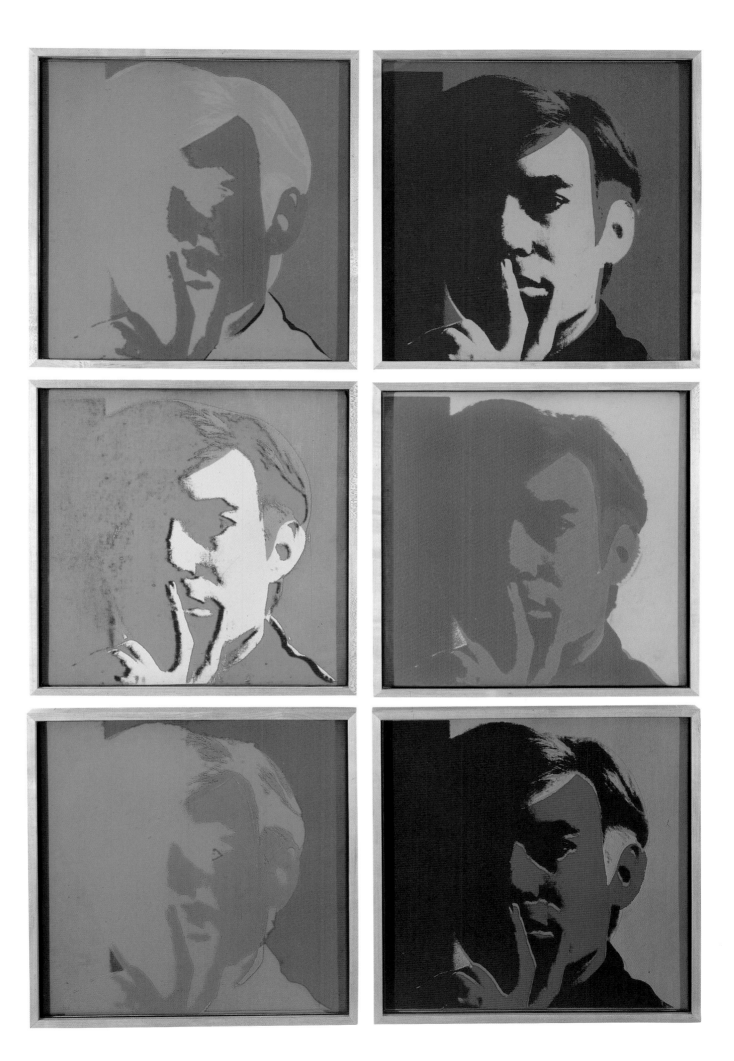

Andy Warhol *Nine Blue Jackies,* 1964
Andy Warhol *Self-Portrait,* 1966

"The L.A. artist Mark Lere once told us that, growing up in Colorado, he visited a museum with his school. He had never been to one before. He asked the teacher, 'What is this? And what do you call people who make it?' She answered, 'It's art, and the people who make it are artists,' and he said, 'That's what I'm going to be when I grow up.' When he told us that I thought, 'That's the kind of experience our foundation could help provide.'" EDYE

Q: How did you get enlisted in forming The Museum of Contemporary Art (MOCA)?

Eli: Let's remember, I'm an entrepreneur. I like to create things. Los Angeles was not one of the seven or eight North American cities that had a separate modern or contemporary art museum. There was a lot of jabbering about creating one. The city required real estate developers to spend 1½ percent of their costs for art. My thought was, "Why don't we aggregate that and create an institution with that money, rather than letting them spend it on individual sculptures or paintings for lobbies around the city?" Marcia [Weisman] was there in the early days. The mayor, Tom Bradley, promised to get funds from the developers for the building, but the museum was not going to get ongoing financial support from the city, so we had to raise a $10 million endowment. We raised $13 million by allowing people to become founders at a modest level: $10,000, $2,000 a year for five years. I was astounded at the number of people who wanted to do that. There were a lot of people at that time who were alienated from the Music Center and LACMA, which were kind of closed corporations. There were people who never wanted to see MOCA happen, and then there were people like Dick Sherwood,[39] who believed Los Angeles could walk and chew gum at the same time, and Robert Anderson,[40] who gave us the first million-dollar gift.

Q: You were the first president of the board of MOCA?

Eli: I was chairman of the board, yes, and I recruited Pontus Hulten to be our first director,[41] and Richard Koshalek to be our chief curator.[42]

Q: You were involved with the Panza acquisition?

Eli: That's an interesting story. Count Panza had a problem.[43] There was a communist government in Italy that decided if Italians had assets outside the country and wanted to bring them into Italy, they had to pay a huge tax, which I never understood: Why would you be taxed for bringing assets home? In any case, Panza wanted his collection kept together, didn't really want to sell it, although he had estimates of $10 to $12 million from both Christie's and Sotheby's. MOCA didn't have any money, but he and I cut the following deal: We would pay him $11 million over five or six years. I said, "You're better off waiting to get dollars, rather than converting the whole thing to lira." At any rate, I convinced the board to borrow from the endowment to buy the collection. Frankly, I thought, "If I can't convince the board to do this deal, I'll buy all the pictures, somehow. I'll figure it out," because I thought it was such a great thing to do. Today, one of the eighty pictures MOCA got would pay for the whole collection.

Q: I saw the collection at MOCA recently and it surprised me because I thought of it as being mostly a minimalist collection, and it isn't particularly.

Eli: No, it's not. It's got the greatest Rauschenbergs in the world and it's got good Klines and it's got very good Rothkos.

Q: What was the impetus for creating The Broad Art Foundation?

Eli: I got the idea of the Foundation in about 1979.[44]

39. Richard E. Sherwood (1928–1993) was president of the board of trustees of LACMA from 1974 to 1978 and chairman from 1978 to 1982.

40. Robert O. Anderson, Chairman of the Board of ARCO Corporation, became a member of the LACMA board of trustees in 1973. In 1994 he was named an Honorary Life Trustee.

41. Pontus Hulten was Founding Director of MOCA, Los Angeles, 1980–82; prior to that he was the first director of Musée nationale d'art moderne, Centre Georges Pompidou, and the director of the Moderne Museet in Stockholm.

42. Richard Koshalek became deputy director of The Museum of Contemporary Art, Los Angeles, in 1980. From 1982 to 1999 he served as the museum's director. Before coming to MOCA, he was director of the Hudson River Museum in Yonkers, New York.

43. Count Giuseppe Panza di Biumo is an Italian collector of American and European postwar art.

44. The Broad Art Foundation was established in 1984 "to build a collection of historically significant contemporary artwork and to make that collection available for loan to art institutions around the world." In 1988 The Broad Art Foundation moved from a bungalow beside Michele De Angelus's house in West Los Angeles to a commercial building in the Ocean Park area of Santa Monica renovated by architect Frederick Fischer. The building includes 22,000 square feet of exhibition space that is open by appointment to "art scholars, museum professionals, and qualified individuals or small museum or university affiliated groups." The Broad Art Foundation brochure.

Edye: At first, Eli wanted to do it, and I didn't, because I thought that I might want to have the art in the house, and I wouldn't be able to if it belonged to the Foundation. As time went on, though, I came to like the idea. We have bought some things we wouldn't have bought otherwise. We were able to help some young artists get started. The Foundation can share art with the public through loans to museums and universities. At some point, how much are you going to keep buying? The Foundation allows us to keep going, and I don't feel a need to have everything. I enjoy what we have at home.

The Foundation is also fun. People were generous to us when we were learning and looking. It's a way to reciprocate. I didn't realize that there are places that don't have exposure to art. We can send our works to those places and a lot of people get to see them. The L.A. artist Mark Lere once told us that, growing up in Colorado, he visited a museum with his school. He had never been to one before. He asked the teacher, "What is this? And what do you call people who make it?" She answered, "It's art, and the people who make it are artists," and he said, "That's what I'm going to be when I grow up." When he told us that I thought, "That's the kind of experience our foundation could help provide."

Q: Lere's experience is similar to the way you got interested in art—on school trips.

Edye: Yes, and maybe the Foundation's a way of getting other people interested. Who knows? Buying art does become an addiction; you don't want to stop, but really, what are you going to do with 700 to 800 works of art? How many times are you going to rotate what's on your walls? You know, that's called a museum.

Q: How do you decide which work goes into the Foundation and which goes into the personal collection, given that they cover the same periods and some of the same artists?

Eli: The decision has to do with whether we will ever have an opportunity to hang a work at home, to live with it. We don't want to own things in the personal collection that are going to be in storage all the time or on loan. If that's going to be the case, we will let the Foundation own them. I don't feel good about things in storage. I want to hang them, lend them, or show them.

Q: How do you decide to add new artists to the collection?

Eli: In the personal collection, we really haven't added many new artists in recent years, and the Foundation hasn't been as diligent as we were in the early days. In those days the activity was in the East Village, and I still remember how much we bought. We're not as aggressive as we were then.

Q: Besides Lichtenstein, what other artists did you visit?

Eli: Many. I especially remember Jasper Johns's studio on 66th Street. He was working on a large painting. I fell in love with it on sight. I did something I'd never done before. I left the studio, went out to the street, and called Leo [Castelli] on a cell phone. I said, "I've got to have the picture." He said, "Jasper won't sell it," but then he got involved. I really wanted it, and sometime later Jasper agreed to sell it to us.

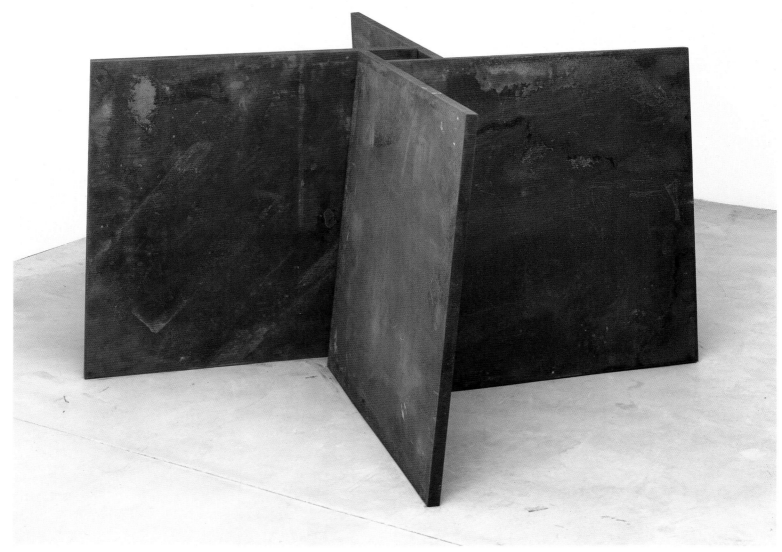

fig 6

"Contemporary art became the 'in' thing to do. People started buying it and then turning around and selling it. It became like an investment program." EDYE

Q: Bob Therrien was a very early acquisition for you.

Eli: I think it was Shelley who knew the work and took us to see it. He had a studio on Pico. Edye and I went to visit him, and I thought it was very interesting work.

Edye: We were looking for art for the office. The budget required that the works be a thousand dollars or less, so Shelley found some younger artists, and we went to see Therrien.

Q: Do you still go to studios?

Edye: Yes, but it's not always as much fun. Some artists are bothered. Everyone's tromping through their place, wanting to see their work. I don't like that part either. Contemporary art became the "in" thing to do. People started buying it and then turning around and selling it. It became like an investment program. A lot of the dealers got involved in it, which I don't think serves the artist. You'd have to put your name on a waiting list for new work.

Q: You've made a commitment to Richard Serra. What did it take to acquire the huge sculpture that you have at your house?

Eli: I respect Serra's work. In my mind, he's the most important living sculptor, without any question. The first Serra we acquired was *Inverted House of Cards*, which we've given to LACMA. We bought it many years ago, and it sat in storage, because we didn't know what to do with it in our previous home. We weren't sure where or how to install it—these objects are big and heavy and if they fall down they could hurt someone—but we finally put it up. When we were

fig 7

building this house, I thought we ought to have some important sculpture, so we commissioned Richard to do something, and he came up with a piece that I thought was wonderful, but it was forty feet high. The more I thought about it, the more I saw that there were a number of problems: One, from a zoning point of view, what is it? Is it a flagpole? Is it a structure? I didn't want to get involved with the city in that way. At the end of the day, when the ether wore off, I said, "It's wonderful, but we're enough of a spectacle in this canyon with the Gehry house." He was disappointed. Then, a few years later, we still wanted something and I'd seen a work outside the Kunsthalle in Basel, and Richard agreed to get involved in a commission. He didn't warn me about how *easy* it would be to do all of this. You should see the film footage we have of the installation. Well, you can imagine. After it was done, he hadn't named it. We were discussing what

"I don't just want one object by an artist. If I believe in an artist, it's important to have a group on display." ELI

we went through to get it here, and kidding around, I said, "No problem." He thought that was nice, so he named it *No Problem.*

Q: You don't usually commission works.

Eli: Life's too short. It's not just the installation; you don't know what you're going to get. It gets involved. The only other semi-commission we've done was an Ellsworth Kelly for our other house.[45] That was simple.

Q: You have a large selection of Koons's work.

Eli: I feel very strongly about Jeff Koons's work now, but it took me a while to appreciate it. Again, I'm not there at the beginning very often. Once I'm convinced about an artist's work, I buy the current work and try to go back and buy earlier work. We really missed Koons the first time around, when it was a heated market. Later we bought the basketballs (*Three-Ball 50/50 Tank,* 1985, p.117). Jeff sold us the *Rabbit* (p.124) and the Michael Jackson from his personal collection, and we added five more works from various dealers. I don't just want one object by an artist. If I believe in an artist, it's important to have a group on display.

Q: Your collection could be described as predominately figurative. Do you think about it in those terms?

Eli: It is somewhat figurative. Sure, I think that's fair. I think it's figurative, and I think some of the works, especially in the Foundation collection, have some social content.

Q: Does that come from your background?

Eli: Yes.

Edye: I think the social and political work in the Foundation's collection may be a reflection of our concern for community and the world, of wanting things to be better, and wanting to highlight a problem that someone will solve. For me, it probably also comes from my family's concerns from a long time ago.

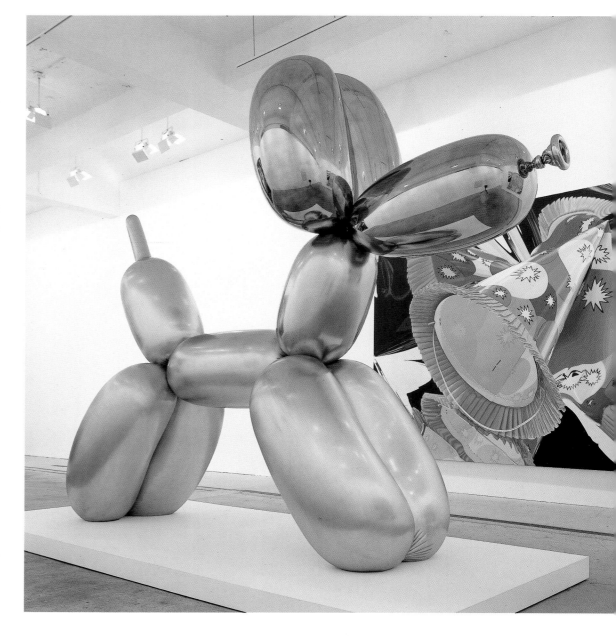

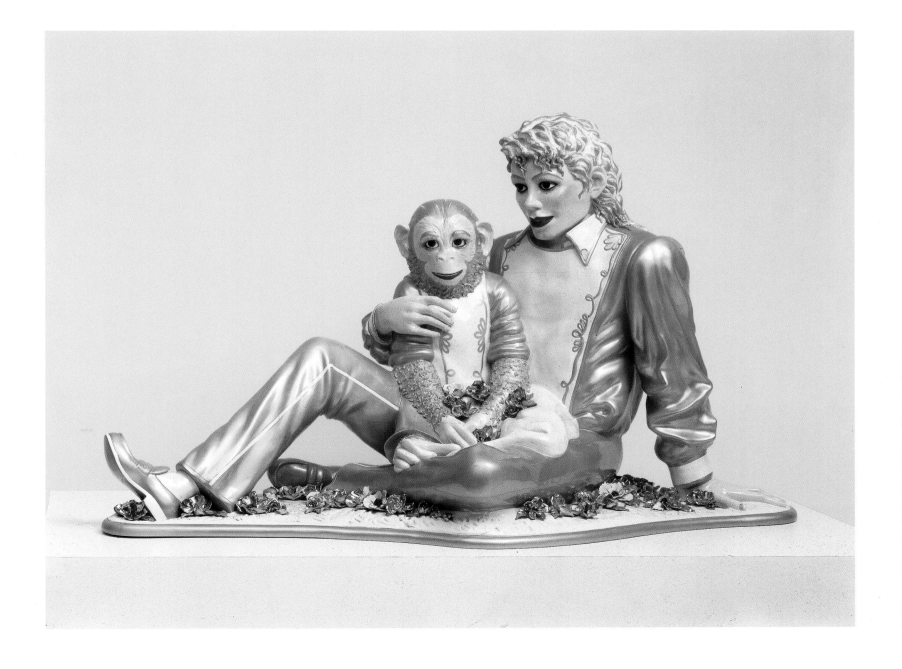

Jeff Koons *Balloon Dog*, 1994–2001, 1999 installtion view of work in progress.
Jeff Koons *Michael Jackson and Bubbles*, 1988

"I think the social and political work in the Foundation's collection may be a reflection of our concern for community and the world, of wanting things to be better, and wanting to highlight a problem that someone will solve." EDYE

Q: How has your collecting evolved?

Eli: I think when you have enough things, and enough going on in your life, you're no longer in the "discover" business. You go through a period when you enjoy discovering, and then after a while, if you have enough work, you just lose some of your interest. The Foundation should get involved—and we have to a degree—in some new artists. But not to the extent we would have ten years ago.

Q: You've recently added Sharon Lockhart in some depth to the Foundation collection. Of all the younger artists, why is she the one?

Eli: I'm not sure I can answer that other than I've looked at other work, and hers appealed to me. I think I was influenced in that case by our curator, Joanne Heyler.

Q: A lot of artists have been working in time-based mediums, yet your recent acquisition of Shirin Nishat's *Rapture* was atypical.

Eli: Exactly. Video is harder for me. You know, I'm interested in painting and to a lesser extent drawings and sculpture, but I'm so practical. What do we do with video? We're a lending institution, and it's difficult to lend a lot of it. It's difficult to show it. I'm not sure I want to live with those sorts of things. So we're not in the video art world, although Joanne thinks we ought to be.

Q: L.A. has the second largest population of working artists. Do you feel any special interest in or obligation to collect L.A. artists?

Eli: We have corporate collections,[46] in which we've done that from day one. But if the artists are good we don't care where they're from. I don't view Baldessari as a Los Angeles artist. I don't think of Ruscha as from Los Angeles. They happen to be here. I think they're important American artists.

Q: What responsibility do you find the collection places on you?

Eli: We feel we're guardians of the works. Although we own the work, we feel an obligation to protect and share it. I feel good being with the art. I feel proud of it. If I thought it was just decoration, I'd feel differently.

Q: Do works change when you live with them?

Eli: Sure, they're interesting, beautiful things, but some works don't challenge me after a time. The Morris Louis and the Frankenthaler did not hold our interest.

Q: But you're still challenged by Johns and Warhol?

Eli: Yes. I learned early on that there will be fashion in art as long as the professionals in the art world come and go. I've learned to be patient. Jean-Michel Basquiat had a great career. Then there was a period where you couldn't give the work away, and then, several years thereafter, it came back into fashion.

Q: Do you think one half of collecting is pursuing the objects and the other half appreciating them?

Eli: I don't know what the mix is, but both of them are part of collecting. I like the chase, but for me it's a means to an end, not an end in itself.

Q: Has the art world changed from when you started collecting?

Eli: The art world is in continual change. When we started there wasn't that heat. Then in the mid- to late eighties it got very heated. If you weren't someone, didn't get to the studio before someone else did, you didn't get the picture. We went through that. Then it calmed down.

Edye: It's more a business now. There was a time when we didn't buy very much because that's what it was all about. I don't like to go to openings for that reason. You can't really look at the show. It's fine if you want to go out and see people, but it's not a way to see art.

Jean-Michel Basquiat *Wicker,* 1984

Q: More things come to you now, rather than you having to find them.

Eli: Yes, for the most part that's true. Dealers know that we buy quite a bit. I wish we had more come to us, but I wasn't willing to do what I should've done. One of the mistakes that I made was not being willing to pay the way David Geffen does for great things. If someone has a great Johns, they're going to call him first. You know, David paid quite a price for the Johns *Target with Plaster Casts* —he did what was right. He decided he'd rather have the picture than the money. They know he'll write the big check. I had a reputation of not being willing to do that. In the last several years, I have paid up for things. But if I had it to do over again, I would've spent more earlier.

Q: You would've?

Eli: Yeah.

Q: Yet you've got a reputation, certainly from your curators, of being enormously disciplined when you buy at auction.

Eli: Yes, for example at the recent auction in New York, there were two works that I wanted to buy, the early Richter and Warhol's *Liz*.[47] But there's a limit. I made one bid higher than I had planned, but I wasn't going to get carried away. Maybe I should. Larry Gagosian thinks I'm nuts. He says, "You've got more money, more real net worth than anyone I deal with, but you're disciplined, you're cheap, or whatever."

Q: Even though you might wish that you had bought Geffen's paintings, you don't do what he does?

Eli: No, but I have paid up for things: I bought a Twombly for a big price at first sight;[48] I paid a great deal for our Johns *Flag* (p. 44), which I thought was a great work.

Q: Other than Geffen, are there collectors, nationally or internationally, whom you admire?

Eli: Norton Simon, without question, was the best collector Southern California's had, from all I can see. His collection had breadth, quality, quantity.[49] Taft Schreiber's was very good, but it didn't have breadth and it didn't have quantity. Bob and Jane Meyerhoff clearly have a collection of quality. Jane did a great job, a far better job than I did. She has embraced the artists, spends time at the collection. You know, she didn't have a day job—the collection *was* her day job—and she did very well with it. I've visited them in Phoenix, Maryland, and it's impressive; the show they had at the National Gallery was impressive.[50] Ray Nasher, without question, has a great sculpture collection.[51] No one comes close that I know of in the world.

Q: Do you think your collecting and the approach that you have taken in both the personal and the Foundation collection has had an influence on other collectors?

Eli: I may have influenced some collectors, but it's often a two-way street. Did Saatchi influence me?[52] In some ways, yes. Saatchi has bought artists a lot earlier than I have. Charles Ray's work for example, Saatchi bought in great depth. Some days he would buy six, seven works of art.

Q: It seems like there's a place in which your social activities and your collection dovetail.

Eli: It did more earlier than it does now. There was a time when we had a greater interest in being with other collectors. But with all the other interests I have—education, projects in Los Angeles—art has more competition now.

Q: Some collectors have taken time off to formally study art history. Have you ever thought of doing that?

Eli: Would I do that if I had time? Maybe. I'm chairman of our company, no longer CEO, but it's amazing what I do every day. I suppose I'm involved in too many things. Today for example, I had a group of CORO fellows over for an hour and a half.[53] Then I had meetings

45. Ellsworth Kelly, *Curve XXVIII*, 1982.

46. The Kaufman and Broad Collection began in November 1981. When SunAmerica Inc. was formed, the two corporations shared this corporation collection. Today there are two collections, The SunAmerica Collection and The KB Home Collection, which share a common vision and a common focus on art made by artists living and working in Southern California. The better-known artists in the SunAmerica Collection include John Altoon, Ingrid Calame, Sharon Ellis, Charles Garabedian, Tim Hawkinson, Mike Kelley, Monique Prieto, Nancy Rubins, Italo Scanga, and Robert Therrien.

47. The auction in question took place on November 15, 2000, at Christie's New York's Post-War Evening Sale. The two works in question are Andy Warhol's *Liz*, 1963, and Gerhard Richter's *Der Kongress*, 1965.

48. *Nini's Painting*, 1971 (p. 49).

49. Norton Simon (1907–1993), a Los Angeles businessman, began to collect art in the 1950s. His holdings include nineteenth-century French painting, Old Masters, and Indian and Southeast Asian art. In 1975 he reorganized the bankrupt Pasadena Museum of Art, which then reopened as the Norton Simon Museum and became a showcase for his collection.

50. Jane and Robert Meyerhoff, Baltimore philanthropists, have collected European and American modern art since the 1950s. In 1987 they promised their collection to the National Gallery of Art in Washington, D.C., which hosted *The Robert and Jane Meyerhoff Collection: 1945–1995* in 1996. To date they have donated more than fifty works to the institution.

51. Raymond and Patsy Nasher are Dallas collectors of primarily contemporary painting and modern sculpture. In 1997 the exhibition *Masterworks of Modern Sculpture: The Nasher Collection* was held at the Fine Arts Museums of San Francisco. In the same year the exhibition *A Century of Sculpture: The Nasher Collection* was held at the Solomon R. Guggenheim Museum in New York. The Nasher Sculpture Garden and Center is scheduled to open in downtown Dallas in 2002.

fig 8

fig 9

fig 8 Installation at The Broad Art Foundation showing (l-r) Kara Walker, *Danse de la Nubienne Nouveaux*, 1998, and Cindy Sherman, *Untitled #205*, 1989
fig 9 Installation at The Broad Art Foundation showing (l-r) Lari Pittman, *With Appreciation, I will have understood the decorum of my mobility*, 1999, and *Like You*, 1995

about the dinner we're having for the new Secretary of Education in Washington, right before the Inaugural Balls. I'm involved with USC; I'm on the board of the Keck Medical Center, where we're trying to create a bioscience park on County property adjacent to the University Hospitals. I enjoy doing things; I enjoy making things happen.

Q: So now that you have more time for philanthropy and other interests, it sounds like, rather than assuming a bigger role, art will be one of a number of concerns?

Eli: Yes. I'm spending the most time on K–12 education right now. The Broad Foundation, which we conceived to address a nationwide social issue,[54] is and will be more deeply funded than The Art Foundation. Our purpose is to improve governance, management, and labor relations in the nation's largest school districts. We're doing a lot of things nationally; we've got some brilliant people on the Foundation staff. Although I'm a lifelong Democrat, I'm especially excited that President Bush appointed Roderick Paige as Secretary of Education. He's from Houston, the seventh largest school district. He's the real thing, a practitioner, not a pontificator or a politician. We think, working with him, there are going to be a lot of positive changes in public education.

Q: Is there a way you can bring the threads together? What about having art as part of the K–12 curriculum?

Eli: That's important. However, having said that, the problems of K–12 in the sixty-five largest urban districts are so great that arts education is not among my top ten priorities. I've done a whole dissertation about what has happened as a result of free trade and technology. You end up with two types of workers: service workers and knowledge workers. The gap between the middle class and the poor widens every day. I'm convinced that the biggest problem facing the country is

> "If I were starting out, and didn't have much money, I'd buy prints and drawings of my own era, or maybe back a bit. It takes going to museums, galleries, and studios, spending time at it, becoming a student. Very few people want to make that commitment. They'll spend the money, but not the time." ELI

creating relevant K–12 education. I'm also convinced that creating a vital core in downtown Los Angeles is important.

Q: Do these concerns put the art in a different perspective for you now?

Eli: I'm still interested, and I'll be involved, but will I increase the amount of time I spend on it? No. I'm going to be in New York, for example, six hours on Thursday of next week, so I'll go to galleries and museums and see things I haven't seen. I'll be in Washington the following weeks, and I'll wander about, see the museum shows.

We're going to continue to collect and improve the quality of the collections. We want the Foundation to continue doing what it's been doing and perhaps expand its activities. We have greater financial resources for both collections. But if we could restructure, reform, and revolutionize K–12 education, that's far more important to society and the country than collecting art. On the other hand, you know, I love the city. I want to see LACMA really move ahead.

Q: What would be an ideal scenario for the future of the collection?

Edye: I'm 64; Eli's 67. At some point we have to make a decision about what we are going to do with the art. Because I do care. Probably we'll fill in some holes in one or several museum collections. I think the Foundation is fun and it serves a purpose, but I don't think that the world needs another separate institution. I'd like to be part of something bigger.

Eli: Our current thoughts are to give the collection to one or more arts institutions—probably in the Los Angeles area, which has been our home.

Q: What advice do you have for young collectors?

Eli: It's an investment of a lot of time, more so than money. If I were starting out, and didn't have much money, I'd buy prints and drawings of my own era, or maybe back a bit. It takes going to museums, galleries,

and studios, spending time at it, becoming a student. Very few people want to make that commitment. They'll spend the money, but not the time.

Q: What did you set out to accomplish as collectors, and how would you like the collection to be remembered?

Eli: We clearly don't collect art as an investment. It's something we want to learn from, live with, and be inspired by. I feel we have a lot to be proud of. Is it the best collection? Is it one of the best selections of works by Jasper Johns? Probably not. It's a very good selection of the works of some artists. I think Twombly and Warhol are well represented, and Lichtenstein is extremely well represented. We hope we are creating a collection that others will feel has quality. We hope they will feel that we knew what we were doing. We want to be remembered as people who had a great collection of art of the last forty years, and who shared the passion with others. It's rare, you know, to create something to give away. It's a legacy. ◎

52. Charles Saatchi, who made his fortune in advertising, and his former wife, Doris, became major collectors of contemporary art in the 1970s. In 1985 they opened the Saatchi Gallery in London to display rotating exhibitions from their collection. The Broads purchased their works by Charles Ray from Saatchi.

53. CORO is an organization founded in 1942 to provide postgraduate training in leadership. Fellows are selected to participate in a rigorous nine-month program in leadership training and public affairs.

54. "The Broad Foundation was established in 1999. Operating as an entrepreneurial grant-making organization, the foundation funds innovative efforts to dramatically improve governance, management, and labor relations in large urban school systems." The Broad Foundation brochure.

fig 10 **Robert Mapplethorpe** *Portrait of Eli Broad*, 1987, collection of Eli and Edythe L. Broad
fig 11 **Robert Mapplethorpe** *Portrait of Edythe Broad*, 1987, collection of Eli and Edythe L. Broad

fig 10

fig 11

roy lichtenstein

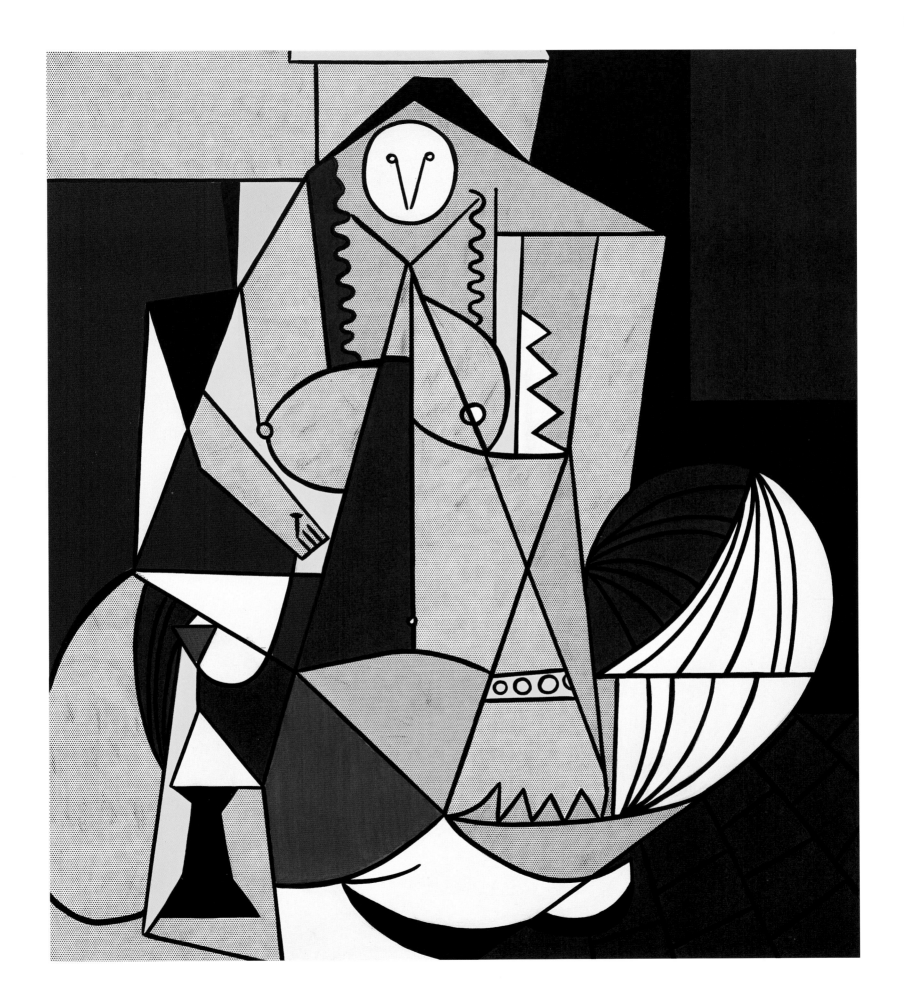

38.

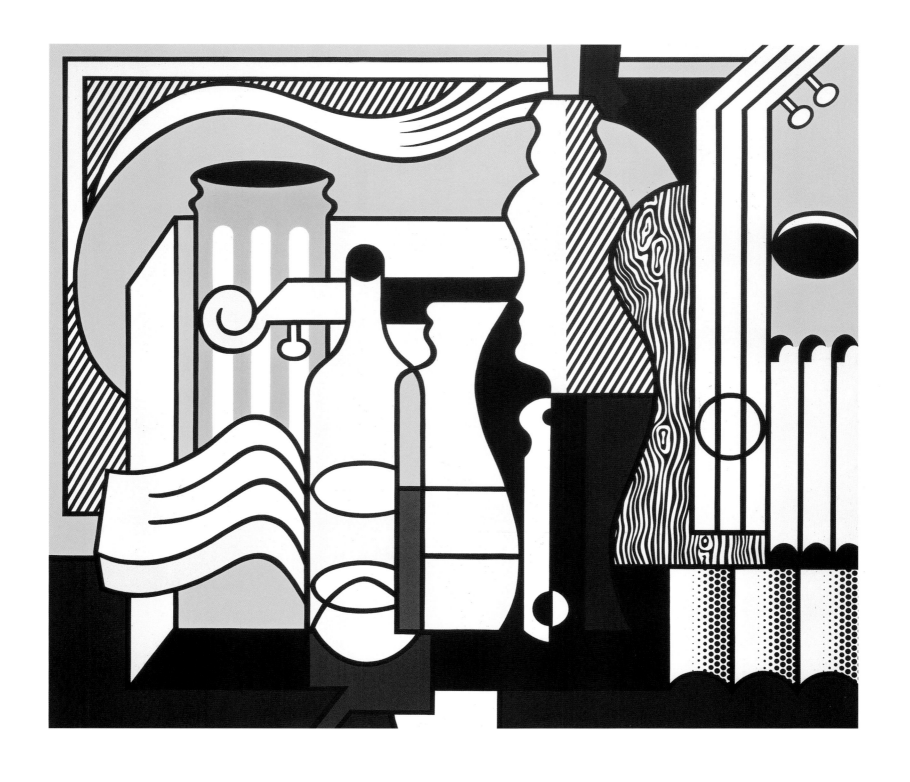

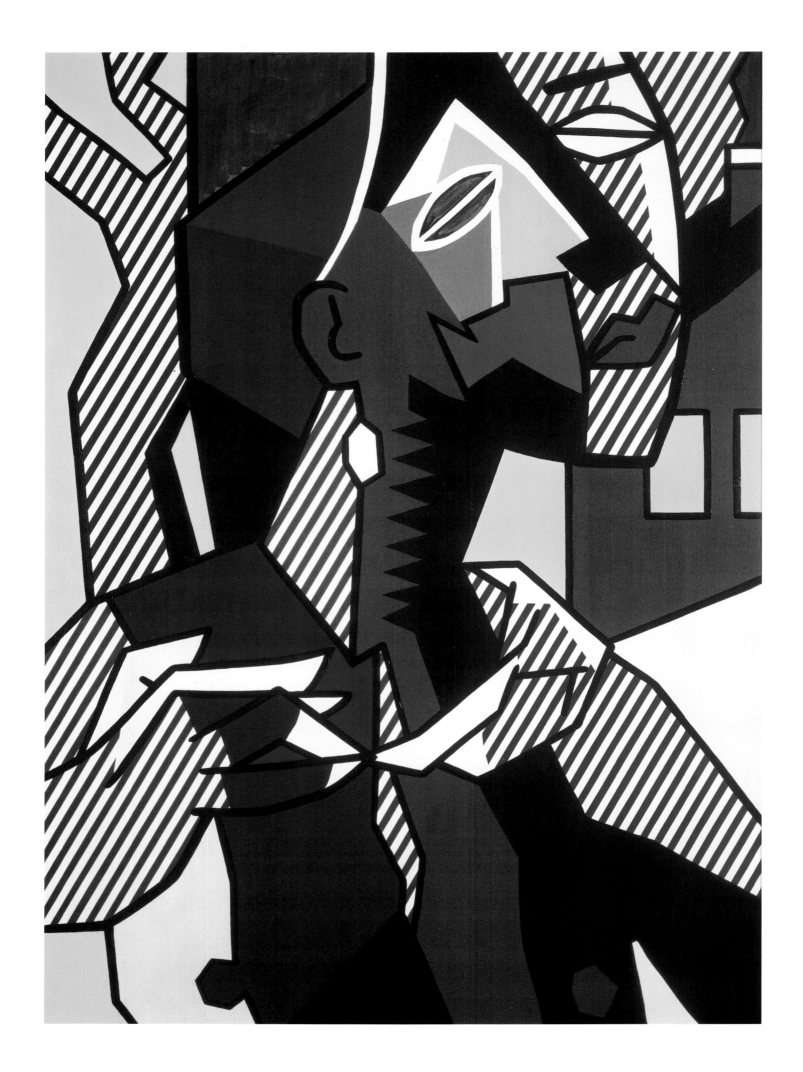

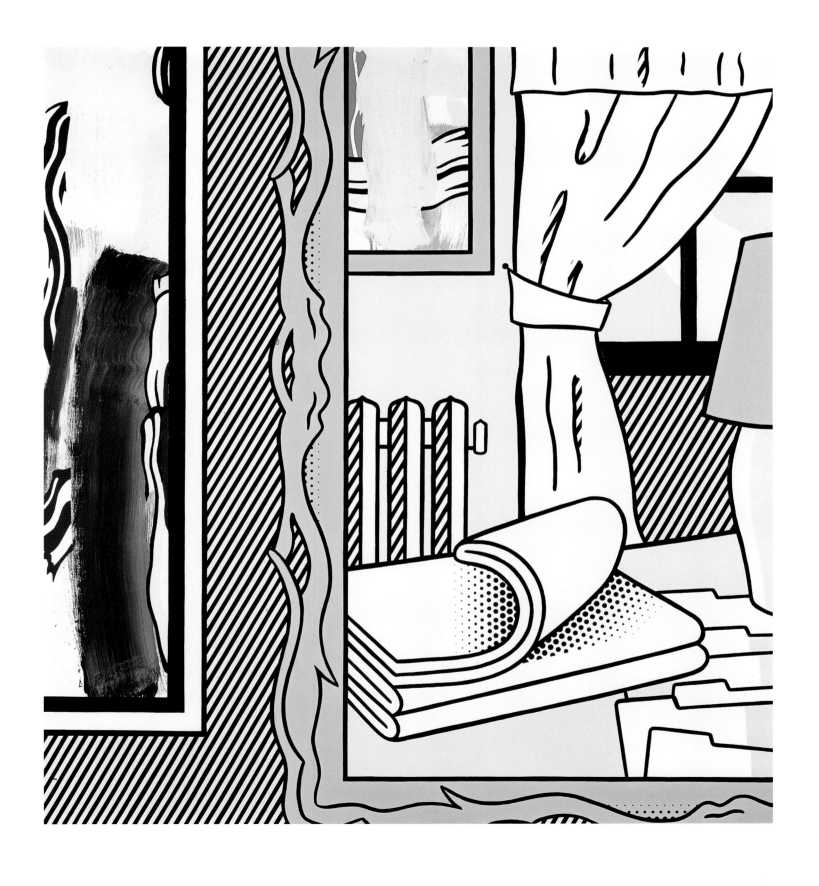

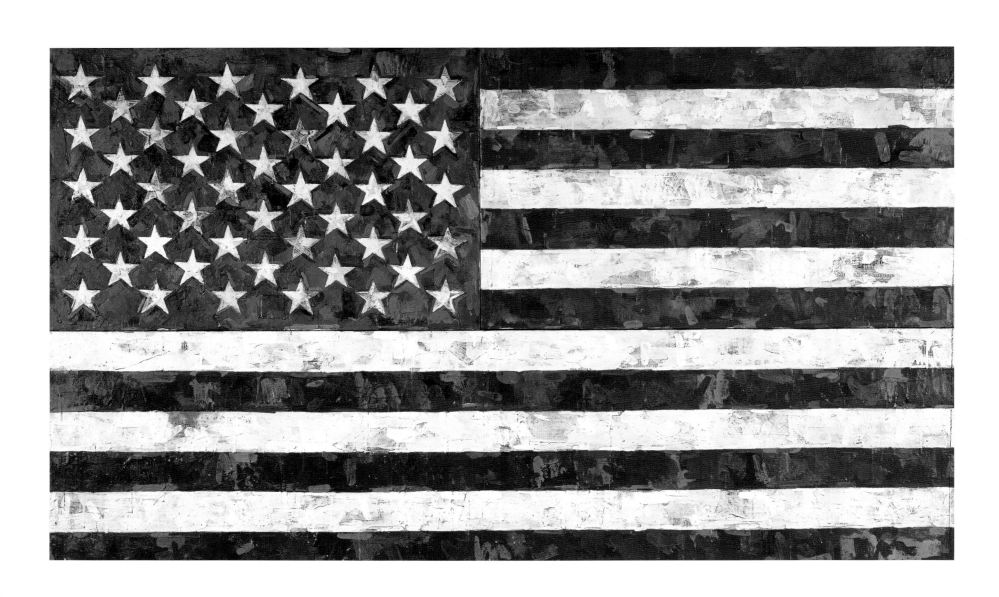

southern boys go to europe

Rauschenberg, Twombly, and Johns in the 1950s

There is probably no more decisive relationship for the history of postwar American art than the one that Cy Twombly, Robert Rauschenberg, and Jasper Johns developed over the course of the 1950s. The nature of their dialogue altered the landscape for artists who followed them in both America and Europe, preparing the ground for the widespread embrace of found, vernacular material, for the ubiquity of assemblage techniques, and for the hollowing-out of the authority traditionally carried by the autograph gesture in paint.

Retrospective accounts of the period, swayed by the dominant impact of Johns's early work, have nonetheless never quite grasped the essential equality of their individual contributions or the central importance of their shared artistic conversation. Perhaps the most decisive event in shaping subsequent perceptions can be located precisely in place and time: On a Saturday morning in January 1958, Alfred Barr, curator of collections at The Museum of Modern Art, paid a visit to the gallery recently opened by Leo Castelli. Barr's longtime assistant and collaborator, Dorothy Miller, recalled being summoned by telephone to brave a cold, pelting rain and join him there at the first solo exhibition of Jasper Johns. That encounter resulted in the remarkable, unprecedented acquisition by the museum of no less than four works by a young artist then barely known outside his immediate circle of friends. Barr and Miller spent only an hour discussing what to buy: "It wasn't a question of one picture," she said, "we chose four pictures. They were inexpensive and they were just so remarkable."[1] The four they settled on were *Green Target* (fig.12), *Target with Four Faces*, an early version of *White Numbers*, and *Flag* (though the last would spend some years under Philip Johnson's proxy ownership). Miller also bought *Grey Numbers* for her own collection.

It is difficult to point to a comparable instance in which an untried young artist so decisively and definitively arrived, and Johns's elevation entailed an immediate eclipse of Rauschenberg, his intimate partner and early mentor. The story is well known that Castelli, seeking a clear counter-voice to the florid rhetoric of Abstract Expressionism, had first been directed to Rauschenberg's Pearl Street studio; a chance detour into the neighboring space where Johns was working brought the dealer face-to-face with *Green Target*, and it was Johns who found himself with a show. Not that he was anything but ready—he had three years or more of production waiting for this opportunity—but so was Rauschenberg, who already had a significant exhibiting record and an impressive body of work, one equally destined for the history books, waiting in reserve. But he would have to remain content for some years with a secondary position in the Castelli constellation.

Barr, too, had known of Rauschenberg's work prior to Johns's elevation, but the museum would not acquire a major Combine until 1972, that is, not before an interval of nearly a decade and a half. In the meantime, Barr's buying decision that January morning sealed a pact, a linking of fortunes, between institution and artist that no one else in that generation would enjoy. It immediately propelled Johns into the public eye, where his way with condensed and emblematic imagery provided the model for much subsequent work in a Pop vein. The memorable reproducibility of Johns's early work was such that Ed Ruscha, for one, remembers finding nothing less than his own vocation

fig 12

for art through a mere photographic reproduction he happened to encounter in Italy at almost precisely this time: "It was," he forthrightly declared, "the atomic bomb of my education."[2]

To this story of the shifting fortunes of Johns and Rauschenberg must be added the earlier eclipse of Twombly, at this point already an expatriate in Italy, who had previously been Rauschenberg's closest companion in his personal and professional life. Twombly's definitive opting for Europe after 1957 (where his work was received by many with the force of revelation) is an overlooked symptom of a struggle between the New and Old Worlds that lay behind Barr's decision and its subsequent consequences for all three of them.

From its founding in 1929, The Museum of Modern Art sought to advance the cause of European modern art and for three decades paid relatively little attention to American artists with ambitions to compete with Europe on the terrain of advanced ideas and techniques. As a native avant-garde gathered strength through the 1940s, New York painters and sculptors vehemently protested that Barr—and by extension his museum—took account of American art only in its naïve and provincial aspects, which conceded in advance an inevitable superiority to Europe. That resentment found further confirmation in Barr's extreme devotion to certain isolated and self-taught American artists, a commitment that he was prepared to pursue at considerable cost to himself.

In 1943 he helped precipitate his own dismissal as director by museum president Steven Clark when he stubbornly insisted on exhibiting—and praising to the press—a wildly decorated shoeshine stand constructed by one Joe Milone (whose existence had been called to his attention by the

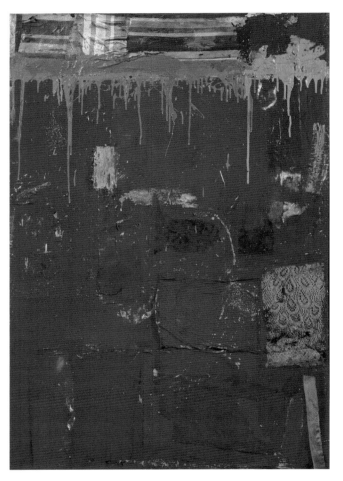

1. Lynn Zelevansky, "Dorothy Miller's 'Americans,' 1942–1963," *Studies in Modern Art* 4 (New York: Museum of Modern Art, 1995), 80.

2. Ed Ruscha quoted in Kirk Varnedoe, *Jasper Johns: A Retrospective* (New York: Museum of Modern Art, 1996), 95.

fig 12 **Jasper Johns** *Green Target,* 1955, encaustic on newspaper and cloth over canvas, 60 x 60 inches (152.4 x 152.4 cm), The Museum of Modern Art, New York, Richard S. Zeisler Fund
Robert Rauschenberg *Untitled (Red Painting),* 1954
Cy Twombly *Ilium (One Morning Ten Years Later),* 1964 [Part 1]

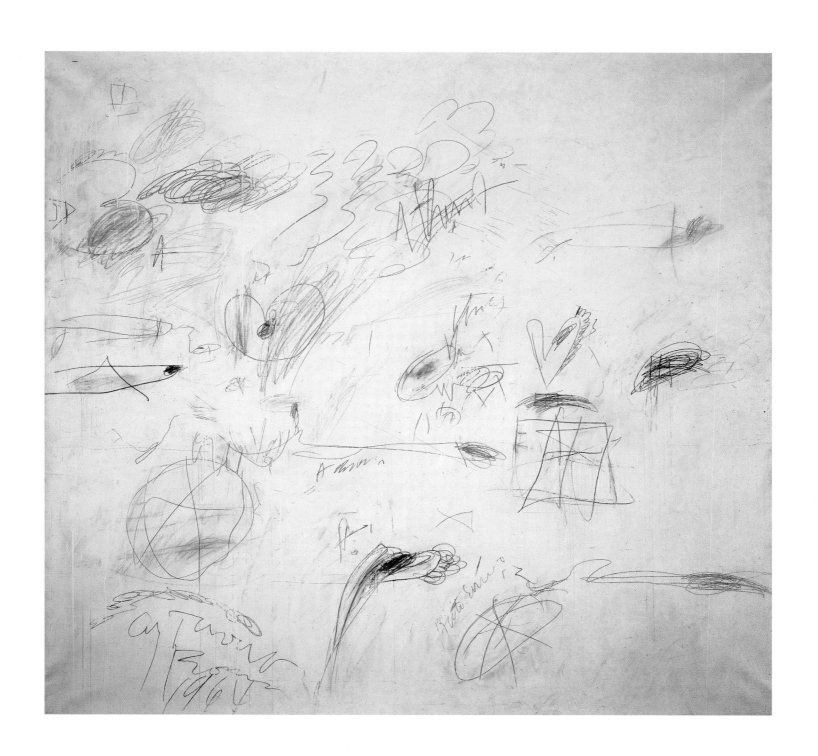

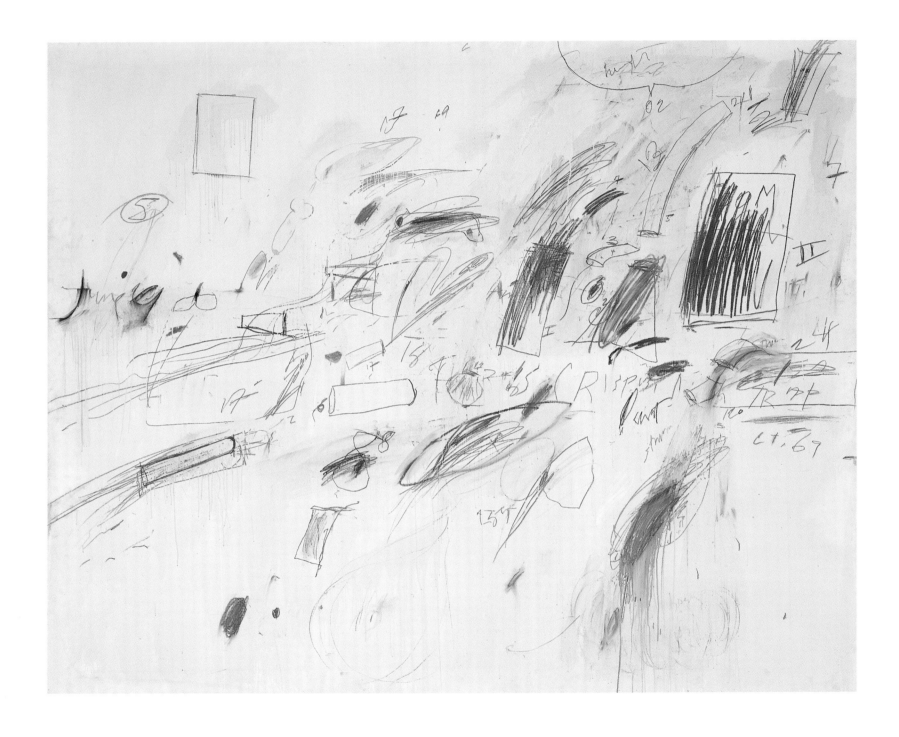

48.

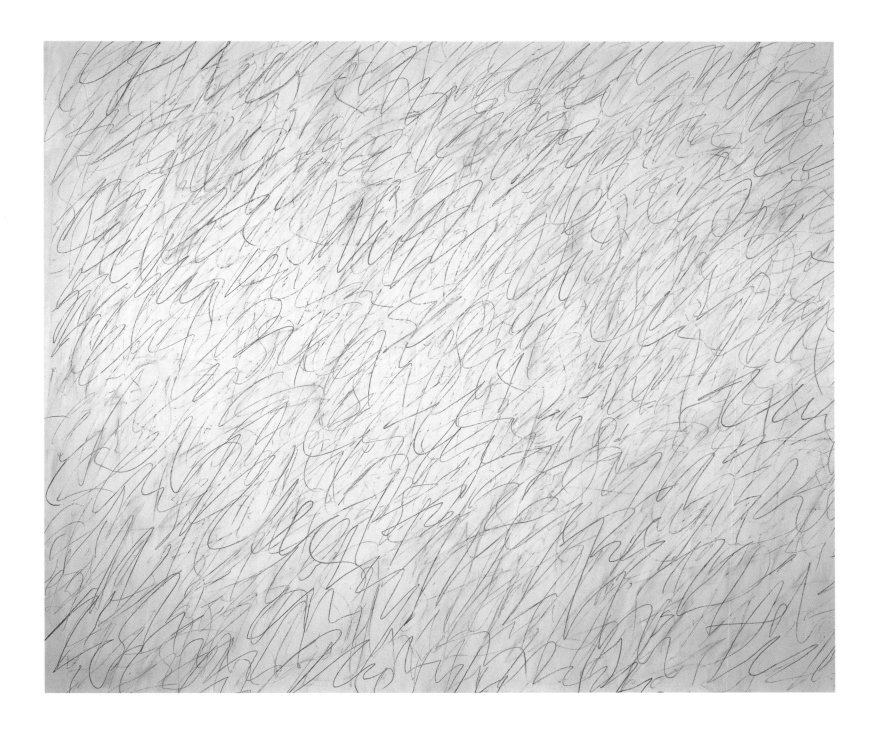

young Louise Nevelson). In its naïve Rococo or art-nouveau extravagance, Milone's stand was something of a miniature version of Simon Rodia's Watts Towers in Los Angeles (which Barr defended against their threatened demolition in the 1960s). And despite the Matisse-loving Clark's appalled incomprehension of his director's determination to celebrate Milone in the museum, it proved to be an inspired piece of public relations, generating positive commentary all over the country in newspapers that would normally have paid scant attention to the museum's activities.[3]

Barr had had the wit to understand—for himself and for his Rockefeller-family patrons—that their museum needed some credible foothold within the country in which it stood. In his view, most American-born artists who aspired to match the Europeans on their own ground would have compromised the aesthetic aspirations of his collection without seeming American enough to soften the alien edge of the European avant-garde. Barr's embrace of untrained but gifted provincials provided him with a way to keep faith with his own country while leaving aside the tricky problem of choosing one or another importunate suitor from the crowd of self-conscious individualists who clustered around the museum in New York.

He had previously been willing to endure ridicule—as well as Clark's exasperation in milder form—by agreeing in 1942 to the dealer Sidney Janis's requests that he exhibit the self-taught painter Morris Hirshfield. That same year he provided the preface to a book written by Janis entitled *They Taught Themselves*, which celebrated "unknown" American painters.[4] Confessing that he wished Janis had been less "generously inclusive" in his choices, he singled out for praise a small group that included Hirshfield and John Kane, whose self-portrait (fig. 13) he declared to be as moving as any he knew; these artists, he asserted, could "hold their own in the company of their best professionally trained compatriots." His loyalty to Kane remained especially marked. After returning to his now-chastened museum as its curator of collections, he raised the artist's name and example in public lectures;

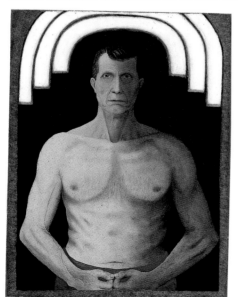

and when he sought to give the best possible account of American art in a 1953 exhibition at the National Museum of Modern Art in Paris, he placed Kane's self-portrait in an unmissable position at the entrance to the installation.

"Independence of school or tradition" was the quality, Barr wrote, that "distinguish[ed] these painters psychologically and genetically from all other kinds of primitives, even from children who . . . often imitate each other." (And in this trait they merited comparison with the museum's beloved icon of untutored modernity, the customs inspector Henri Rousseau.) But there were in fact strong tendencies shared among them. Janis pointed out that virtually every artist he encountered had painted a portrait of Lincoln, whose legend of humble origins and greatness in adversity made him their idol. Many added a

fig 13

50.

patriotic fascination with the American flag, and Kane himself readily combined the two: In one canvas, he superimposed a Lincoln portrait over the flag, the stripes serving as a ruled field inscribed with the words of the Gettysburg Address. Jasper Johns in 1958 offered him and Miller the closest possible homology to such naïve forms, to their modesty and restraint, to their tendencies toward symmetry and toward embellishment of entire surfaces, to their masking of obsessive and private meanings in commonplace vocabularies and self-imposed disciplines of work.

But Johns was, at the same time, plainly an artist of the highest self-consciousness, whose faux-naïf technique—the patient piecing and melding of wax-saturated collage with which the pre-1958 paintings had been fashioned—radiated a knowing sophistication. To look at a Johns in that first show was to see the central cultural dilemma of the museum resolved in one tightly constructed package; that is to say, its allegiance to the refinement of School of Paris modernism could henceforth be kept in contact with the "authentic" qualities of the American interior. These no longer had to be maintained in uneasy proximity to one another, Picasso in mere juxtaposition to John Kane; this new revelation, Jasper Johns. managed to perform both allegiances with such mute, simultaneous perfection that there was no way to view one separately from the other.

◎

This convergence between art and two powerful spectators can, however, represent no more than half the story. No adequate interpretation can rest on the data of consumption without production, the latter encompassing the materials, education, and circumstances that allow certain works to be made. The regard of Barr and Miller isolated Johns, but his formation had been a shared enterprise. How, then, had Johns learned to do the work that so captivated them, work that appeared magically to set aside the smothering overhang of European precedent without sacrificing the sophistication that went with it?

3. The abundant press clippings have been collected in a scrapbook in the archives of The Museum of Modern Art.

4. Sidney Janis, *They Taught Themselves: American Primitive Painters of the 20th Century* (New York: Dial Press, 1942).

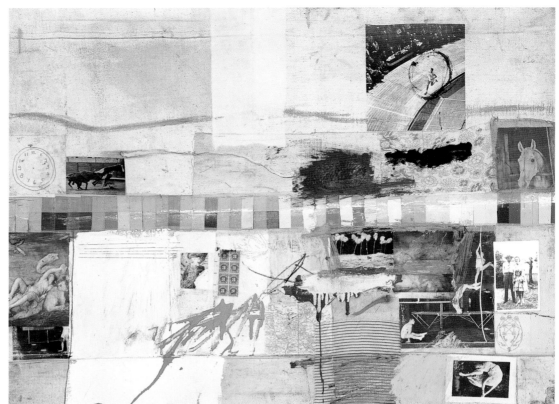

fig 14

His closest associates since his arrival in New York had, of course, been Rauschenberg and Twombly. The climate of their mutual teaching and learning had been one of homoerotic attachments, but the fact that none of the three will talk about this aspect of their lives means the historian is limited to vague terms of personal affinity (like the ones adduced above). Their extreme reticence concerning the biographical details of their lives in this period places nearly all the historical weight upon the dialogue implicit in their art. In many ways, this is as it should be, as it directs attention to the creative products of their alliance and sets aside the soap-opera distractions that bedevil writing on artists whose personal lives are more exposed.

I would offer as a mute description of their working milieu a piece by Rauschenberg from 1956 titled *Small Rebus* (fig. 14), which maps their common territory in an almost literal way. He fashioned its central motif, a virtual hinge between its two distinct halves, from pieces of cut and collaged maps. Their arrangement is such that the eastern part of Europe, including the peninsula of Greece, adjoins the American Midwest: The Baltic Sea, as a result, flows into the northern Great Lakes, and the Adriatic approaches the Mississippi, in sum establishing a new, mythical continent as a setting for the energetic action of the piece.

A group of clean-cut athletes of a distinctly American cast dominates the right side of the panel, the half marked by the European map fragments. Their homegrown identity is underscored by a bit of overt autobiography: a portrait of Rauschenberg's parents with his younger sister Janet between them. The left-hand side, the one marked by the invented map as American, is, by contrast, dominated by ancient European motifs, indeed by the very namesake of the continent: Above a lone displaced gymnast (who is thus transformed into an ancient Atlantid figure), a clipped reproduction of Titian's *Rape of Europa* anchors this half. The ascent of Zeus's beloved parallels that of the agile gymnasts, but hers is violent and frightening. Where there is ascent, descent must follow, and two falls exhibit the same contrasting characters: That of the athletes is comparatively gentle, inscribed in the falling arc of the runner in the uppermost zone. The bull of Zeus, on the other hand, suffers a crashing fall into agony and death for his having submitted to the body of a beast, as a Spanish bull in the ring (in a clipped newspaper photograph) collapses under the toreador's lances and sword in one of Europe's most archaic public spectacles.

Those who want to read the vernacular quotations in American Pop art as a rebuff to Europe (and this view has adherents on both sides of the Atlantic) should note that *Small Rebus* seems to be all about finding an ancient Europe in the most near at hand materials of Rauschenberg's life as a displaced,

fig 14.1

working-class Texan in New York. At the time, if scanned as if it meant to offer the totalizing field of a typ-ical Abstract Expressionist painting, it yielded the interpretation of random accumulating, of death of meaning, with which Rauschenberg has been saddled ever since. But the intricate variety embedded in what seems to be ragged improvisation serves as the functional equivalent to the play of imagery and diction found in traditional allegories—indeed this is probably the only such equivalent our disabused age would find credible. Rauschenberg has reflected that it felt at the time like he and his friends were remaking art from the ground up. The memory rings true, but, like many changes in the arts, the new proves to be something very old, bypassed and neglected until a freshly compelling use for it arrives.

The theme of release from the constraint of gravity and an inevitable, often deadly, fall to earth persists in Rauschenberg's work. As here, it comes clothed in a variety of found emblems and per-sonae: The relevance of these motifs for the present argument lies in their perpetual oscillation between European and American references. The map in *Small Rebus* (fig. 14.1) makes it something of a key to the persistence in much of Rauschenberg's work, at least through the end of the 1950s, of this oscillation. The pull toward the Old World was a key element in the sense of displacement that set both Rauschenberg and Twombly apart as they made their way among a largely stay-at-home American avant-garde. Having forged a bond as untried students in New York and then among the luminaries at Black Mountain College in 1951, the two set out together on a formative journey to Italy in 1952. They traveled on money from a grant that Twombly had obtained from the Virginia Museum of Art on grounds that any young neoclassicist of the eighteenth century would have found entirely famil-iar: "What I am trying to establish [he wrote in his application to the museum] is—that Modern Art isn't dislocated, but something with roots, tradition and continuity. A Fellowship . . . would enable me to experience European cultural climates both intellectual and aesthetic . . . not only for the painting I intend to do there, but for a lifetime of work."[5]

In the short run, Twombly's zeal to acquire physical souvenirs of "European cultural climates" so strained their shared finances that Rauschenberg, the dependent partner, found himself broke and in desperate need of a temporary livelihood. A chance encounter sent him off to do building work in

5. Cy Twombly quoted in Kirk Varnedoe, *Cy Twombly: A Retrospective* (New York: Museum of Modern Art), 56.

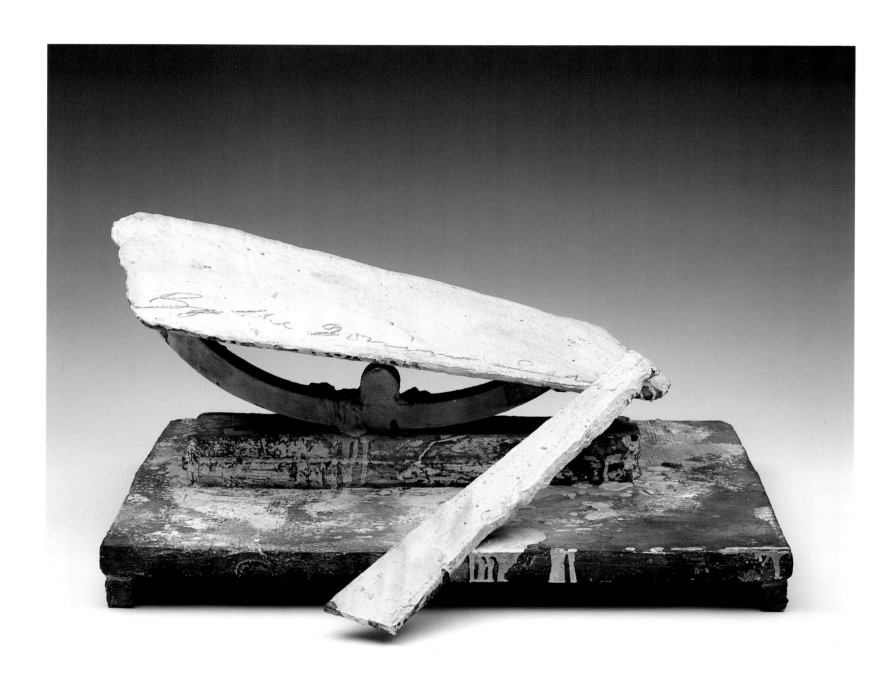

54.

fig 15

fig 15.1

North Africa—which added to his repertoire of classical references another rich set of Roman remains. The rift was soon repaired: Twombly joined him in Morocco, and, after their return to New York in mid-1953, they shared a studio on Fulton Street, where they jointly embarked on a complex reckoning with their recent, intensely shared experience.

Twombly's initially stronger impulse proved to be toward sculpture rather than toward painting. He had been making small objects from found materials since the late 1940s, but his post-European sculptures—which set the pattern for his work to this day—turned away from any materials of modern technology. From pieces of scrap timber, chunks of palm trunk, the homely handcraft of reed pipes, wooden spoons, and palm-frond fans, Twombly conjured an unexpected monumentality that defies its unassertive size. None of his materials, whether natural or humanly fashioned, would have been unknown to the ancient Romans themselves, giving their ensemble the air of an archaeological find. Some are wrapped in yellowing cloth bundles, and all are uniformly encased in a coat of loosely applied white gesso. This device lends each piece a stately, mummified silence, a masking redolent of ritual and a certain hermetic secrecy. While these sculptures carry little in the way of overt Old World themes, they aim, in their unassuming formality, for a Cycladic primitivism saturated with a sense of deep Mediterranean origins. *By the Ionian Sea*, 1988, its few bits of worn timber and scrap of discarded furniture conjuring but not illustrating an oared trireme, demonstrates the resolute continuity and undiminishing freshness of Twombly's approach to the medium.

The bleached whiteness of these sculptures also had a longer history in Twombly's dialogue with Rauschenberg and a strong generational connotation as well. In 1951, shortly before their European departure, Rauschenberg's so-called White Paintings had prompted outrage among the older artists of the New York School group. Originally conceived at Black Mountain in the spirit of John Cage's chance procedures (where the composer praised them for their receptivity to the slightest plays of light and shadow in their environment), they also sealed the surface of the canvas, with the impersonally uniform rollers of a housepainter, against the emotive, autobiographical gestures of Abstract Expressionism. When Twombly first established his signature manner in painting, in work undertaken simultaneously with the sculptures described above, he began with a smothering coat of white housepaint (as seen in the early *Untitled*, 1955, fig. 15), into which his marks were scratched like the "blind drawing" of Renaissance fresco artists adjusting their lines in the plaster ground before the final colored layer was applied.

The creased and buckled surfaces of Rauschenberg's so-called Black Paintings, made before the European sojourn, also traded in a rhetoric of concealment, as did the large, livid Red Paintings that he made immediately on their return to New York: typically, as in the untitled example on p. 46, the exposed pieces of fabric at the top and sides serve largely to call attention to the larger number of their buried counterparts, suffocated beneath the enveloping dominant color. His smaller panels filled in with dirt, gold leaf, or white lead represent more provocative variations on the same procedure. But his work began shortly thereafter to diverge from Twombly's hermeticism toward

Cy Twombly *By the Ionian Sea*, 1988 **Cy Twombly** *Untitled* [with detail], 1955

fig 15, 15.1

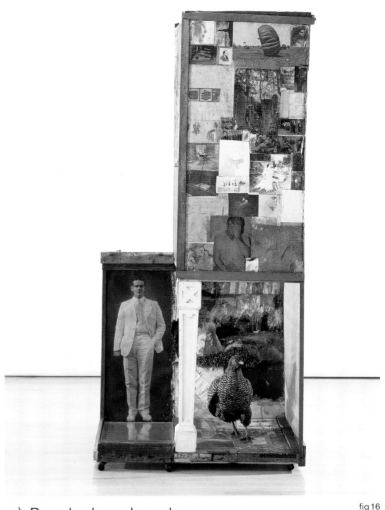

fig 16 **Robert Rauschenberg** *Untitled Combine (Man with White Shoes)*, 1954, oil, graphite, and collage on construction with objects, 86¹/₂ x 37 x 26¹/₃ in. (219.7 x 93.9 x 66.9 cm), The Museum of Contemporary Art, Los Angeles
Cy Twombly *Untitled*, 1972

openness and revelation in both theme and form. In the autumn of 1953, the two young artists held simultaneous shows at Eleanor Ward's new Stable Gallery (cleared from a disused cellar by the exhibitors themselves); Rauschenberg showed a wide selection of his earlier and latest work, among the latter constructions that he called Elemental Sculptures. In these he employed many of the same basic elements—blocks of wood, stones, bits of rope—as did Twombly, but each material shows itself exactly for what it is, with no embellishment to disguise or unify them.

fig 16

The large untitled work from late in 1954 that Rauschenberg designated as his first Combine (fig. 16) carried just as strong a recollection of the Mediterranean in its formal mimicry of an altarpiece, by means of which the piece maintains the frontality of painting but in multiple aspects that simultaneously give it the presence of monumental sculpture. An imposingly elevated panel surmounts the boxlike base, where there appear to be myriad *ex voti* or testimonials, such as might be found on a miracle-working shrine in a pilgrimage church. Standing in for the cult image is an immaculately turned-out young man in a *white* suit captured in a full-length photograph from the 1920s. Through its form alone, leaving aside the intricacies of its iconography, the piece inaugurates the European-American dialogue continued in subsequent works like *Small Rebus* (see p. 52). And it further posits that an examination of the self can be sustained only by a transformation into an exotically alienated reliquary, such as a fascinated tourist might encounter in some unexpected and out-of-the-way corner of the Old World.

◎

The date of that first Combine, where Rauschenberg's project of allegorical theater properly begins, coincides with the transformation of his dyadic bond with Twombly into an unstable triangle of Southern manhood that included the young South Carolinian Jasper Johns. Twombly found himself conscripted into military service at the end of 1953. His period of active duty was brief and entirely served

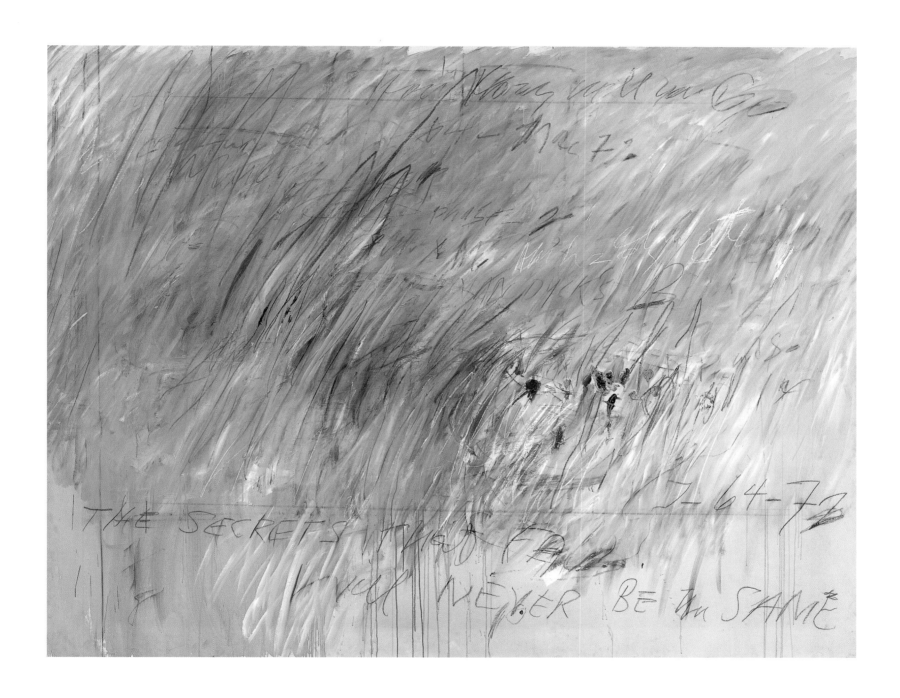

in the eastern United States, allowing him intermittent visits back to their Fulton Street studio. Johns and Rauschenberg met around the time of Twombly's first army posting and, a year later, were occupying adjacent studios in new quarters on Pearl Street. By February 1955, Twombly decamped for a teaching position at an obscure college in his native Virginia; by 1957 he had departed for a permanent expatriate's life in Rome.

The strong affective bond that took over between Rauschenberg and Johns has become one of the most celebrated and scrutinized (if inconclusively) in modern art history, but Twombly's imprint on their dialogue, particularly as it affected Johns, has barely been recognized. Only a few works survive from Johns's output during the year of the Fulton Street interlude when all three artists intermittently occupied the same space; in a famous act of renunciation he destroyed every object he possessed from this period; only the small number he had previously given to friends survive.

Among this handful is an untitled, six-pointed star composed of two interlocking, equilateral triangles, which is covered in a uniformly white coating of house paint and encaustic over canvas and newspaper (fig. 17). As Twombly's sculptures from the same moment have become better known, the family resemblance of the Johns piece, with its homely materials and rough application of pigment, becomes increasingly apparent. One wonders, of course, how many more like this he made and, indeed, why he would want to suppress work with such an austerely haunting presence. The strictly symmetrical geometry with which he assembled the thin, edgewise battens of his star point directly toward his subsequent flags and targets, the foundation of his fame. This quality is quite foreign to Twombly's studied sculptural effects of fortuitous juxtaposition. But the color white itself may well have possessed an overdetermined significance within the fraught personal and artistic alliances being negotiated among the three of them during that year, one that may help explain this fit of personal iconoclasm.

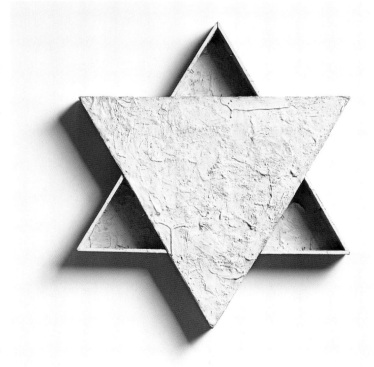

Johns's large *White Flag* of 1955 represents, of course, a return to the rhetoric of whiteness with a magisterial assurance in both execution and scale, but the formal matrix provided by the American national emblem was one for which he bore no personal responsibility. It was also as far from any European reference as it was possible for a fine artist to go, thus safely distant from Twombly, while still offering a ready vehicle for the lessons that the latter had left behind. The effect of silence that accompanies the sealing action of wax runs through nearly all of Johns's early production, an effect that he had deftly extracted from Twombly's quasi-archeological constructions and attached to his own disarmingly everyday repertoire of motifs. He was able to see the match between a Twomblyesque rhetoric of disguise and the anonymity of American

CROW

fig 17 **Jasper Johns** *Star*, 1954, oil, beeswax, and house paint on newspaper, canvas, and wood with tinted glass, nails, and fabric tape, 22¹/₂ x 19¹/₂ x 1⁷/₈ inches (57.2 x 49.5 x 4.8 cm), The Menil Collection, Houston
Jasper Johns *White Flag*, 1960

fig 17

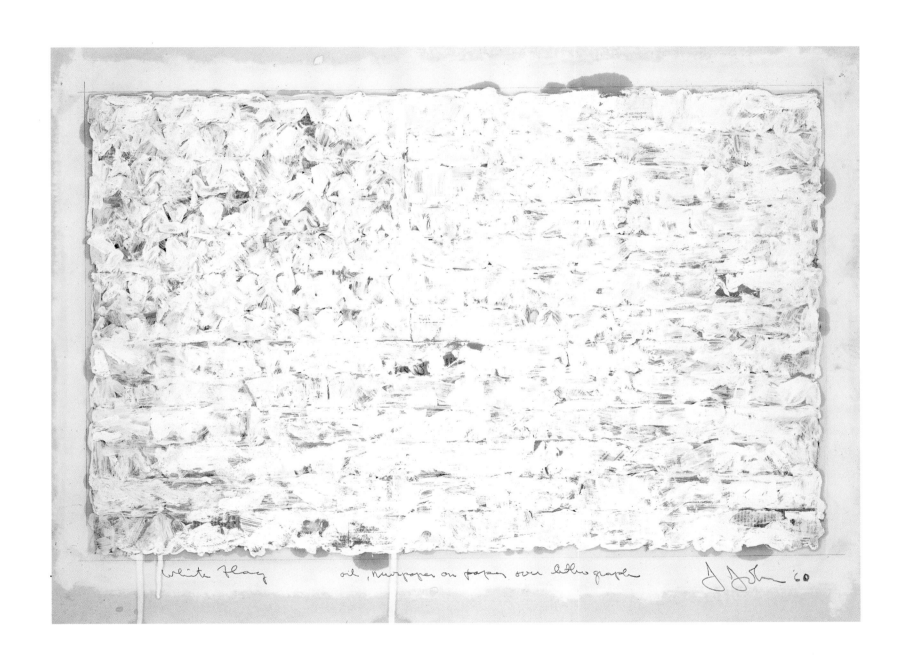

White Flag oil, newspaper on paper over lithograph J Johns '60

figs 18–20

vernacular handcraft. Ultimately this act of displacement would guarantee his dramatic appeal to Castelli, Barr, and Miller, but at the moment of invention, it offered him a way forward that escaped comparison with the intimidatingly worldly experience precociously embodied by Twombly and Rauschenberg, in a direction that lent a commensurable dignity to his own provincial origins and lack of European experience.

Johns's mixed-media *White Flag* of 1960 returns to this scene, the smothering strokes of white roughly adhering to the underlying pattern but in the end overwhelming the object's precise geometry in their accumulated, congealed meanderings. Rauschenberg, in an unpublished portion of an interview with Barbara Rose, later recalled this core of Johns's practice in less than flattering terms.[6] The exchange begins when Rose brings up "a painting of his [Johns's] that's a book . . . ," at which point Rauschenberg jumps in, "Right, you were talking about that, about how he covers it. He mummifies everything he really wants." She then prompts him (in complicit agreement), "Or that meant something to him," and he shoots back, "Well, don't sit still too long. I got out."

The flippant description of an aesthetic maneuver shades immediately into an ascription of some unattractively controlling character in Johns's personality, over which both speakers plainly feel aggrieved. At that point Rauschenberg's thoughts switch to a rueful recollection of the aftermath of his old companion's sudden rise to celebrity: "Once he learned that he could expect more than . . . [ellipsis in original] everything was downhill from then." To "expect" here means some prospect of material success, as Rauschenberg then explains, "When I knew him there was no reason, no evidence that either one of us could expect anything. It was more on my side because at least I had a gallery."

The shock of this reversal still resonated with force some thirty years later (the published portions of the interview appeared in 1987).[7] In the immediate event, it propelled Rauschenberg toward an explicit engagement with the high classical and later Italian traditions, culminating in his prodigious effort to illustrate Dante's *Inferno*, his technique a breakthrough to the photographic transfer procedures that would dominate his work during the early 1960s. He moved in those years from the simple solvent transfer of magazine clippings in the Dante drawings (which effected a quasi-miraculous translation of contemporary dross into late-medieval epic) to the use of photographic silkscreen on a much larger scale. That transition, however, coincided with an abrupt reversal in his choice of themes, a shift from his deepest embrace of European antiquity to the contemporary American spectacle and the same fascination with technological power that typified the new Kennedy era. In his *Round Trip I* of 1963 (fig. 21), the oval of an American football looms larger than a Gothic cathedral. His longstanding fantasies of release in flight abandoned the mythic realm of Europa, Icarus, Phaeton, and Ganymede, to be enlisted instead into a sustained celebration of the American space program, where the hardware of anonymous engineers replaced the contrivances of Daedalus and Apollo. Whether intentional or not, that change in subject matter coincided with his first flush of mainstream success: victory at the Venice Biennale of 1964 and, finally, a celebrity of his own on a par with that of Johns.

fig 18 Robert Rauschenberg sitting on one of his sculptures in his studio, 1953
fig 19 Cy Twombly in his Fulton Street studio, 1954, courtesy of Robert Rauschenberg/Untitled Press, Inc.
fig 20 Jasper Johns with *Target with Four Faces* and *Target with Plaster Casts*, c. 1960, courtesy of Woodfin Camp and Associates, Inc., New York
fig 21 **Robert Rauschenberg** *Round Trip I*, 1963

Thomas Crow is director of the Getty Research Institute. He was formerly Robert Lehman Professor of History of Art and chairman of the Department of the History of Art at Yale University. His most recent books include The Intelligence of Art *(1999) and* The Rise of the Sixties: American and European Art in the Era of Dissent *(1996).*

fig 21

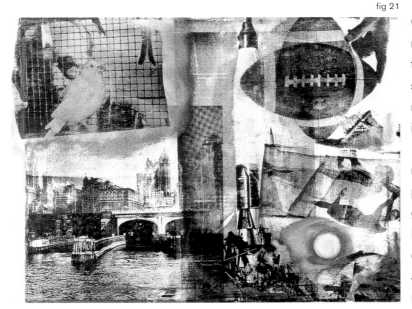

Grown apart, the two former partners thus found fame linked to certain American themes as personal signatures (for Johns the flag itself recurs, both as repetition of the original gesture of 1955 (see *Flag*, 1967, p. 44) and as an embedded motif in his increasingly complex painted allegories). Among their growing number of admirers in Europe were surely those who seconded the complacent American assumption that this wave of innovation could come only from a country without ancient roots, which made its consumption safe and unthreatening to cultural stereotypes stubbornly held on both sides of the Atlantic.

After some four decades, the grip of those stereotypes has lifted sufficiently to clarify the deeply European component in this key episode of artistic change, an engagement with the Old World long disguised by the appearances of its nativist trappings. And that new realization may well have arisen, as much as from any other factor, through the accumulated, undeniable authority over time of Twombly's work, which refused any specifically American vernacular and held its original course, while the approaches of his former companions shifted markedly with each change in their personal circumstances (*By the Ionian Sea* came thirty years after Twombly had settled his approach to sculpture and does not alter its terms in the slightest). That remarkable persistence keeps alive the original, extranational core of the compact among the three of them and demonstrates that its materials and preoccupations are by no means exhausted. ◎

6. Getty Research Institute, Special Collections, Barbara Rose papers, Rauschenberg folder, 12B.

7. Robert Rauschenberg and Barbara Rose, *Rauschenberg* (New York: Vintage Books, 1987).

jasper johns

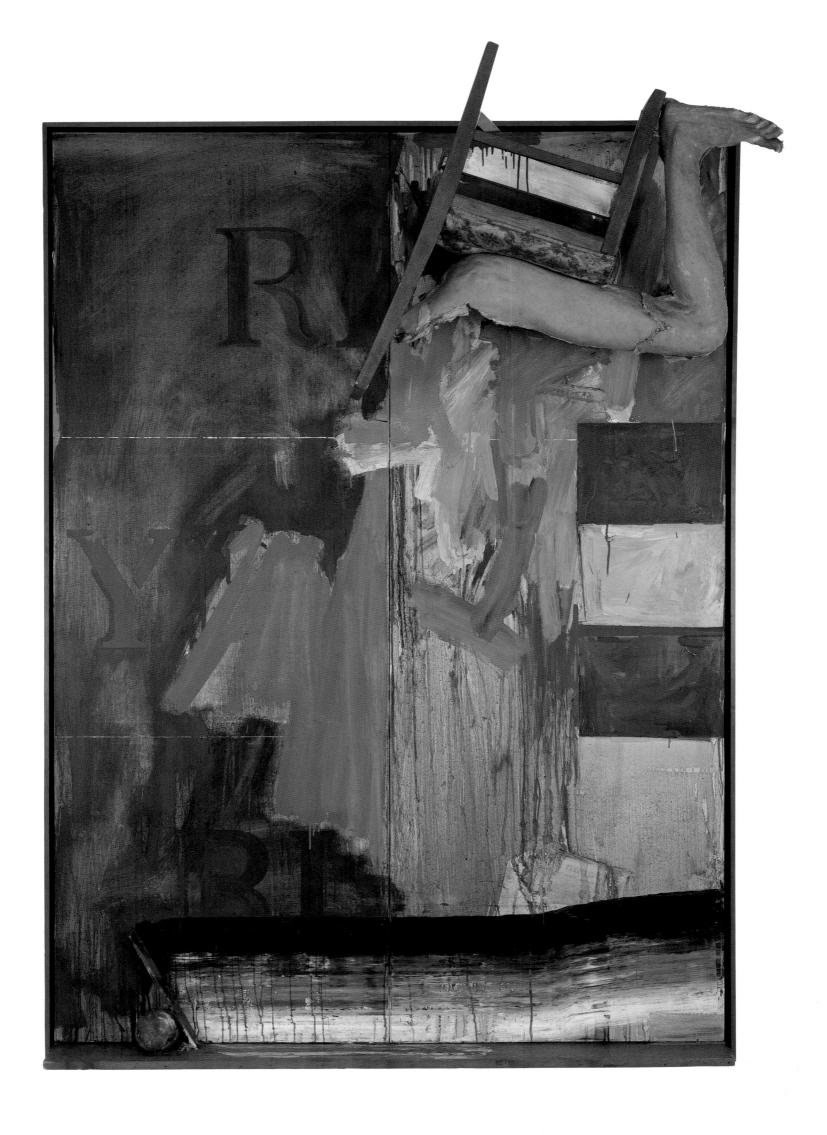

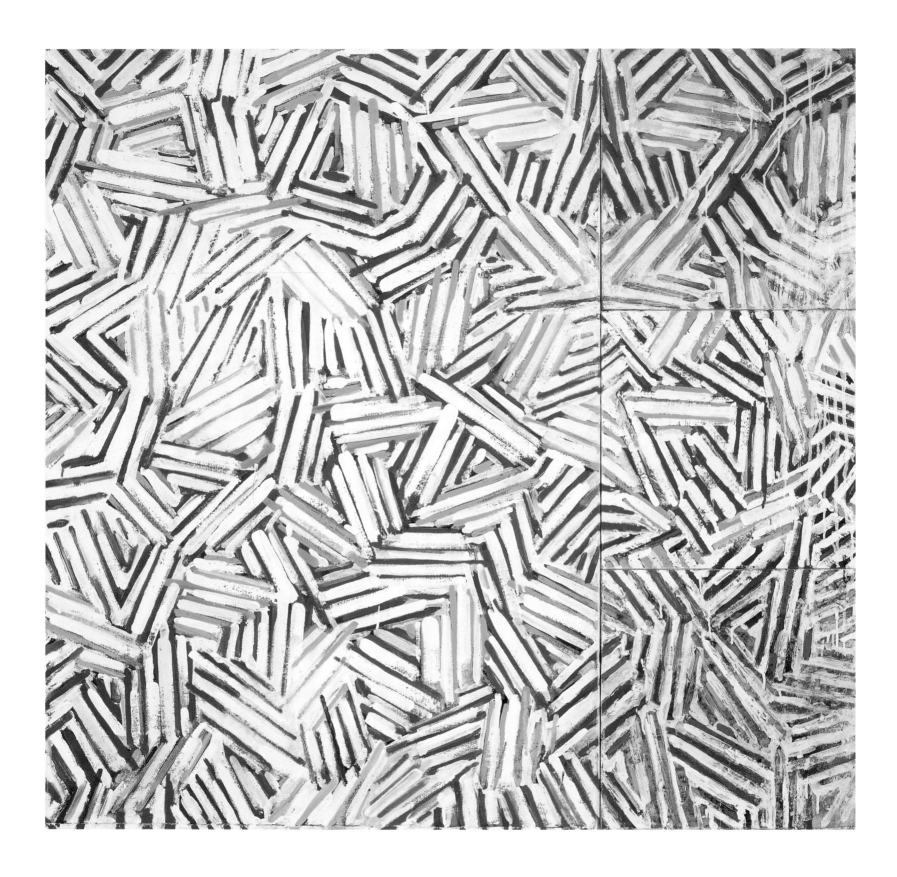

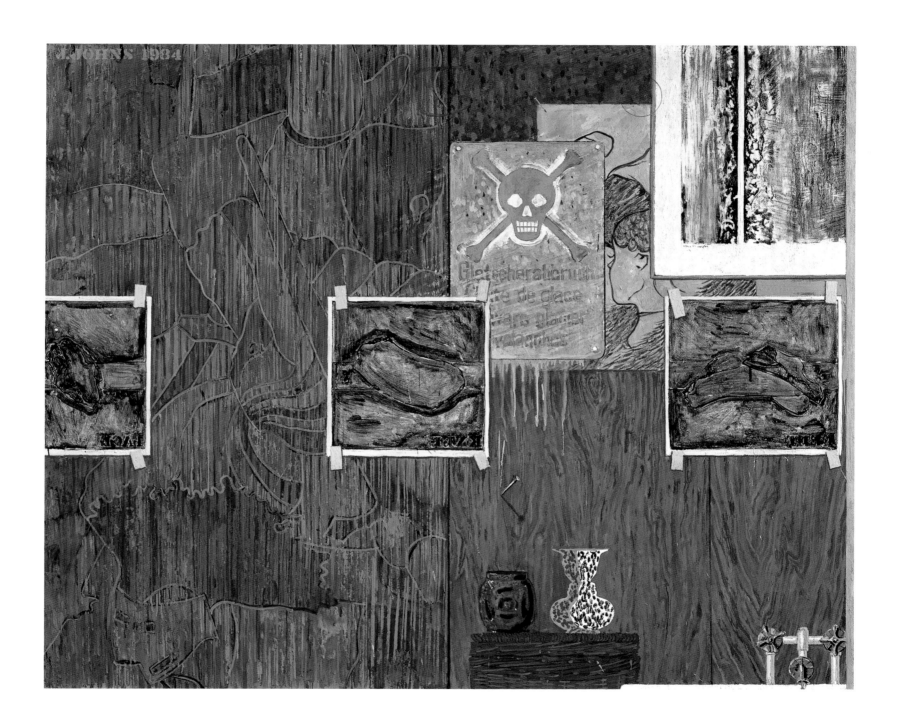

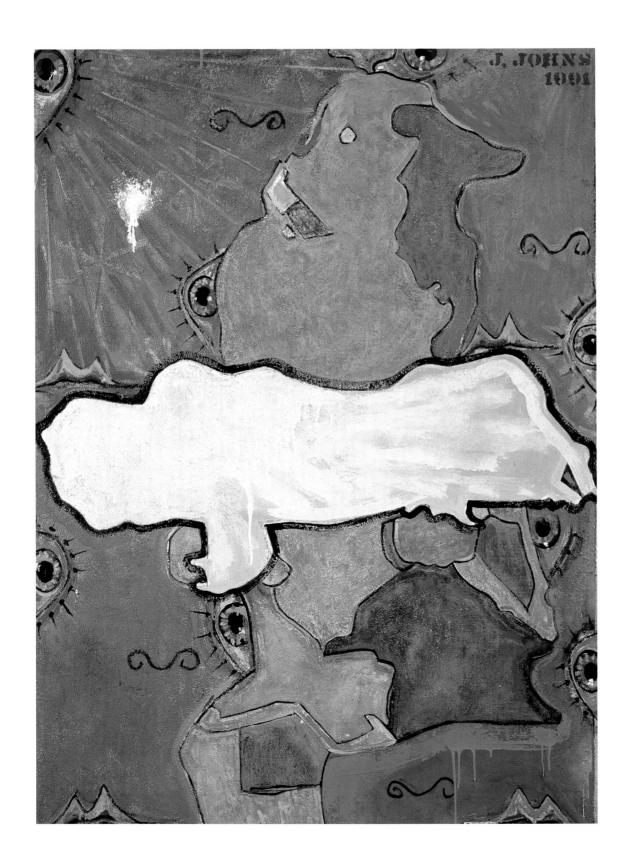

66.

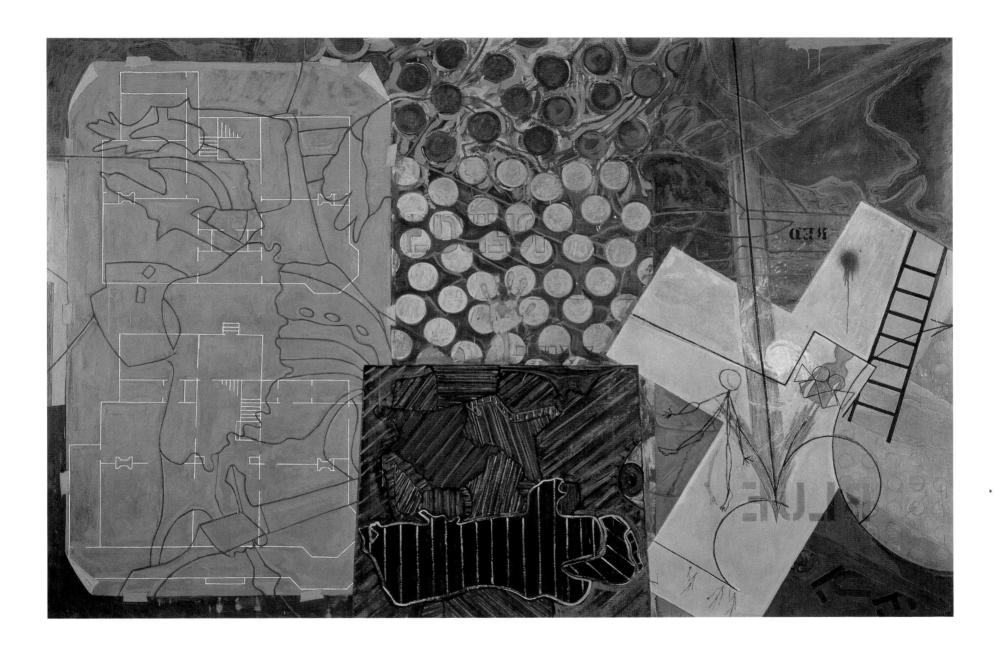

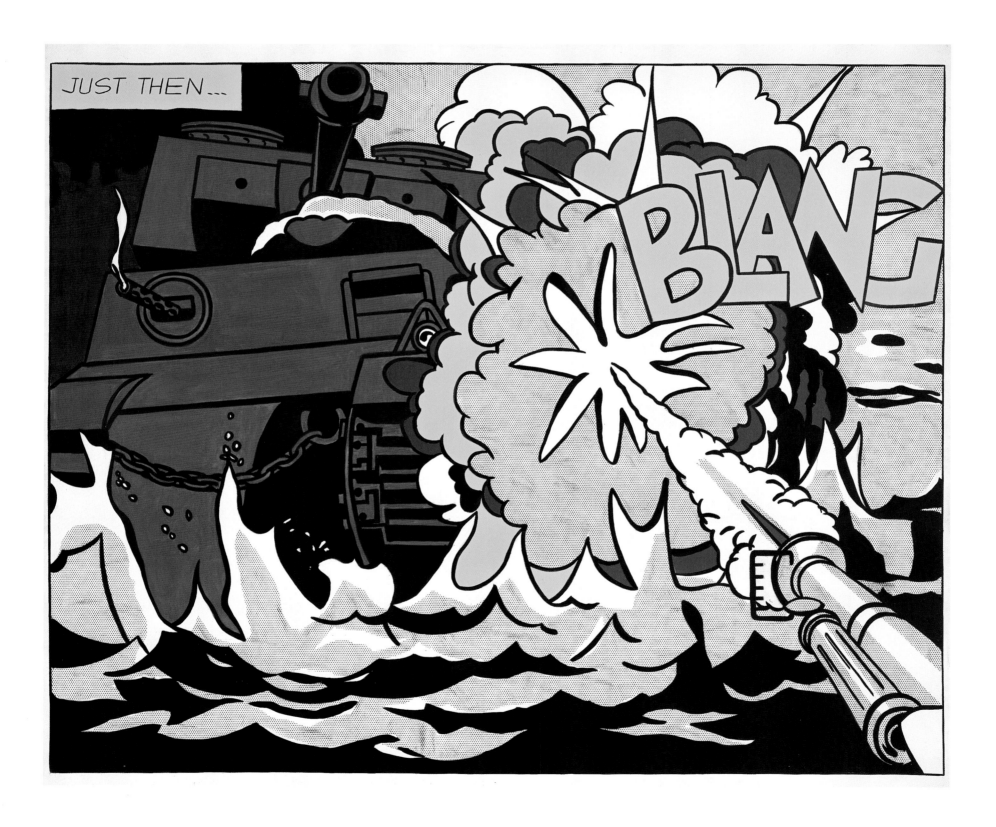

live ammo
The Art of Roy Lichtenstein, Andy Warhol, and Ed Ruscha

Do you think Picasso's ever heard of us?

ANDY WARHOL, *POPISM*, 1980[1]

. . . Are you warm, are you real, Mona Lisa?

Or just a cold and lonely, lovely work of art?

NAT "KING" COLE, "MONA LISA," FIRST RECORDED 1950
NATALIE COLE RE-RECORDING, 1991

Much of the art of the 1980s and 1990s is unimaginable without the precedent of 1960s Pop. Pop can be seen as the first permutation of Postmodernism, loosely defined as artists' use or "appropriation" of other works of art or fragments of popular culture. Its much-debated implications—that there is no essential, single truth to a human being or work of art, that, culturally speaking, "you are what you eat"—come directly from Pop's conceptual core. Pop first made boundaries permeable: between advertising and art, between high and low, between the real thing and its reflection. As Andy Warhol famously observed, Pop "puts the inside on the outside and the outside on the inside." Poised at the cusp of the postindustrial age, Pop art pulled off a conceptual sleight of hand, capturing in art cultural shifts that continue to play out today.[1]

Pop and Postmodernism are the keystones of the Broad collections, a rare instance in which one collector acquires in great depth the work of a movement of nearly forty years ago and more recent art that shows its influence. The Broads' twenty seven works by Roy Lichtenstein, spanning thirty years, illustrate some of the evolutionary ties between Pop and Postmodernism. His Reflections series, for example, painted from 1988 to 1990, could be described in Pop and Postmodern terms. Like most Pop, the paintings appropriate their imagery: *Reflections on Interior with Girl Drawing* quotes a Picasso painting in MoMA's collection; *Reflections: Vip! Vip!* alludes to Lichtenstein's own war comic paintings of the 1960s. But Lichtenstein doubles up the appropriation by adding to his paintings cartoonish trompe l'oeil frames and abstract diagonal streaks signifying the glass held in the frame. He shows us once again that glass, mirrors, and surfaces of paintings or old war cartoons all provide the points of contact, the illusory, memorial vehicles through which we see ourselves. Lichtenstein chose a peak Postmodern moment, the late eighties, to amplify the role reflections have played in his own work at the same time that many Pop ideas surfaced and were reinterpreted in the work of younger artists.

The reflection is important in much concurrent work by artists such as Jeff Koons and Cindy Sherman. In Jeff Koons's sculpture *Rabbit*, 1986 (p. 124), a very Pop item, a mass-produced inflatable toy, is replicated in stainless steel. Its supremely reflective surface puts the viewer and the object in a symbiotic relationship, pushing even further Pop's mingling of the inside and the outside. Cindy Sherman's History Portraits of 1989–90 are photographs of herself, posed in garb and settings

reminiscent of famous paintings from the Renaissance forward (see pp. 146–47), echoing Lichtenstein's bold quotations of–his "reflections" upon–famous paintings such as Picasso's *Femmes d'Alger*. Sherman's and Koons's iconic works of the eighties employed figurative imagery and a sophisticated approach to trompe l'oeil trickery and artifice–devices that are in fact as ancient as Western art itself. It was Pop that used these same apparently old-fashioned strategies to propel art radically forward into the late twentieth century.

Where did Pop come from, when it burst onto the scene in the early sixties? For most of the twentieth century, popular imagery bounced around the precinct of fine art, a fragment here and there, occasionally puncturing the membrane between internal and external, high and low, the eternal and the right now. In the early twentieth century, Marcel Duchamp's readymades, employing ordinary items as sculpture, prefigured the important conceptual shift to come. In the mid-1950s, Jasper Johns's paintings of flags and targets shed charged, metaphysical light on quotidian symbols (fig. 22). Rauschenberg's Combines, of the same era, in which he made everyday objects fundamental to his art, poetically acted in, as he put it, the gap between art and life. Art's underpinnings shifted as demographic sea changes–the growth of the middle class, the increasing accessibility of college education–swept postwar American society. For everyone, the flickering ephemerality of television and film changed the world radically, making it both more spectacular and more flat, more accessible and more distant. In an era known by the oxymoronic term *Cold War*, the work of vanguard Pop artists likewise embodied contradictory changes, as the underground and the elite began to exchange fluids through the vernacular of the middle class.

Like all revolutions, Pop got somewhere new by recapturing something lost. As Lichtenstein said about the state of painting–"that old thing, art"[2]–during Pop's formative moments, "It was almost acceptable to hang a dripping paint rag." The cosmopolitan shamanism of Abstract Expressionism was

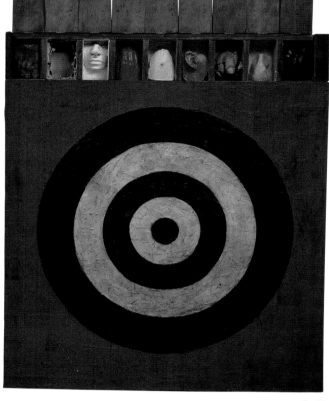

fig 22

1. For one analysis of the current state of these cultural and economic forces see John Seabrook, *Nobrow: The Culture of Marketing/The Marketing of Culture* (New York: Vintage Books, Inc., 2000).

2. See Roland Barthes, "That Old Thing, Art . . ." in Steven Henry Madoff, ed., *Pop Art: A Critical History* (Berkeley and Los Angeles: University of California Press, 1997), 370–74.

3. Regarding Roy Lichtenstein in particular, see his discussion of the teaching techniques of his mentor Hoyt Sherman, who was professor at Ohio State University during Lichtenstein's years as a student there, in Ann Hindry, "Conversation with Roy Lichtenstein," *ArtStudio* (May 1991): 11–12. For a detailed analysis of pseudoscientific perception techniques taught by art school instructors of both Warhol and Lichtenstein, see David Deitcher, "Unsentimental Education: The Professionalization of the American Artist," in Donna De Salvo and Paul Schimmel, *Hand Painted Pop: American Art in Transition*, exh. cat. (Los Angeles:

Museum of Contemporary Art in association with Rizzoli, New York, 1992), 95–118.

4. Neal Benezra, "Ed Ruscha: Painting and Artistic License," in *Ed Ruscha* (Washington, D.C.: Hirshhorn Museum and Sculpture Garden, 2000), 146 and 145–55.

5. Roy Lichtenstein quoted in G. R. Swenson, "What Is Pop Art? Part I," in Steven Henry Madoff, *Pop Art: A Critical History*, 109.

being validated ad nauseam by collectors' wallets and media column inches. Although the emerging performance art of Allan Kaprow and others proposed the dematerialization of the art object altogether, Abstract Expressionism remained painting's bogeyman. It had emerged symbiotically with the first viable American "art world," and its lock on that freshly laid socioeconomic cable seemed unshakable.

But the signal carried on the shiny new art network did not quite reach the upcoming generation. In the early sixties, Abstract Expressionism's unchecked proliferation in academia registered deeply with Andy Warhol, Roy Lichtenstein, and Ed Ruscha. "When I was in school, I painted like an Abstract Expressionist—it was a uniform. Except you didn't really have to wear it, you just aped it," Ruscha recalls of his days at Chouinard Institute in Los Angeles. The "artist" in those days was imagined in a High Romantic state—a cappella, the lone voice in the wilderness (of New York), engrossed in psychodrama (an archetype that persists in the popular consciousness today). In contrast, many of Pop's leading figures cut their teeth on training and professional experience in graphic design and advertising. They had a sense of how to capture a viewer's attention with quick impressions,[3] and perhaps most importantly, how to identify with their audience-slash-clients. Many worked with type, photography, drafting, and other commercial techniques. The crafting of communication, as opposed to the accessing of emotion, became their indispensable mode of art making.

Ruscha carried his early skepticism about painting through the sixties and beyond, moving back and forth on a conceptual path between painting, photography, and printmaking.[4] Lichtenstein, a bit older, conducted a career in painting of modest success during the fifties, mostly in New York, trying on Abstract Expressionism and other, more idiosyncratic styles. Warhol observed the phenomenon as a very successful commercial artist in New York during the same period. Although the three of them emerged separately, from different backgrounds, they happen to provide posterity one exceptionally clean starting line, completing parallel transitions about late 1961.

At that moment, each artist shed his ambivalence about the startling path his painting was taking and accelerated into the mature phase of his career. Each observed the prevailing norm—including the fact that there was an "art world" to conquer—and decided to restore objective imagery to art in the boldest way possible. They didn't just nod approvingly or ironically at popular or commercial imagery; they transmuted painting with it. And their art really didn't just hold up a mirror to society—it consumed and became the image in that mirror. As Lichtenstein noted in 1967, Pop "doesn't look like a painting *of* something, it looks like the thing itself. Instead of looking like a painting *of* a billboard—the way a Reginald Marsh would look—Pop art seems to be the actual thing."[5] In effect, without completely severing its ties to modernism, Pop presented advertising, comic imagery, and celebrity portraits allegorically, using the overlooked imagery of everyday life to trip up assumptions about taste, economic class, and desire.

Coincidentally, a similarly complicated realism had launched modernism itself one hundred years earlier in Europe, when Manet and his cohorts displayed controversial images of everyday urban life, such as *Olympia* and *Dejeuner sur l'herbe,* to a startled mid-nineteenth-century Paris. Those

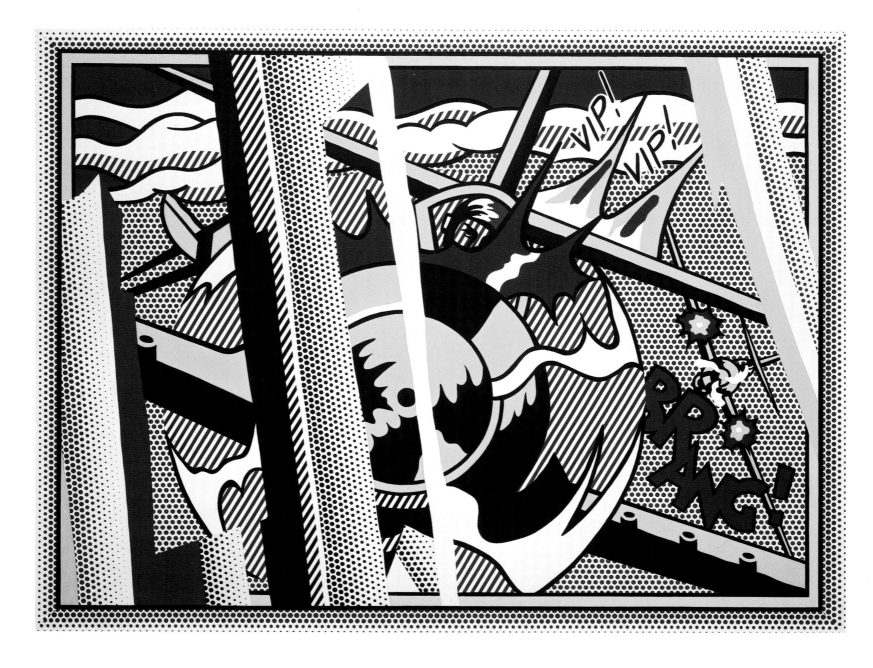

Roy Lichtenstein *Reflections: Vip! Vip!,* 1989
Roy Lichtenstein *Reflections on Interior with Girl Drawing,* 1990

upstart artists of the 1860s were, like Pop artists of the 1960s, uninterested in tagging onto a seemingly irrelevant and aged movement. Their increasingly fast-paced, mediated urban environment made much more sense as subject than the historical and mythological scenarios that filled the canvases of their teachers. This same emptying of myth from canvases and filling them back up with everyday imagery happened again a century later, starting perhaps with Jasper Johns, whom critic John Yau has called one of the first artists to recognize that the division of subjective and objective into separate categories was an illusion.[6]

It was also in 1961 that Warhol, Lichtenstein, and Ruscha encountered one another's work for the first time. The well-known stories of Warhol discovering Lichtenstein's work and vice versa come in several versions,[7] but the undisputed connecting link was the Leo Castelli Gallery, then located in a townhouse on Manhattan's Upper East Side. In October 1961 Castelli displayed and sold Roy Lichtenstein's earliest product and war comic paintings in the back room, as a prelude to Lichtenstein's first exhibition in February 1962. Warhol bought a Jasper Johns lightbulb drawing from Castelli,[8] wandered into the back room, and happened upon Lichtenstein's work. Warhol collected art with a passion and a sense of its social cachet; as writer and artist Gerard Malanga, Warhol's long-time assistant, said, it was "by being a collector [that] he had *entrée* into the art world."[9] He persuaded Ivan Karp, the young director of Castelli, to see the comic- and advertising image-based works he himself had begun to paint. A few years later, once Pop had become a phenomenon, Castelli began to show Warhol's work.

Ruscha first visited New York and Castelli on his way back from Europe. He made an appointment with the gallery, as did many ambitious young artists of the time. Karp introduced Ruscha to Castelli and invited him to see the Lichtensteins in the back room. Although Ruscha was familiar with the work of Johns and other vanguard artists through galleries such as Ferus in L.A., he "just came alive" when he saw those Lichtensteins, struck by the ruthlessness of the direct and uncompromising cartoon-based imagery.[10] Castelli and Karp's introduction of these artists to one another, which likely bolstered and solidified the gallery's decision to represent Lichtenstein, added seasoning to the

6. See John Yau, *The United States of Jasper Johns* (Cambridge, Mass.: Zoland Books, 1996).

7. For Lichtenstein's account of his first encounter with Warhol's work see Hindry, "Conversation with Roy Lichtenstein," 11; and Milton Esterow, "Roy Lichtenstein: How could you be much luckier than I am?" *Artnews* (May 1991): 90; for Leo Castelli's account of Warhol and Lichtenstein's discovery of each other see Patrick Smith, *Andy Warhol's Art and Films* (Ann Arbor: UMI Research Press, 1986), 266–67;

and for Warhol's account see Andy Warhol and Pat Hackett, *Popism* (San Diego and New York: Harcourt Brace Jovanovich, 1980), 6–8.

8. The archives of the Warhol Museum has a receipt, probably for this drawing from Castelli, dated December 12, 1961. However, both Warhol's and Lichtenstein's accounts of discovering each other's work would suggest a date much earlier in the year.

9. Gerard Malanga quoted in Smith, *Andy Warhol's Art and Films*, 400.

10. Author's interview with the artist, August 31, 2000.

11. Ibid.

12. John Rublowsky, *Pop Art* (New York: Basic Books, Inc., 1965), 44. This is one of the early accounts of the involvement of Lichtenstein's sons with the development of his Pop imagery; many retellings have been published since.

13. For one account of this early history see Rublowsky, *Pop Art*, 43–45, where Lichtenstein is quoted as saying, "When my boys asked me to paint Donald Duck, unencumbered by art, their request provided a good excuse for doing something I was already on the verge of doing at the time. My conversations with other artists and my familiarity with the work of Johns, Rauschenberg, Dine, and Oldenburg provided at least an equal impetus for the gesture. . . . I showed them to Allan Kaprow, George Segal, and Bob Watts. They were very enthusiastic

fig 23 **Dennis Hopper** *Roy Lichtenstein*, 1964, gelatin-silver print, 24 x 16 inches (61 x 40.6 cm), courtesy of the artist
fig 24 Roy Lichtenstein autographing Pasadena Art Museum billboard for Lichtenstein's first solo museum exhibition, April 1967, Norton Simon Museum Archives, Pasadena, Calif.

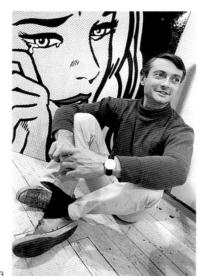

fig 23

just-picked raw ingredients of Pop art. This groundwork yielded, from 1961 to 1963, the initial boom of exhibitions and publicity (both admiring and negative) that would bring Pop into the consciousness, ready or not, of the wider art world and the general public. Although their mutual admiration never brought Lichtenstein, Warhol, and Ruscha into close collaboration, each staked out discrete territories that would together define much of the 1960s Pop landscape.

○

> Roy's and Andy's, man, it was devoid of art—
> it was a new art, and in that respect, ruthless. —ED RUSCHA[11]

Lichtenstein's early Pop style appears to have nothing in common with his work in the preceding decade. But even in his early paintings, in which he depicted American myths such as the Wild West or Washington's crossing of the Delaware with mocking, deprecating humor, Lichtenstein showed a strong interest in the devices of style and a hierarchy of subjects. This conceptual thrust was transformed when, in 1960, his sons asked him to make paintings of their favorite cartoon characters, Donald Duck and Mickey Mouse.[12] He copied several cartoons quite faithfully, and the resulting paintings, including *Look Mickey, I've Hooked a Big One,* wound up interesting him more than anything else he had done.[13]

Soon afterward, however, he steered away from recognizable cartoon icons, choosing instead to work from comics about World War II heroism and romance—soapy episodic serials filled with stock

about the work and recognized the same potentiality that I could discern in the medium. Allan Kaprow suggested that I show them to the people at the Castelli Gallery who had a reputation for sympathy with new art."

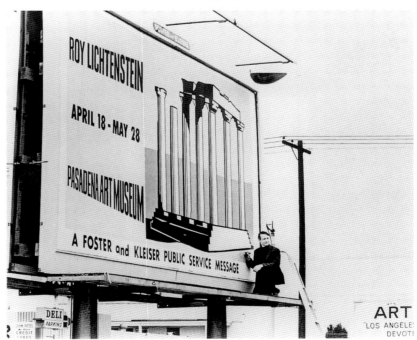

fig 24

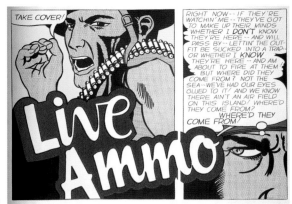

fig 25

characters. The turn to stock comic sources served Lichtenstein's desire to emphasize the cliché—a term he used often in interviews about his work—in a manner that specific, recognizable figures would not allow. Audiences might have turned more easily away from distinctive, "brand name" characters such as Mickey Mouse, toward which they'd probably already established feelings of some kind, cynical or sentimental; the simultaneous vagueness and familiarity of generic comic imagery provided less of a foothold. By using culturally "powerless" images in many early comic paintings, Lichtenstein entered an uneasy ground between high and low, and made viewers deal more directly with their own relationships to artistic hierarchies.

Among the war comic images, one of the most complex was the serial painting *Live Ammo* (fig. 25). The title aptly describes the explosive potential both critics and admirers found in Pop's images—for all the alleged detachment and irony of the art. Lichtenstein, fully aware of his role in this drama, left behind oblique hints at insider art humor in many paintings.[14] In *Live Ammo*, the suspenseful situation of the soldier-protagonist, attempting to decipher the moves of the enemy—"they've got to make up their minds whether I don't know they're here"—humorously echoes Lichtenstein's relationship to his audience and critics. Having startled some with its seeming absence of self-expression, Pop presented intellectual complications to an audience accustomed to the cathartic soulfulness of Abstract Expressionism. In one 1960s interview, Lichtenstein specifically stated that one of his objectives as a painter was to "make people aware without handing it to them on a silver platter."[15]

Live Ammo's center panel, *Blang!* (above and p. 68) is the most active, depicting the climactic moment of the narrative. Viewers might assume that Lichtenstein simply duplicated these source comics, but in fact he played with and rearranged them in keeping with "high" modernist rules of composition. To create *Blang!*, Lichtenstein worked from fragments of two comics, breaking apart the original images, rebuilding and rejoining parts from both. He severely reduced the palette and flattened all hints of gesture found in the original comic drawings, turning *Blang!* into a highly stylized scene of conflict between two machines, tank and gun, rather than a window onto good and bad guys at battle. His tendency to isolate and rearrange images, both visually and narratively, mainly served his

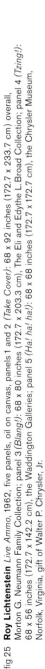

fig 25　**Roy Lichtenstein** *Live Ammo*, 1962, five panels, oil on canvas, panels 1 and 2 *(Take Cover)*: 68 x 92 inches (172.7 x 233.7 cm) overall, Morton G. Neumann Family Collection; panel 3 *(Blang!)*: 68 x 80 inches (172.7 x 203.3 cm), The Eli and Edythe L. Broad Collection; panel 4 *(Tzing!)*: 68 x 56 inches (172.7 x 142.2 cm), the Waddington Galleries; panel 5 *(Ha! ha! ha!)*: 68 x 68 inches (172.7 x 172.7 cm), the Chrysler Museum, Norfolk, Virginia, gift of Walter P. Chrysler, Jr.

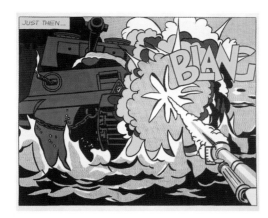

objective of forcing the viewer to deal with painting in a way that was fresh and yet, for him, rooted in tradition. As he said about his work, "The viewer goes to it and is held back slightly from being able to get the whole picture; he has to work a little to deal with the problems—old artistic problems, that particular mystery that goes on in painting."[16]

Likewise, the painting *I . . . I'm Sorry*, 1965–66, drawn from a romance comic strip, knits together the generic elements of a cartoon into a sophisticated aesthetic unit. A late example of Lichtenstein's "blondes" series, which depicts women in distress over their beaux, *I . . . I'm Sorry* both typifies and departs from these works. This blonde displays tearful regret, but it's unclear why—she could just as easily be breaking up with her offscreen boyfriend as begging for his return. Aesthetically, the painting incorporates elements of the "brushstrokes" series Lichtenstein was developing concurrently. The girl's hair, the patterning of the tree trunk, and the shadows of her blouse betray his interest in the design devices of Art Nouveau. The overlap of the girl's finger onto her "thought balloon" further tightens the composition.

Like a sophisticated science experiment, Lichtenstein's work infiltrates formulaic art and makes it behave differently than expected. His work adopts certain blatant signs of popular culture— such as the thought balloon and the banal colors of newsprint comics—but eliminates many *beaux-arts* drawing techniques a comic artist might use, such as crosshatching, in favor of a reductive, modernist-friendly selection of flat colors, black lines, and Ben Day dots. He often commented about the resiliency of visual art, as opposed to music, to this kind of stealth: "A slight change of color or line isn't really as evident as it is in music, where you can hear instantly that the composer is tinkering with a well-known tune."[17] Pop's resonance, and its long-lasting influence on art of succeeding decades, comes from its subtle operations on imagery that most people automatically dismissed. Lichtenstein's war and romance comic paintings of 1962–65 brilliantly caricatured "low" aesthetic norms, but took social norms along for the ride, pointing out that the two are inseparable.

To further complicate the low- to high-class circuitry set up by his comic paintings, Lichtenstein, an arch consumer of art history, also used works by Picasso and Mondrian as source material in his

14. Among the many Lichtenstein paintings seemingly referring to contemporaneous issues in the art world are *Image Duplicator*, 1963, which pokes fun at the artists' own practice of appropriation; the war comic picture *O.K. Hot Shot*, 1963, which lampoons a classic action painting gesture in its text "Okay Hot-Shot, Okay! I'm Pouring!"; and *Popeye*, 1961, of which Paul Schimmel, in *Hand Painted Pop*, 46, has written, "Lichtenstein could have appreciated the theme of the skinny little guy Popeye (i.e., the artist himself), punching out the giant Brutus (i.e., Abstract Expressionism)."

15. Roy Lichtenstein quoted in Gene Swenson, "What Is Pop Art? Part I," in Madoff, *Pop Art: A Critical History*,111.

16. Ibid.

17. Roy Lichtenstein in Esterow, "Roy Lichtenstein: How could you be much luckier than I am?," 87.

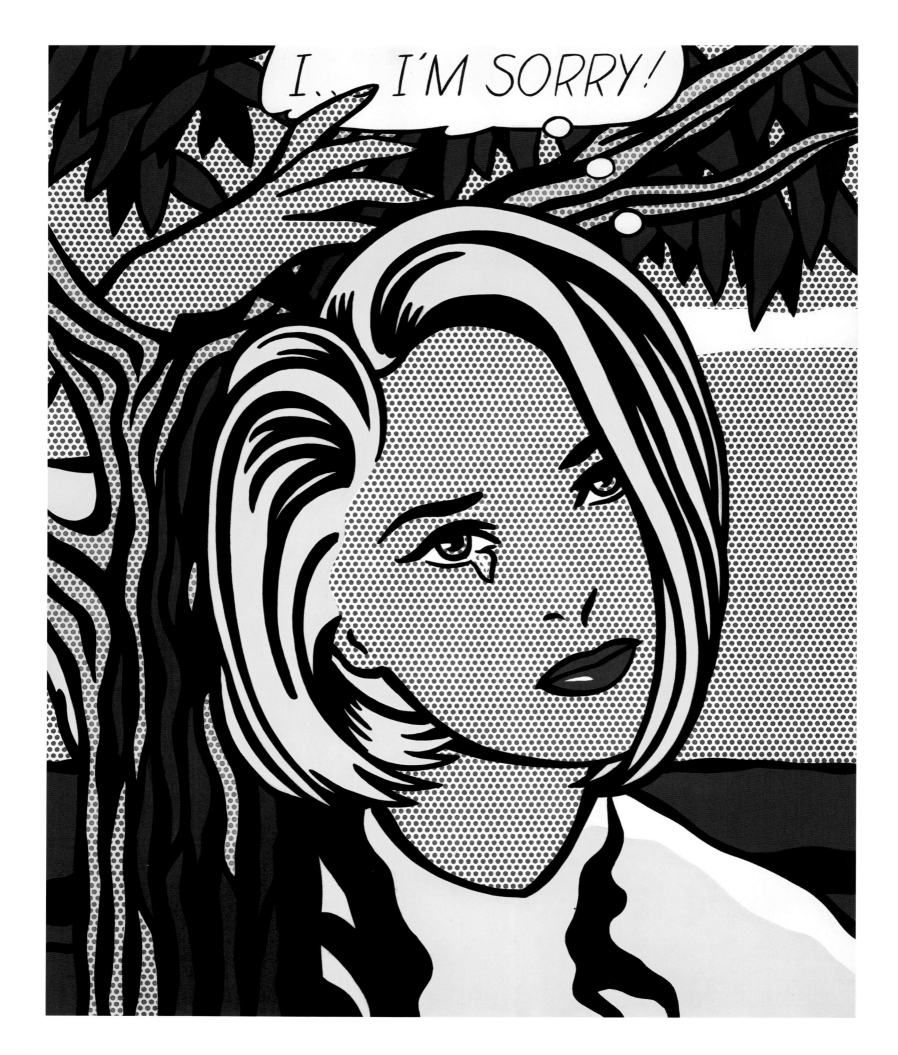

78.

early Pop years. In *Femme d'Alger* (p. 37), Lichtenstein took a Picasso painting, itself based on a painting by Delacroix, and rendered it in the cartoon devices of heavy black outlining and Ben Day dots. Lichtenstein remarked that to an uninformed observer, even "Picasso's rendering of Delacroix or Velazquez could probably look like a sort of trashy copy of a masterpiece."[18] By overlaying works by hallowed masters with the severe stylization of the comics, Lichtenstein opens wider the aperture through which we view the art of the past, so often constricted by assumptions about class, taste, and perhaps above all, our desire to believe blindly in the authority of the status quo.

○

> I couldn't believe that we were actually two people doing not only similar things but also things that were so contrary to what was going on . . . the source is advertising or vernacular art. It's a strong influence. –LICHTENSTEIN ABOUT HIS DISCOVERY OF WARHOL'S WORK IN 1961 [19]

For his painting *Elvis*, 1963 (p. 84), Warhol chose a publicity still from one of the star's kitschy movies of the period, *Flaming Star*, which depicted him in the midst of a staged gunfight. For all the innovation in Warhol's figurative works, such as strategic repetition and the then-taboo mating of photography and painting, the vast majority of them are at their core traditionally formatted portraits.[20] Here Warhol puts Elvis's entire body on display. The star stands with gun drawn, feet splayed, ready to shoot at something slightly to the viewer's left. The image emphasizes male sexuality and offers up the star as a product, complete with Western costume cheesiness, spectacular body language, and gun as phallic prop. In contrast to other Elvis paintings Warhol made around the same time, this one incorporates an unusual band of gold spray paint along the bottom edge. The combination of silver and gold certainly suits this image of an idol of the gold record and silver screen, and the gold spray paint serves as ethereal proscenium, marking a rare moment in 1960s Warhol in which a trace of the artist's action is left intact. One imagines the artist (or for that matter, one of the assistants in his studio, the Factory) turning "the gun," in the form of a can of spray paint, on the gunslinger.

fig 26

18. David Sylvester, *Some Kind of Reality: Roy Lichtenstein interviewed by David Sylvester in 1966 and 1997 (with plates of six new paintings)* (London: Anthony D'Offay, 1997), 33.

19. Quoted in Hindry, 11.

20. For a compelling examination focusing on Warhol's portraits, see Nicholas Baume, *About Face: Andy Warhol Portraits* (Hartford: Wadsworth Atheneum, 1999).

With *Big Electric Chair*, 1967, and *Most Wanted Men No. 6, Thomas Francis C.*, 1964, Warhol addresses criminality and transgression. In 1975 he observed that contemporary celebrity did not make moral distinctions: "Nowadays if you're a crook, you're still considered up there. You can write books, go on TV, give interviews—

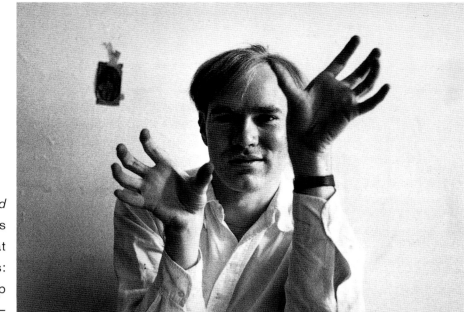

fig 27

you're a big celebrity and nobody even looks down on you because you're a crook. You're still really up there. This is because more than anything people just want stars."[21] But earlier, in 1964, Warhol tried placing images of noncelebrated criminals into the public realm as art and uncovered a minefield. At a peak moment, as publicity about his work and the Factory surpassed the public attention any American artist had ever attained, he was asked to contribute a large-scale outdoor artwork to the New York Pavilion at the 1964 World's Fair. Rather than reformulate a movie star portrait or product image, Warhol chose to introduce a new type of portrait: mug shots.[22] He created a mural, *Thirteen Most Wanted Men*, featuring images of hardcore criminals from FBI files. By literally elevating images normally limited to leaflets on the walls of post offices, Warhol gave images of criminals the same status, within his repertoire, as glamorous movie stars, rupturing the element of seamless, socially condoned celebrity fantasy that his work had begun to represent to a wider public. Further, the homoerotic double entendre of the title conflated the state's desire to apprehend these men with sexual desire.[23] Ultimately, and somewhat predictably, the authorities in this transaction had no interest in sharing the fair's stage with these images, and in the end,

THE

THIRTEEN

MOST WANTED

POLICE DEPARTMENT
City of New York

fig 28

21. Andy Warhol, *The Philosophy of Andy Warhol (From A to B and Back Again)* (San Diego and New York: Harcourt Brace Jovanovich, 1975), 85.

22. The photographs Warhol used came from a booklet of photographs of "wanted men" published by the police (fig. 28). The Police's source photos were in some cases casual snapshots.

23. For detailed analysis see Richard Meyer, " Warhol's Clones," *The Yale Journal of Criticism* 7, no. 1 (1994): 79–109.

fig 29

fig 27 **Duane Michals** *Portrait of Andy Warhol*, 1958, printed later, gelatin-silver print, ed. 4/30, 4³/₄ x 7 inches (12.1 x 17.8 cm), Los Angeles County Museum of Art, gift of an anonymous donor, Los Angeles, M2000.174.22

fig 28 **New York Police Department** Cover for "The Thirteen Most Wanted Men" booklet, 1962, 6¹/₈ x 4⁵/₈ inches (15.6 x 11.7 cm), archives of The Andy Warhol Museum, Pittsburgsh Founding Collection, Contribution The Andy Warhol Foundation for the Visual Arts, Inc.

fig 29 **Marcel Duchamp** Poster for the Pasadena Retrospective, "At the Pasadena Art Museum...Wanted $2,000 Reward...by or of Marcel Duchamp or Rrose Selavy...a retrospective exhibition....October 8 to November 3, 1963," 1963, color-offset lithograph, edition 300, 34¹/₂ x 27¹/₄ inches (87.6 x 68.6 cm), Norton Simon Museum Archives, Pasadena, Calif.

Warhol was cast as the transgressor. He was asked to take down and replace the mural. He offered to replace it with a grid portrait of fair president Robert Moses, but this offer was declined, and the mural was covered with aluminum paint.[24] Later, Warhol used the screens for the project to make paintings on canvas of the Most Wanted Men series, eventually shown together at Ileana Sonnabend Galerie in Paris in 1967.

The ambiguities the artist points to regarding the criminals in Most Wanted Men also figures into *Big Electric Chair*, 1967, which employs a particularly brutal image. Made in three series, in 1963, 1965, and 1967, the electric chair paintings have neither the topicality nor the perverse voyeurism of his car accident images, which came mostly from photos deemed even by the press too graphic for publication. Nor did they have the immediacy of the race riot images (p. 99) and the paintings of Jacqueline Kennedy after her husband's assassination (p. 20), which Warhol culled from newspapers and magazines in the early 1960s.[25] Although the death penalty was a subject of much debate in the U.S. in the 1960s (the Supreme Court would rule the penalty "cruel and unusual punishment" in 1972, because of the capricious manner in which it was sometimes applied) and rising crime rates preoccupied the public and the media, no specific incident anchors *Big Electric Chair* in the outside world. The chair itself, as a government-mandated punishment, by definition involved the conscience of every American, and Warhol, master of understatement, wisely let that psychological trigger stand alone.

Warhol's manipulation of found images in his sixties paintings, from Elvis's publicity photo to the mug shots of the Most Wanted Men series, converted paintings into receptacles for premade images and the assumptions made about them by viewers. Like fingerprints left by a social unconscious, they are loaded but incomplete clues whose very vagueness calls for the viewer's participation on a moral and emotional level. In this way Warhol's work shares with Lichtenstein the idea that imagery should "make people aware without handing it to them on a silver platter."

Whereas Lichtenstein explored the devices that create cultural conventions in well-edited, rigorous compositions, Warhol's 1960s paintings recomposed popular imagery by what appear to be

24. There are conflicting accounts of exactly who painted over the mural, Warhol or the fair authorities. Gerard Malanga stated in his interview with Patrick Smith that the mural was painted over because the alleged criminals "were no longer wanted, or they had served their terms in prison, or whatever.... we had to paint over some of the images, and . . . the esthetic decision occurred—it was just to leave them blank and do it over." Smith, *Andy Warhol's Art and Films*, 399. Rainer Crone attributed the fair authorities' order to dismantle the piece to their perception that the photos would offend Italian-Americans because so many were of known Mafiosi.

25. See Thomas Crow, "Saturday Disasters: Trace and Reference in Early Warhol," *Art in America* 75, no. 5 (May 1987), in which Crow writes, "In his selection of these photographs, Warhol was as little as ever the passive receptor of commonly-available imagery. Rather than relying upon newspaper reproductions that might have come to hand randomly, he sought out glossy press-agency prints normally seen only by professional journalists. (Some of these were apparently regarded as too bizarre or gruesome ever to see print . . .)"

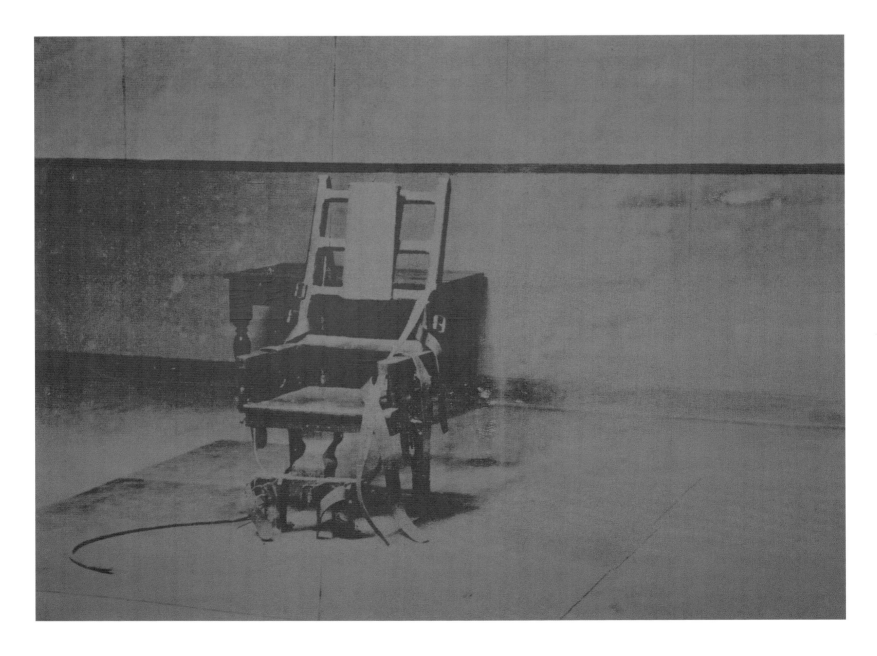

82.

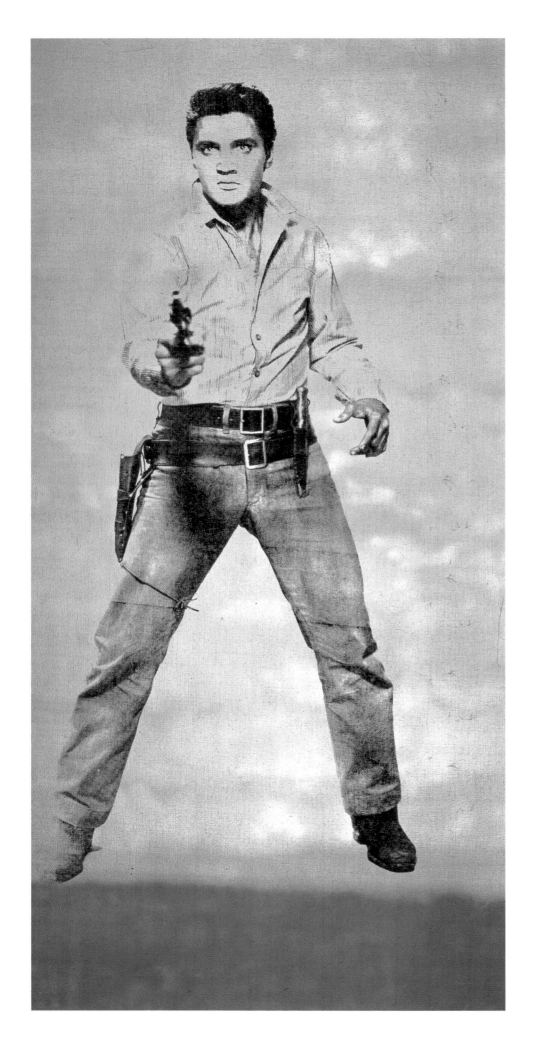

84.

haphazard means, such as uneven cropping or murky silkscreening. But such random-seeming techniques often yield a quality of poignancy or nostalgia. Warhol himself converted his "difference"—as an openly gay artist from an impoverished immigrant family, as cultivator of fringe personalities—into savvy self-promotion. And as a successful alien, he tells us as much about the past as about the future, pointing out unprocessed transitions, and the important things that have been left behind. As one critic has remarked, "Warhol's real genius was for the off-register print; for the lag moments in culture; for the thing just on its way out."[26] His signature Marilyn Monroe paintings, made just months after her death, are at their core memorials, using a promotional film still from the star's peak nearly ten years earlier. The Most Wanted Men series cribs mug shots from the 1940s and 1950s, rather than contemporary images.[27] Even the name of his studio, "The Factory," denotes industrial revolution-era manufacturing right at the dawn of the postindustrial age. Just about everything Warhol made or did had at least a hint of nostalgia about it.

The slippage between past, present, and future is reflected in the imperfect, sometimes smudgy screens he used to make his paintings. In *Two Marilyns*, 1962 (p. 97), as in many of Warhol's images of Marilyn, the artist mars an image that Hollywood presented as inviolate. Among Warhol's famous quotes about sameness and repetition, the ones about difference tend to be overlooked: "I can only understand really amateur performers or really bad performers, because whatever they do never really comes off, so therefore it can't really be phoney. . . . Every professional performer I've ever seen always does exactly the same thing at exactly the same moment in every show they do. They know when the audience is going to laugh and when it's going to get really interested. What I like are things that are different every time."[28] The Marilyn paintings take an image of a polished film still and obsessively make it imperfect, amateur, at times even grotesque in its flaws—a bit different every time, and a little sad every time.

○

26. Kirk Varnedoe and Adam Gopnik, *High Low: Modern Art and Popular Culture* (New York: Museum of Modern Art in association with Abrams, 1991), 193.

27. Richard Meyer, "Warhol's Clones," 83.

28. Warhol, *The Philosophy of Andy Warhol*, 82.

fig 30

HEAVY
INDUSTRY

The farther west we drove, the more Pop everything looked on the highways. . . . Once you "got" Pop, you could never see a sign the same way again. Once you thought Pop, you could never see America the same way again. —WARHOL AND PAT HACKETT, *POPISM*, 1980

Ed Ruscha considers *Boss*, 1961 (fig. 30), his first fully resolved word painting,[29] the culmination of three or more years of experimentation. In it, four capital letters in black sit in a chocolate brown background. The blunt serif type and the painting's distinctly dense palette leave the word in limbo, not clearly denoting any of the word's meanings: your boss at the office, or a "boss," great-looking hot rod. The image actually originates from a label for Boss work clothes; the sense that the painting is actually a portrait of a square of fabric is reflected in the rectangular impastoed area around the letters. At the time, Ruscha was deeply impressed with the work of Jasper Johns, and the thickly painted letters echo Johns's encaustic brushstrokes, already famous by 1961. Far from homage, however, *Boss* conveys the profound shift under way in the sixties art world, asking, Who's the boss? Individual, painterly expression, or the signs and symbols of the outer world? Encasing painterly, "subjective" expression in a word denoting authority or beauty, Ruscha uses deadpan humor in a manner that leaves a great deal of ambiguity as to his stance in this debate. In a manner unprecedented in art up to that point, *Boss*, as well as the 1962 painting *Heavy Industry*, lends pictorial and psychic weight to words. Unlike his East Coast contemporaries Warhol and Lichtenstein, whose work is often figurative, Ruscha allows words and lettering to stand alone in a nebulous new territory between abstraction and figuration. Warhol picked up on Ruscha's fascination with vacant places when he saw Ruscha's classic book of photographs, *Twentysix Gasoline Stations,* and asked, "Oh gosh how'd you get all these photos without people in them?" Words, architecture, and roads *are* the figures in Ruscha's art, and throughout his oeuvre, they move back and forth on a circuit of deadpan reality, dreamy still lifes, and weightless landscapes. (One of the only figures appearing in a Ruscha painting is in the Broad collections: the 1996–97 painting *Bloated Empire*, in which a wiseguy profile derived from an H. C. Westerman drawing hovers beneath the hazy brown surface.)

fig 31

fig 32

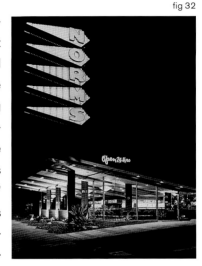

From his West Coast perspective, Ruscha captures the peculiar and surreal way that media and advertising meet landscape, not only on long stretches of desert highway, but also in the urbanized landscapes of western cities. *Norms, La Cienega, on Fire*, 1964, one in a series the artist informally calls his "summer paintings," featuring buildings on fire, shows a diner on La Cienega Boulevard in Los Angeles. Its noirish, cinematic perspective—in which the bottom edge of the canvas unsettlingly stands in for the ground, and the viewer's gaze is at ground level—was first described as "baseline perspective" by a critic, and Ruscha has used the term ever since. *Norms* thrusts from lower right to upper left with a dark blue night sky as its backdrop. The building's exaggerated Cadillac fins spew violent red-orange flames whipped to the left edge of the canvas as if by Santa Ana winds blowing in from the desert. Norms looks a bit like a dragster leaving the starting line, tires smoking and engine ablaze. The disorienting perspective and the unpopulated disaster of the painting evoke a filmlike mood and space, while the broad color fields and painterly flames allude to modernist abstraction. The tension between the immediacy of a fire in a familiar diner (fig. 32) and Ruscha's concise, cool, signlike treatment of the scene leaves the viewer questioning the difference between it and the illusions presented by film, painting, or photographs. In the painting *Damage*, made the same year, Ruscha heightens this conceptual tension, this false space, by depicting the letters in his painting of the word "Damage" as literally on fire.

Ruscha's surrealist bent sets him apart from Warhol and Lichtenstein and lends credence to his reluctance to consider himself a true Pop artist.[30] His fundamental reordering of the illusion of space in painting, however, and his interest in making portraits of signs and words put his work in Pop territory. Rather than exploiting the everyday for aesthetic or political shock, Ruscha's works simply seem open to everyday things, whether an everyday expression or an everyday diner.

○

29. Author's interview with the artist, August 31, 2000.

30. Ibid.

fig 31 **Dennis Hopper** *Ed Ruscha*, 1964, gelatin-silver print, 16 x 24 inches (40.6 x 61 cm), courtesy of the artist
fig 32 **Jack Laxer** *Norms Coffee Shop, La Cienega Boulevard*, 1957, courtesy of Newlove, Armet and Davis Architects

HEYLER

Ed Ruscha *Norms, La Cienega, on Fire,* 1964
Ed Ruscha *Where Are You Going, Man? (For Sam Doyle),* 1985

Beyond Pop

By about 1968, Pop's fashionable cachet was wearing thin, and critics widely pronounced the movement dead. This negative criticism centered on Pop's commercial success, and, in an echo of the hostile reception of their work in the early 1960s, Pop artists were accused of decadence, political complacency, and naïve complicity with the institutional "banality" of the media. For example, in 1973, Max Kozloff sharply criticized the politics of Pop: "It became necessary for audiences to feel removed from, yet assimilate with full indulgence of their typed, insolent glamorly [sic] impulses, events and objects they knew to be depraved. For having discovered this formula in art, Pop was instantly acculturated and coopted by the mass media on which it preyed."[31]

Warhol, Lichtenstein, and Ruscha each changed course in the late sixties. Warhol, who nearly died in 1968 after being shot by disaffected hanger-on Valerie Solanis, declared his retirement from painting, devoting himself instead to filmmaking and his magazine, *Interview*, although he resumed painting in the early seventies. An important if less radical shift occurred in Lichtenstein's work: He not only left behind the imagery of comics, but detached the tools, such as black outlining and Ben Day dots, from their moorings and applied them to a range of visual effects wholly divorced from their comic book origins. He moved decisively in this direction with a five-part painting he referred to as his "machine made" Monet, *Rouen Cathedral (Seen at Five Different Times of the Day) Set III*, 1969 (pp. 40–41) (this and *Live Ammo* are the only five-part works Lichtenstein made). Using Ben Day dots

fig 33

in complex, layered patterns, he interweaves colors and patterns in a manner hinting at an underlying sympathy with minimalist artists, which was in part awakened by the broad-ranging exhibition *Serial Imagery*, curated by John Coplans for the Pasadena Art Museum in 1968. *Serial Imagery* included Monet's Rouen Cathedral paintings along with works by contemporary artists such as Ellsworth Kelly (fig. 33).[32] Lichtenstein's Rouen Cathedrals go further than his paintings based on Picasso, Mondrian, and others. Not only do they comment on the vernacularization of art history, but they also reference the work of minimalist colleagues like Kelly, making more explicit his belief in the permeability of hierarchical boundaries between types and methods of art making.

Ruscha, also in about 1968, largely turned away from paint and canvas, embarking on his famous "stain" paintings and drawings wherein juices, bodily fluids, and other liquids took the place of paint, and paper or fabric stood in for canvas. His more recent work has also led to deeper investigation into multiple layers of illusion, while remaining true to many of his main Pop ingredients. His paintings' compositional frameworks have remained largely consistent, alternating between the grids that underpin paintings like *Heavy Industry* and *Boss*, and the extreme baseline perspective he first explored in paintings like *Norms, La Cienega*. In *Where Are You Going, Man?* *(For Sam Doyle)*, 1985, city lights on a diagonal grid are overlaid with the words "Wass a Guin Mon? U Dig Me?", a Gullah phrase excerpted from a work by folk artist Sam Doyle that Ruscha saw in a Washington, D.C., exhibition.[33] *Strong, Healthy*, 1987, uses baseline perspective to depict two suburban houses shrouded in eerie blackness, the airbrushed scene disrupted by two blank rectangles, aligned under each house like expectant labels.

Sunset-Gardner Cross, 1998–99 (p. 7), breaks from this layering of one pictorial field over another, echoing Ruscha's early first photobooks of gas stations, the Sunset strip, and parking lots. Here, the faintly demarcated intersection—Sunset Boulevard and Gardner Street—occupies a vast, mottled gray space, topped by a brilliant orange sunset across the top strip of the canvas. The cruciform streetscape represents the intersection in Hollywood where Ruscha made his film *Premium* and hints at a crossroads of spiritual and mystical dimensions. With its distant sunset, Ruscha's painting

31. Max Kozloff, "American Painting during the Cold War," in Steven Henry Madoff, *Pop Art: A Critical History*, 365.

32. See John Coplans, *Serial Imagery. exh. cat.* (Pasadena: The Pasadena Art Museum, 1968).

33. Author's interview with the artist, August 31, 2000.

displays the kind of place described as Los Angeles in Kerouac's classic *On the Road:* "Everybody was rushing off to the farthest palm—and beyond that was the desert and nothingness." The kind of simultaneous deployment of factuality (a map), traditional devices (dramatic perspective), and loaded content ("a cross") in *Sunset-Gardner Cross* echoes the main ingredients in Pop of the sixties, yet alludes to introspection more directly than any Pop work.

The work of Warhol, Lichtenstein, and Ruscha also presented the postwar art world with a crossroads. Hidden in its coolness and apparent restraint, Pop's heart pumped ambivalence and paradox, reanimating what Lichtenstein called "that particular mystery that goes on in painting." Their art looked unlike anything made before it, while incorporating traditional means of making images. Their intellectual position was tremendously complex, taking into account both the power and vulnerability of social forces, pop culture, the media, and consumerism. Pop acknowledged that the individual and culture are interdependent, separated by a permeable and ever-shifting conceptual membrane that these artists felt could be very well represented by a painting masquerading as a cartoon, or as a word, or as a movie star photo.

Pop art firmly took hold of the American art world, where the boundaries between high and low are perpetually under question and stress, and where "blurring boundaries," and becoming something or someone else, is built into the cultural imagination. In the work of succeeding generations of American artists, including many in the Broad collections, Pop inspired the widespread use of appropriation, the hallmark of Postmodernism, and decades of investigation into the uncertainties of perception—and the art object's capacity to carry those uncertainties. ◎

Joanne Heyler is curator of four collections of contemporary art established by Eli Broad: The Broad Art Foundation, The Eli and Edythe L. Broad Collection, and the corporate collections of SunAmerica Inc. and KB Home. Heyler has written art criticism for magazines such as FlashArt *and* Visions.

Ed Ruscha *Strong, Healthy,* 1987

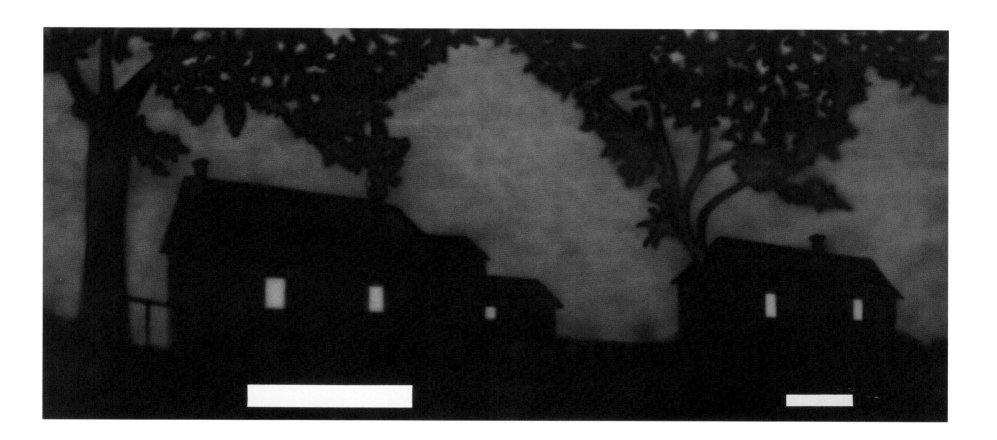

andy warhol

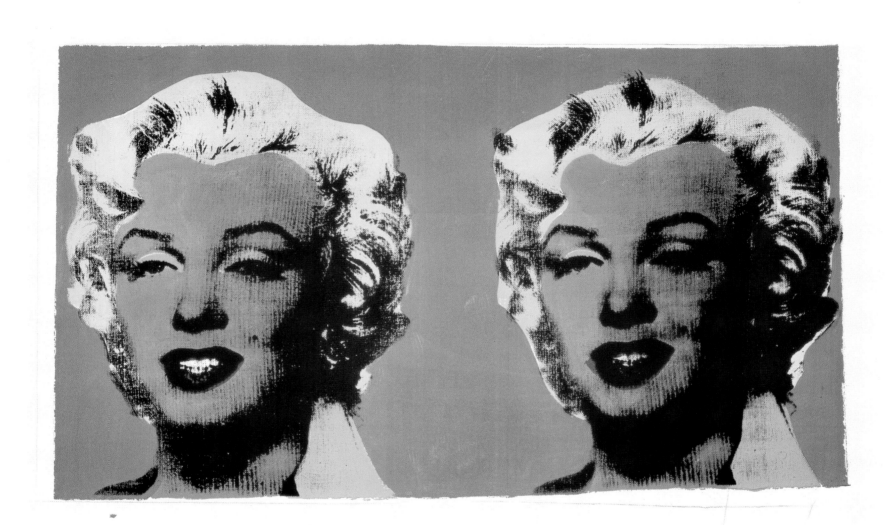

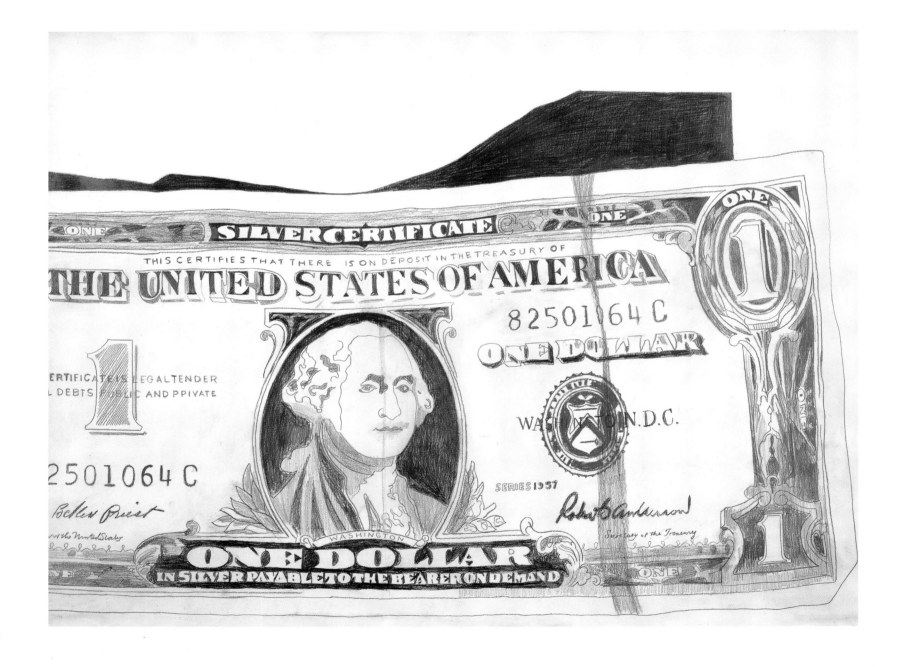

98.

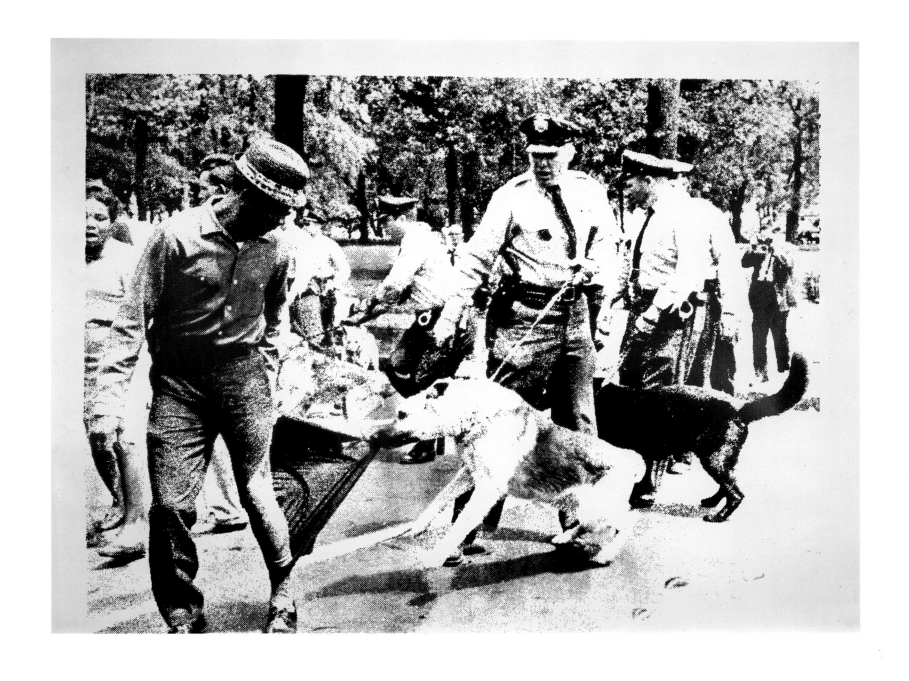

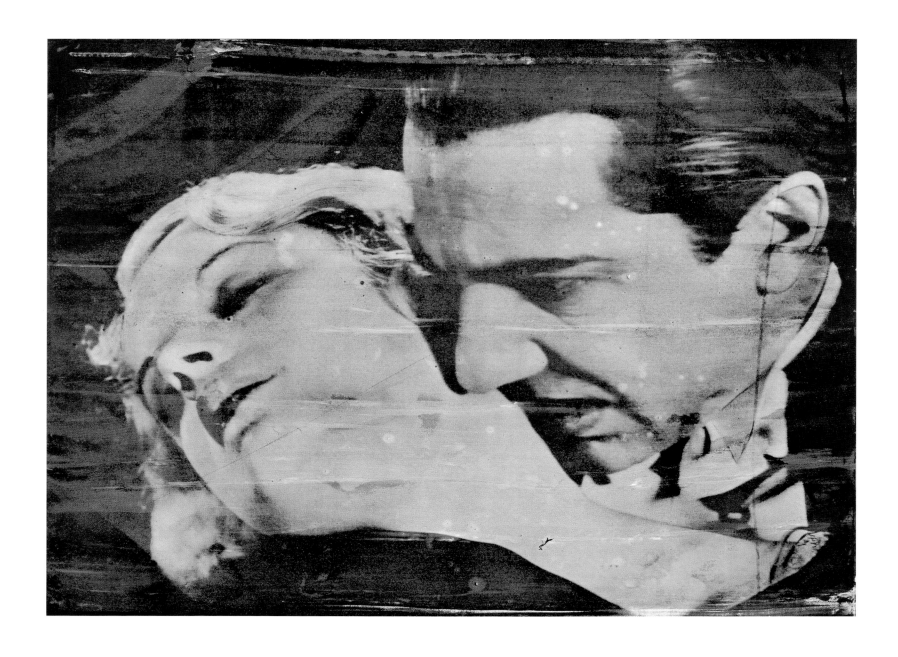

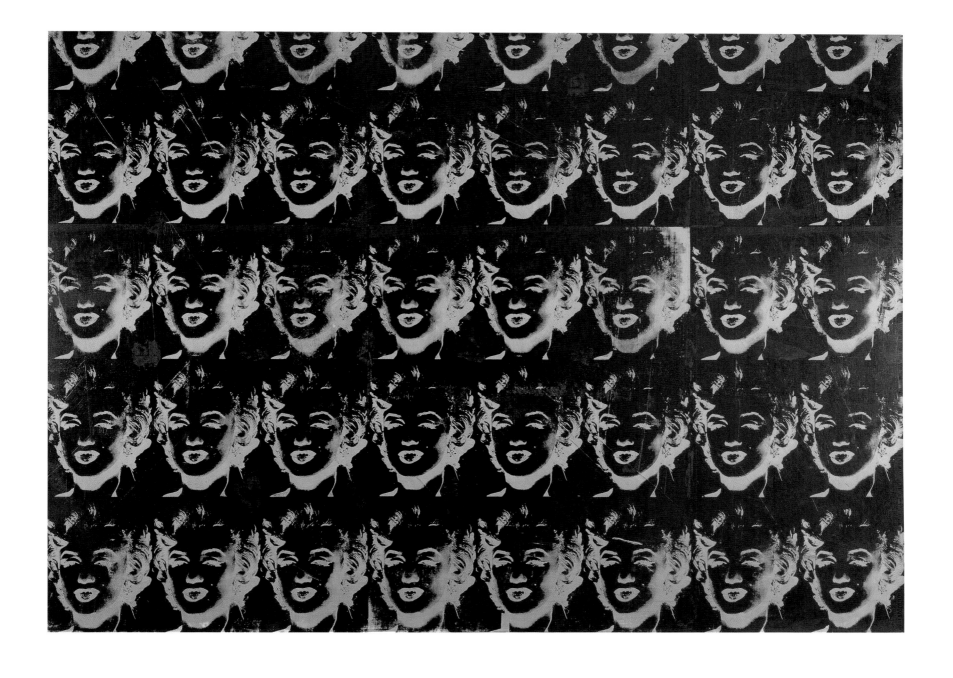

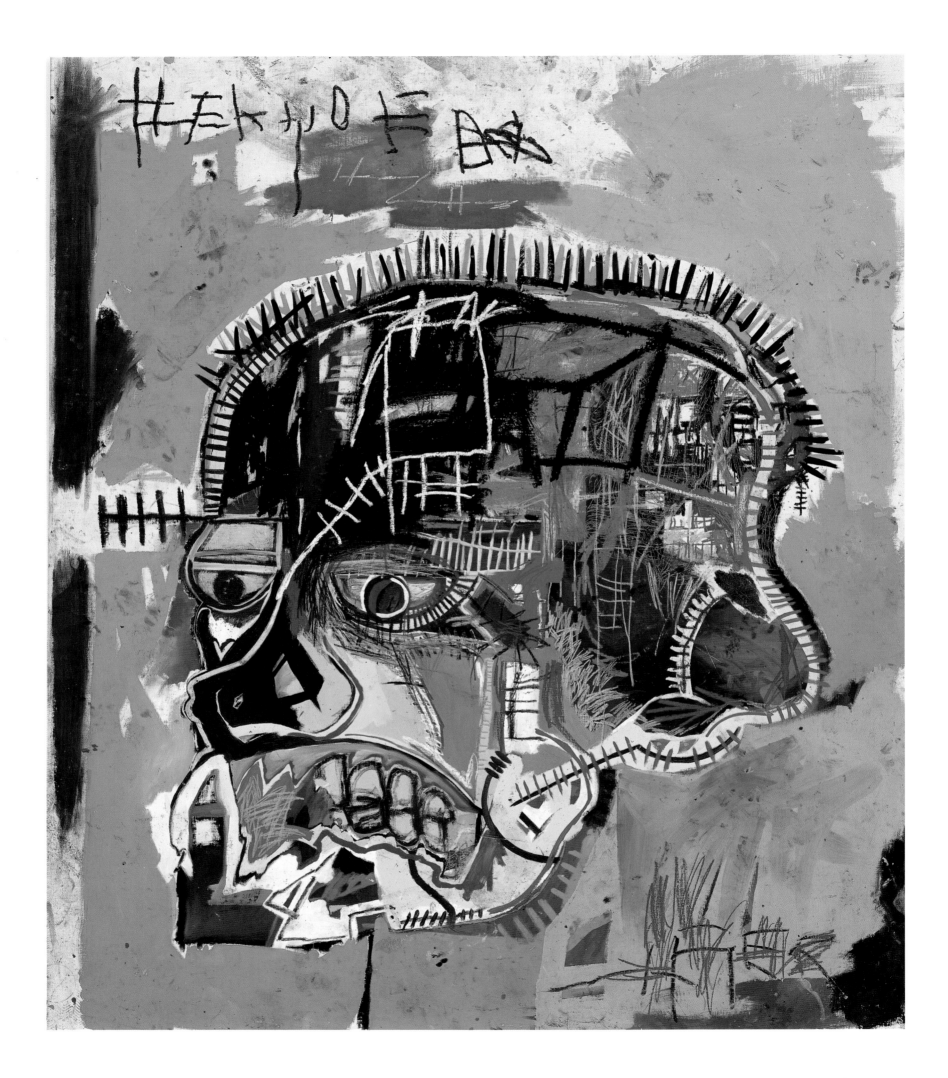

oedipus wrecks New York in the 1980s

Painting struck back in the 1980s. Ten years earlier, it seemed to have been permanently vanquished by the rebel forces of Conceptualism and Process art, but it now returned in force. Soho was suddenly full of big canvases covered with big, sloppy brushstrokes, showing big nudes in compromising positions. There was a crowd of young painters with big prices, big egos, big features in *Vanity Fair* and *House and Garden*, big waiting lists for as yet unpainted pictures. It was the epoch of Neo-Expressionism, of Graffiti art, of the painter as rock star.[1]

At the same time, it was an epoch of anti-painting: artists who worked with borrowed images, photographs, and text, by remaking objects in surprising materials, or simply by placing them on display. The romantic upsurge of Neo-Expressionism seemed to call forth its exact contrary: a puritanical refusal to give in to the sensual pleasures of paint, of individual sensibility, of self-celebration. The critics of the period never settled on a single label for this tendency, but perhaps historical analogy can suggest an appropriate tag. Since the original Expressionist movement provoked a reaction in favor of a cool "objectivity," it seems appropriate to describe the reaction against Neo-Expressionism as a movement toward Neo-Objectivity. Indeed the intense anxiety masquerading as clinical detachment that characterized the *Neue Sachlichkeit* of the 1920s is also typical of much 1980s art.[2]

The division between Neo-Expressionism and Neo-Objectivity mirrored the social divisions of the Reagan era. After the recession of 1981–82, the American economy embarked on a rapid expansion that seemed, however, to benefit Wall Street at the expense of Main Street. Stocks, bonds, and real estate boomed while the old industrial economy sank into decline. The gap between rich and poor grew visibly wider.[3] Although the Neo-Expressionists seemed happy to cater to the crowd of prosperous, well-educated bankers and lawyers, the Neo-Objectivists clung to the 1960s idea that avant-garde art should oppose the capitalist system. True, there had been little political content to most Minimal or Conceptual art. But the art's antiaesthetic stance, use of everyday materials, or simple insubstantiality made it hard to sell; and this refusal to engage with the art market could be seen as an act of symbolic aggression against capitalist society as a whole.

From this point of view, Neo-Expressionism looked like a craven surrender to the system, a cynical decision to give collectors exactly what they wanted: paintings with recognizable imagery that could hang over a sofa, a name brand disguised as a distinctive vision. In contrast, Neo-Objectivity, with its denial of personality, seemed to deprive collectors of the chance to invest in individual genius.[4] Both movements, however, depended on recognizable figuration, and in that sense they were both reactions against the art of the late 1960s and the early 1970s.

The rehabilitation of figuration in painting began with the Whitney Museum's 1978 exhibition *New Image Painting*. The curator, Richard Marshall, brought together a group of younger artists, such as Susan Rothenberg, Nicholas Africano, Lois Lane, and Robert Moskowitz, who tended to set flat, silhouetted images against blank color fields in a manner recalling the "Post-Painterly Abstraction" of the 1960s.[5] In retrospect, it was Rothenberg, among the *New Image* painters, who most clearly pointed the way forward, combining an atavistic subject matter—the outlines of horses, echoing the

outlines of Paleolithic cave paintings—with lushly expressive brushwork that energized the pictorial field despite its monochromy. Rothenberg seemed to announce the imminent arrival of Neo-Expressionism, with its roster of "bad boy" painters including David Salle, Julian Schnabel, and Eric Fischl. Another kind of figurative expressiveness would soon emerge in the work of Graffiti artists such as Jean-Michel Basquiat and Keith Haring.

The Neo-Objective tendency found its first formulation in a 1977 exhibition, *Pictures*, organized by the critic Douglas Crimp at Artists Space, an influential not-for-profit gallery. The original exhibition included Sherrie Levine, Robert Longo, and several other artists; in 1979, when Crimp rewrote his catalogue text for publication in the journal *October*, he expanded this roster to include Cindy Sherman, who would turn out to be the most influential of the Neo-Objective artists.[6] The artists championed by Crimp seemed to embrace the ideal of a cool, ironic art that was intellectual rather than visceral. Instead of painting, they made photographs, or copied them. Instead of sculpting, they re-created the icons and commodities of mass culture. They quoted the imagery and the language of film and advertising, defamiliarizing them by placing them in new contexts. To its supporters, this was an art that retained its critical edge, resisting the embrace of the establishment.[7]

Within a few years, however, the differences between movements no longer seemed so clear-cut, if only because many of the Neo-Objective artists had achieved success comparable to the Neo-Expressionists' and had begun working in more substantial or more traditional materials. It was increasingly apparent that whatever their differences in style, their work was full of similar images of glamour, vanity, alienation, sex, and violence, and that the work of the Neo-Objectivists was, in its own way, every bit as expressive as the art of the Neo-Expressionists. Ultimately, the movements shared a film noir sensibility that seems to have been the common property of many artists of their generation.[8]

◎

1. For the supporters of Neo-Expressionism and Graffit art, the first priority was to rescue painting from "the sterile Conceptual and Minimalist art that had numbed the art scene during the post-Pop decade, boring both critics and collectors," as Phoebe Hoban put it in *Basquiat: A Quick Killing in Art* (New York: Viking, 1998), 7. A more reasoned version of this argument appears in Hilton Kramer, "The New Expressionism," *The New Criterion* 1, no. 3 (November 1982): 40–45; see esp. p. 42, where Kramer complains that, in the advanced art of the 1960s, "all evidence of subjective emotion . . .

anything that suggested the role of the unconscious or of the irrational in art was suppressed in favor of clean surfaces and hard edges. . . . There was a virtual ban on revelations of the soul. . . . For the first time in the history of criticism, boredom in art was upheld as an exemplary emotion." To its supporters, Neo-Expressionism seemed like a long-overdue corrective. Nonetheless its status was sufficiently problematic that *Art in America* devoted two issues (December 1982 and January 1983) to an extended debate on the topic.

2. The term "Neo-Objectivity" was not used during the period under discussion. The partisans of this type of art typically referred to it as "postmodernist." The problem with this term is that it was also used by more mainstream critics to refer to contemporary art in general (including Neo-Expressionism), insofar as modernism seemed to have come to a dead end in the 1970s. This use seems to have been borrowed from architecture critics, who applied "postmodernism" to the rejection of the International Style by architects Robert Venturi, Michael Graves, and Frank Gehry. (See, for instance, Charles Jencks, *The Language of Post-Modern*

Architecture, 1977). Douglas Crimp argues for a more restrictive use of the term in his essay, "Pictures," *October*, no. 8 (spring 1979); reprinted in Brian Wallis, ed., *Art after Modernism: Rethinking Representation* (New York and Boston: The New Museum of Contemporary Art, New York, and David R. Godine, 1984), 186–87; see also the discussion of this issue by Hal Foster in "Re: Post," *Parachute*, no. 26 (spring 1982); also reprinted in *Art after Modernism*, 189–201.

Susan Rothenberg *Double Masked Heads*, 1974

3. The period was brilliantly evoked in a number of books. For fiction see Jay McInerney, *Bright Lights, Big City* (New York: Vintage, 1984); Tom Wolfe, *The Bonfire of the Vanities* (New York: Farrar Straus Giroux, 1987); Douglas Coupland, *Generation X* (New York: St. Martin's Press, 1991). For useful nonfiction see Martin Mayer, *The Money Bazaars: Understanding the Banking Revolution around Us* (New York: E. P. Dutton, 1984); William Greider, *Secrets of the Temple: How the Federal Reserve Runs the Country* (New York: Simon and Schuster, 1987); Connie Bruck, *The Predator's Ball: The Junk Bond Raiders and the*

Man Who Staked Them (New York: Simon and Schuster, 1988); Michael Lewis, *Liar's Poker: Rising through the Wreckage on Wall Street* (New York: W. W. Norton, 1989); see also L. J. Davis, "Chronicle of a Debacle Foretold: How deregulation begat the S&L scandal," *Harper's*, September 1990, 50–66. Perhaps the most visible symbol of the boom in the art market was the young dealer Mary Boone, as well known for her exotic beauty and her elegant openings as for the artists she represented; see Anthony

Haden-Guest, "The New Queen of the Art Scene," *New York*, April 19, 1982, 24–29; "Boone Means Business: Hot Dealer in Wild Art," *Life*, May 1982, 83–86; and Laura de Coppet and Alan Jones, *The Art Dealers* (New York: Clarkson N. Potter, 1984), 272–81.

4. Benjamin Buchloh, "Figures of Authority, Ciphers of Regression: Notes on the Return of Representation in European Painting," *October,* no. 16 (spring 1981): 39–68; reprinted in Wallis, *Art after Modernism,* 106–35; see especially the quotes from other critics on pp. 119–21.

5. See Richard Marshall, *New Image Painting,* exh. cat. (New York: Whitney Museum of American Art, 1978); and Clement Greenberg, *Post-Painterly Abstraction,* exh. cat. (Los Angeles: Los Angeles County Museum of Art, 1964); Greenberg's exhibition featured painters such as Frank Stella, Kenneth Noland, Ellsworth Kelly, Paul Feeley, and Friedel de Dzubas.

6. Douglas Crimp, *Pictures* (New York: Artists Space, Committee for the Visual Arts), 1977; revised text printed in *October,* no. 8 (spring 1979); reprinted in Wallis, *Art after Modernism,* 175–88.

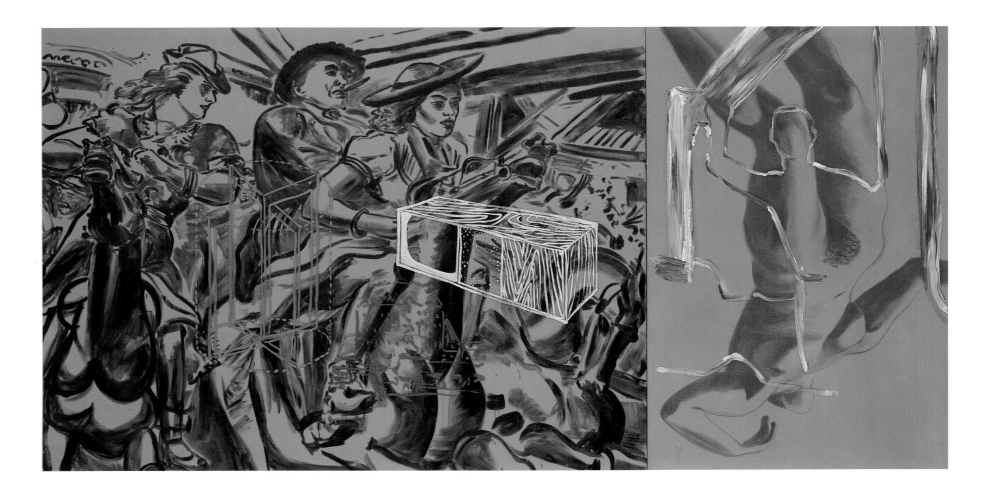

Of the seven artists under consideration here, three—Susan Rothenberg, Eric Fischl, and Ross Bleckner—were born between 1945 and 1949. Another three—David Salle, Cindy Sherman, and Jeff Koons—were born between 1952 and 1955. The youngest of the group, Jean-Michel Basquiat, was born in 1960, and died, tragically young, in 1988. Whether because of their birth dates or because they experienced an extended *wanderjahre*, all of them came of age as artists in the 1970s, too late to participate in the revolutions of Minimalism and Conceptualism.

Several of them—Fischl, Salle, and Bleckner—studied at Cal Arts in the early part of the decade, when the guiding spirit of the program there was John Baldessari, a leading exponent of the California version of Conceptualism.[9] The State University of New York at Buffalo, and the Hallwalls exhibition space there, played a similar role in the formation of Cindy Sherman and several other important Neo-Objective artists. Coincidentally, Susan Rothenberg had also grown up and begun her art studies in Buffalo, where the Albright-Knox Art Gallery provided an exceptional overview of the history of modern art.[10]

7. Also, to its supporters, the work of Levine, Kruger, Sherman, Longo, and Holzer seemed to continue the modernist tradition of political radicalism. It should be noted, however, that to see this art as *political* required an act of faith in the then-fashionable theory of the "simulacrum." This theory held that the economy no longer depended on the manufacture of *things* but rather on the creation and circulation of *images*. The implication was that the creation of images could be a genuinely political action. It wasn't necessary to form a political party, or to canvass for votes, or even to organize a demonstration. If you could disturb the flow of conventional words and images (the "precession of simulacra"), that alone might be enough to shake the system to its foundations! See Jean Baudrillard, *For a Critique of the Political Economy of the* Sign (trans. St. Louis, Mo.: Telos Press, 1981) and *Simulations* (trans. New York: Semiotext[e], 1983); Robert B. Reich, *The Work of Nations: Preparing Ourselves for 21st-century Capitalism* (New York: A. A. Knopf, 1991); Fredric Jameson, "Postmodernism and Consumer Society," in Hal Foster, ed., *The Anti-Aesthetic: Essays on Post-* *Modern Culture* (Port Townsend, Wash.: Bay Press, 1983), 111–25; and Jameson, *Postmodernism, or, The Cultural Logic of Late Capitalism* (Durham: Duke University Press, 1991).

8. One symbol of the rapprochement between Neo-Objectivists and Neo-Expressionists was the Whitney's 1989 exhibition *Image World: Art and Media Culture*, which quietly included David Salle along with Sherman, Longo, and the rest of the Neo-Objective roster. The curators—Marvin Heiferman, Lisa Phillips, and John G. Hanhardt—seemed simultaneously to celebrate and to mourn the idea that the American people had lost contact with reality—that they lived in a world constructed almost exclusively from the images of television, films, and magazines. History, with its sequence of cause, intention, and effect, had dissolved into an endless flux of images, in the mass media *and* in art. The accumulation of borrowed images, the layering of image upon image, the longing for wealth, fame, and sex—all this seemed directly to reflect the fantasy life of the popular imagination without revealing any deeper meaning. There

"At Cal Arts they thought that painting was dead," Fischl later remarked.[11] It was performance, rather than object making, that represented the cutting edge of art in the early 1970s. Salle later recalled being particularly impressed by the performances and videotapes of Vito Acconci: "Vito's primary device was the winning salaciousness of his honesty, his 'confessions,' which created a terrifically *present* feeling for the audience."[12] Minimalism had shifted the emphasis from the artist to the object, from personal expression to impersonal process. At the same time, however, it had increased the viewer's awareness of the gallery as a theatrical setting. It thus, paradoxically, gave a new lease on life to the genre of art performance, which had flowered in the late 1950s and would, in the natural course of events, have expired by the end of the 1960s.[13] Having more or less eliminated the art object, Minimalist performance made the artist's *self* into an artistic medium.[14] Ironically, it might be said that this transformation of Minimalism provided the starting point for Neo-Expressionism, which reclaimed painting as a mode of self-expression.

The artists coming of age in the 1970s had come along too late to participate in the long, heroic revolution of Modernist art. They had also, for the most part, come along too late to participate wholeheartedly in the countercultural revolution of the 1960s. Even the older artists of this group never fully embraced antiestablishment lifestyle and ideals. "I wasn't a very good hippie," Eric Fischl told an interviewer. Their attitude toward their parents' generation was one not of rejection but of profound ambivalence. Something was deeply wrong with suburban America, where they had grown up, and yet there was something extremely attractive about it.[15]

The artists' parents belonged to the generation that had fought in or at least lived through the Second World War, and that had gone on to enjoy an unprecedented era of prosperity. More than that, the two decades after the war marked a quantum leap in the degree of American education and cultural sophistication.[16] It seems significant that three of the artists discussed here—Salle, Basquiat, and Koons—had parents involved with fashion or interior design—"minor" arts that gave visible expression to the new sophistication of the American middle class.[17] The right half of Salle's 1981 painting *View the Author through Long Telescopes* (fig. 34) offers a series of fashion illustrations

no longer seemed any point in pretending that contemporary art could analyze—much less change—the social and political assumptions of this all-encompassing image culture.

9. David Salle's work of the mid-1970s, reproduced in Janet Kardon and Lisa Phillips, *David Salle* (Philadelphia: Institute of Contemporary Art, 1986), 8 and 88, combines photographs and text in a manner clearly indebted to Baldessari's paintings of the late 1960s (e.g., *The Spectator Is Compelled . . .*, p.184). Salle modifies Baldessari's format by placing photo and text side by side, instead of one

over the other. The diptych format of these early works seems to have led directly to much of Salle's 1980s work.

10. Calvin Tomkins, "Her Secret Identities [Cindy Sherman]," *The New Yorker*, May 15, 2000, 77; and Joan Simon, *Susan Rothenberg* (New York: Harry N. Abrams, 1991), 10–12.

11. Donald Kuspit, "An Interview with Eric Fischl," in *Fischl* (New York: Vintage, 1987), 28.

12. Peter Schjeldahl, "An Interview with David Salle," in *Salle* (New York: Vintage, 1987), 13–16.

13. As Robert Morris noted in "Notes on Sculpture, Part 2," *Artforum* 5, no. 2 (October 1966); reprinted in Gregory Battcock, ed. *Minimal Art: A Critical Anthology* (New York: E. P. Dutton, 1968), 232: "the better new work takes relationships out of the work and makes them a function of space, light, and the viewer's field of vision." The "theatricality" of Minimal art was denounced by the critic Michael Fried in a brilliant polemical essay, "Art and Objecthood," published in *Artforum* in June 1967; also reprinted in Battcock, *Minimal Art*, 116–47. Subsequent critics have largely accepted Fried's description

of the theatrical quality of Minimal art while rejecting his negative assessment of it. On the birth of art performance in the United States, see Barbara Haskell, *Blam! The Explosion of Pop, Minimalism, and Performance, 1958–1964*, exh. cat. (New York: Whitney Museum of American Art, 1984).

14. Rosalind Krauss, "Video: The Aesthetics of Narcissicism," *October*, no. 1 (spring 1976): 51–64.

15. Kuspit, "An Interview with Eric Fischl," 24, and, more generally, 19–20 and 24–27.

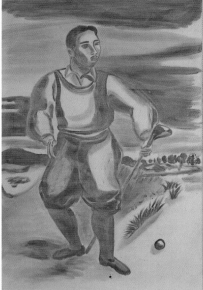

showing women in characteristic 1950s outfits, with mannish col-
lars, pinched waists, and long narrow skirts. Salle's slashing blue
brushstrokes, here, reproduce the deliberately offhand line of the
drawings that once graced the pages of *Vogue*. (The left half of the
painting, executed in a looser, more tonal style, shows a Ronald
Colman–like golf player with breeches and a pencil mustache; he seems to belong to an earlier stra-
tum of American social history.) Cindy Sherman's *Untitled Film Still #54* reveals a woman hurrying
through a darkened street in clothes of approximately the same vintage. At the same time that we won-
der about the source of her visible anxiety, we cannot help but note her elegance.

Similarly, Eric Fischl's paintings stress the unnerving beauty, rather than the banality, of the
environment in which he grew up. As he commented,

> The suburbs are based on visual presentation, visual stimulation. I think that the reason I'm a
> painter has everything to do with this fact. . . . The suburbs always try to represent themselves
> through a look. Everyone tried to live up to the image of the kind of ideal life promised by the
> look of the suburban scene and invested all their feelings in that effort. And when life wasn't
> so ideal, the feelings suffered all the more because of the investment in the look, the ideal liv-
> ing implied by the scene.[18]

The work of Fischl, Salle, Sherman, and their contemporaries does not reject the world of their parents.
Rather, it explores the gap between the beauty of that world and the messy reality of their parents' lives.
It corresponds, in effect, to a common complaint of children: that their parents have not lived up to the
ideals they espouse.

It might be said, in a larger sense, that the artists of the 1980s were caught in an Oedipal rela-
tionship to their biological and cultural parents. They admired and desired the world that had given
birth to them, but, having grown up believing that the façade was a reality, they could not accept that
it was merely a facade. Their disappointment made them want to desecrate the cultural symbols that

16. "The work week has shrunk, real
wages have risen, and never in history
have so many people attained such a
high standard of living as in this coun-
try since 1945. College enrollment is
now over four million, three times what
it was in 1929. Money, leisure and
knowledge, the prerequisites for cul-
ture, are more plentiful and more
evenly distributed than ever before."
Dwight MacDonald, "Masscult &
Midcult," *Partisan Review*, spring
1960; reprinted in Dwight MacDonald,
*Against the American Grain: Essays
on the Effects of Mass Culture* (New
York: Random House, 1962), 36–37.

17. Salle's father was a ladies' clothing
buyer for stores in Norman, Oklahoma;
Basquiat's mother invited him to help
her sketch dress designs; and Jeff
Koons's father ran an interior-design
business.

18. Kuspit, "Interview with Eric
Fischl," 21.

fig 34 **David Salle** *View the Author through Long Telescopes*, 1981, acrylic on canvas, 72 x 96 inches (182.9 x 243.8 cm),
The Museum of Contemporary Art, Los Angeles
Cindy Sherman *Untitled Film Still #54*, 1980

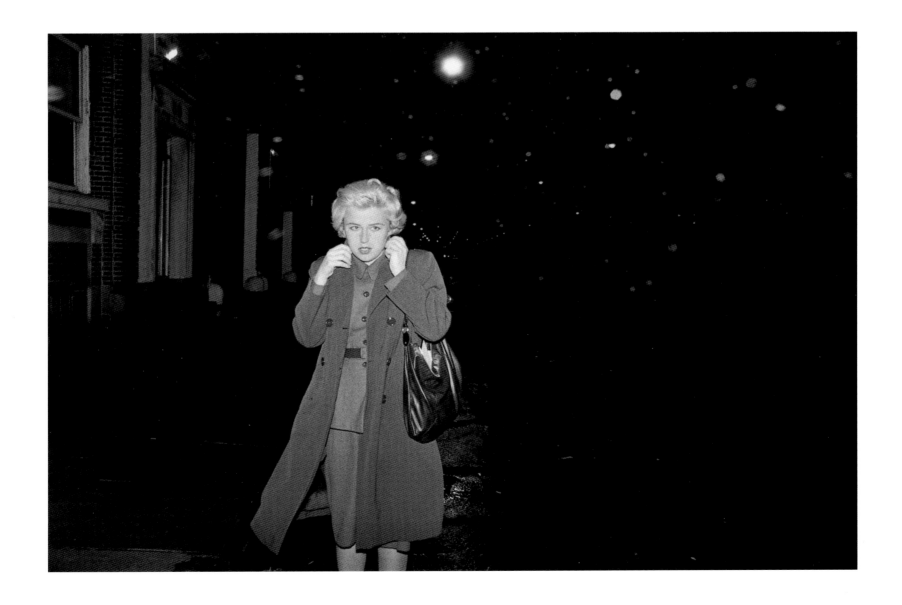

110.

stood as emblems of cultural authority. And yet, at bottom, they wanted nothing more than to assume the same position of authority. These conflicting emotions—rage, sorrow, nostalgia, conflict—inspired the art of the 1980s, and, in different guises, provided its central subject matter.

◎

At a formal level, the profound nostalgia of the later 1970s and the early 1980s often manifested itself as a craving for the visibly handmade—a rejection of the slick, mechanical surfaces favored by both Minimal and Pop artists. This nostalgia was often noted in the work of narrative painters such

fig 35

as Schnabel, Fischl, and their German counterparts. But it was equally important in the work of abstract painters such as Sean Scully, and painters working on the border between figuration and abstraction such as Susan Rothenberg and Louisa Chase. Rothenberg's preference for building up an image from countless small brushstrokes is evident in *Blue Body*, painted in 1980–81, as she was shifting from the equine motifs of her 1970s work to the human imagery that would dominate her work of the 1980s. Rothenberg often arrived at her highly condensed images—here, a wavering circle and a horse's head, superimposed on the outline of a standing human figure—only after a long process of reworking, and this process remained visible in the finished canvas.[19] A similar process of reworking can also be seen in the paintings of Rothenberg's contemporary, Louisa Chase (fig. 35). Both artists seem to look back to the figure paintings of Alberto Giacometti (fig. 36), where the image is clearly the result of a long, existential struggle, the attempt to reconcile the abstract demands of paint and canvas with

19. The extent of Rothenberg's reworking is made evident in a pair of photographs in Joan Simon, *Susan Rothenberg*, 77, showing the completed version of a 1977 canvas next to a studio view of the same work in progress. On p. 79, Simon cites Rothenberg using the term "exoskeleton" to describe the extended outlines of *Blue Body* and saying that the blue circle represents a minimal version of the figure's torso.

fig 36

fig 35 **Susan Rothenberg** *Blue Body*, 1980–81, oil on two canvas panels, 108 x 144 inches (274.3 x 365.8 cm) overall, The Broad Art Foundation
Louisa Chase *Yellow Spooks*, 1986, oil on canvas, 25²⁄₃ x 17⁵⁄₈ inches (65 x 45.5 cm), Alberto Giacometti Foundation, Kunsthaus Zurich
fig 36 **Alberto Giacometti** *Head of a Man III (Diego)*, 1964, oil on canvas, 25²⁄₃ x 17⁵⁄₈ inches (65 x 45.5 cm), Alberto Giacometti Foundation, Kunsthaus Zurich

112.

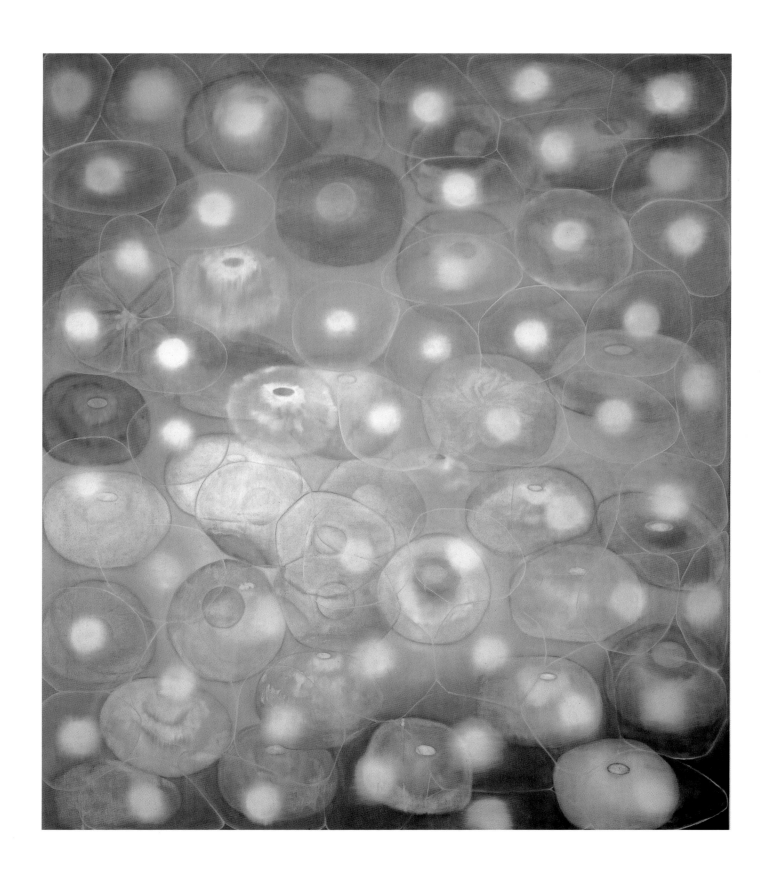

Julian Schnabel *The Walk Home*, 1984–85
Ross Bleckner *In Sickness and in Health*, 1996

the imperative to create a human likeness.[20] Their brushwork also recalls the poetic quality of Philip Guston's early, Abstract Expressionist work.

For many American artists, however, it was no longer possible to cling to the idea that a handmade appearance could serve as a guarantee of spiritual authenticity. To make his 1988 sculpture *String of Puppies*, Jeff Koons hired skilled woodcarvers to reproduce a found photograph of a couple, seated on a park bench, holding their brood of eight adorable puppies. The photographer, Art Rogers, subsequently sued for copyright infringement. Legal argument in the case centered on the question

fig 37

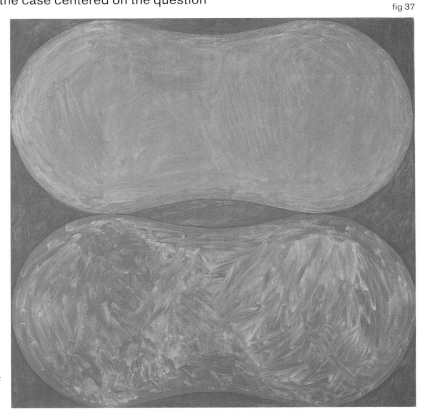

of whether the bright colors of the painted sculpture, where the orange shirts of the couple clashed with the unnatural blue fur of the puppies, were sufficient to establish that the work was meant as a parody—and not just a three-dimensional copy—of the original photograph.[21] Carved from wood, the sculpture was also covered with countless hatch marks (which are difficult to see in reproduction), recalling the conspicuously handmade work of the German sculptor Stephan Balkenhol (see his *Large Classical Man*, p. 176). Here, the usual relation between form and content was reversed: The kitsch content of the image provided a critical commentary on its form, suggesting that the idea of handmade art was now hopelessly obsolete.

Indeed, through much of the 1980s, it seemed as if the formal vocabulary of high modernism could be deployed only in an ironic mode, placed between visual quotation marks. In Koons's "equilibrium" sculptures of 1985, two or three basketballs would be placed in the half-full tank of an aquarium, halfway submerged and positioned at equal intervals from one another. The formal relationship of round balls and rectangular tank unmistakably echoed the "look"

20. Giacometti's struggle is eloquently conveyed in James Lord's brief narrative, *A Giacometti Portrait* (New York: Farrar Straus Giroux, 1965, rev. 1980).

21. Brian Wallis, "We Don't Need Another Hero: Aspects of the Critical Reception of Jeff Koons," in *Jeff Koons* (San Francisco: San Francisco Museum of Modern Art, 1992), 31.

of geometric abstract paintings from the 1950s and 1960s, for example Tony Smith's *Louisenberg #2*, 1953–54 (fig. 37). Koons's chosen medium–basketballs–removed his sculpture from the Platonic realm of pure form and rooted it, instead, in the contemporary reality of the 1980s (and 1990s), when a sports-mad public made a handful of talented basketball players into superstars, their names and faces recognized around the globe. Koons's decision not to use any kind of hidden technology to keep the basketballs in place seems to acknowledge the social *dis*-equilibrium produced by the elevation of a few individuals to a situation of unimaginable fame and wealth: The balls frequently float out of position and need to be readjusted. Koons considers this phenomenon part of the work's meaning: "The balls go out of equilibrium, and the work must be reset. But it's pure."[22]

Already in the early 1970s, feminist artists and art historians had drawn attention to the manifold links between high modernism and everyday life, pointing out, for instance, that women had made quilts employing an abstract geometric vocabulary long before male artists had "invented" abstract painting, and that Victorian women had made photocollages decades before the Cubists or Dadaists.[23] In the later 1970s and the 1980s, this idea gradually lost its feminist associations and became a commonplace. Sherrie Levine, a Neo-Objectivist who attracted attention by practicing the craft of "appropriation" in its purest form–rephotographing earlier photographs by Walker Evans and Edward Weston–also produced a series of modest abstract paintings, many of which employed the recognizable forms of game boards (chess, checkers, backgammon, etc.). The "Neo-Geo" painter Peter Halley combined squares, grids, and textures in canvases that recalled the early work of Donald Judd, but which Halley described as references to the "cells" of electrical grids and penitentiaries.[24] David Salle painted several canvases in which the left-hand panel consisted of an abstract pattern of colored strips that had originally served as a floor covering.[25]

This crossover between decorative and abstract pattern acquired a surprising emotional resonance in the 1980s paintings of Ross Bleckner, who frequently covered some or all of his canvases with a pattern of narrow vertical stripes that blurred at their edges so that one stripe seemed to bleed into the next. Combined with the translucency of the paint surface, this blurriness evoked the optical

22. Koons quoted in *Jeff Koons*, 1992, n.p. [between plates 9 and 10]. Koons's basketball tank pieces were accompanied by a series of works in which he simply framed a series of posters produced by Nike, which used star players to promote their sneakers. On the phenomenon of sports superstars and the way that their marketing distorts the financial equilibrium of sports, see Thomas J. Friedman, *The Lexus and the Olive Tree* (New York: Farrar Straus Giroux, 1999; rev. ed., New York: Anchor Books, 2000), 306–18.

23. See, for instance, Melissa Meyer and Miriam Schapiro, "Waste Not Want Not: An Inquiry into What Women Saved and Assembled," *Heresies* (winter 1978).

24. The Broad collections include several Peter Halleys, of which the 1981 *Freudian Painting* is closest to Judd, and two representative works by Sherrie Levine, *After Walker Evans*, 1987, and *Lead Checks and Chevron: 9*, 1988 (the latter combines a checkerboard and a backgammon board).

25. Fiona Irving, in her chronology of Salle's career, published in Janet Kardon and Lisa Phillips, *David Salle* (Philadelphia: Institute of Contemporary Art, 1986), 84–85, describes a 1978 installation piece done in the Netherlands, combining "photographs of a nude woman . . . wearing paper cones" with an "elaborately painted floor." This work was reinstalled at Anina Nosei's New York gallery in 1980. Salle's 1981 canvas *Autopsy* seems to have been a more permanent

version of this installation; a similar pattern appears in another 1981 canvas, *The Happy Writers*. Although Salle himself invented the pattern in these works, it is almost certainly modeled on the decorative linoleum often used in 1950s–60s interiors.

fig. 37 **Tony Smith** *Louisenberg #2*, 1953–54, oil on canvas, 39¼ x 39¼ x 39¼ inches (99.7 x 99.7 x 99.7 cm), Collection of of Chiara Smith

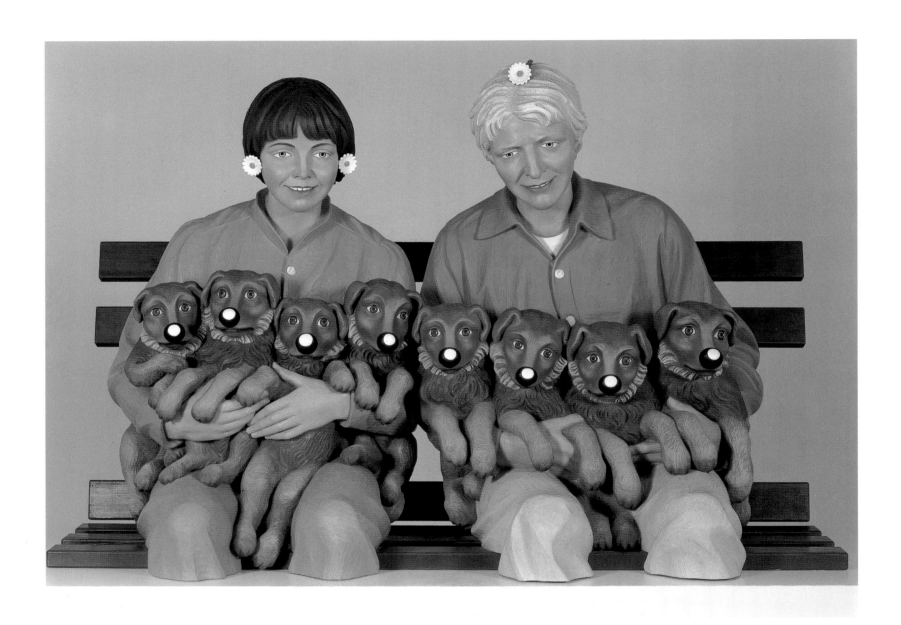

116.

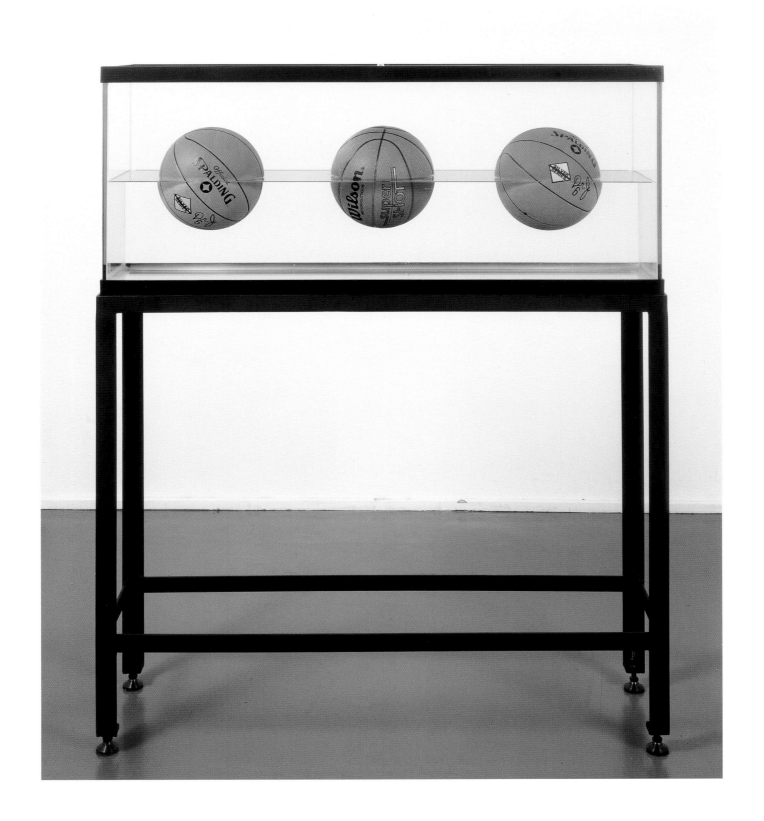

Jeff Koons *String of Puppies*, 1988
Jeff Koons *Three-Ball 50/50 Tank*, 1985

shimmer of 1960s Op art. It could also be read as a sign of three-dimensional form, as if the stripes were advancing and retreating like the pleats of a curtain hung from a straight rod. In the 1986 canvas *Brothers' Sword*, the strips are topped by a row of small fleurs-de-lis, glowing like incandescent finials. The black strip around the fleurs-de-lis reinforces the sense that the stripes constitute a kind of curtain, hanging between the viewer and a dark, vacant space on the other side of the canvas. Like so much of Bleckner's work, the canvas radiates a palpable sense of mystery and loss: We will never know what is concealed on the other side of the curtain.

The stripes are absent in Bleckner's small 1985 canvas *Bed Flower*, but the sense of mystery is equally intense. The dominant form of the composition is a variant of the fleur-de-lis motif, positioned at the top of the canvas, but overturned like an extinguished torch. Flanked by a few curving white strokes at left (again suggesting a curtain), the torch seems to hover in a vast cosmic space, interrupted by occasional scintillations and bursts of light. Two series of lines have been scratched into the ground. In its lower half, the lines radiate from the edges of the canvas and converge at its center, like a demonstration of classical one-point perspective. In its upper half, the lines descend from the corners, converging at two different vanishing points, located at either side of the canvas. The perspectival spaces are inconsistent with each other, and with the cosmic space of the painted image; nonetheless, the reiterated idea of a *vanishing* point resonates with the painterly evocation of emptiness. Without making a direct allusion, Bleckner succeeds in powerfully evoking the tragedy of the AIDS epidemic.

◎

Rather than invoking the allure of the handmade object, like Rothenberg or Bleckner, many artists of the 1980s chose instead to adapt the pseudo-documentary procedures of art from the years 1968–72. Baldessari's photo-and-text paintings (see pp. 184–85) provided one important model. The typological photographs of Bernd and Hilla Becher provided another. Though they lived and taught in Düsseldorf, the Bechers' book *Anonyme Skulpturen: A Typology of Technical Constructions*, published in 1970 in German, English, and French, made their work available to an international audience. Examining a series of lime kilns, cooling towers, blast furnaces, winding towers, water towers (see pp. 154–56), gas tanks, and silos, the photographs in *Anonyme Skulpturen* revealed the structural

120.

similarities dictated by function, but also the stylistic differences possible within those structures. The Bechers thus combined the concept of photographic-documentation-as-art with another crucial concept of the 1960s: the belief in the *series* as the fundamental unit of artistic creation.[26] The same combination played an important role in the work of feminist artists such as Eleanor Antin.[27]

The ideas of a series of documents (or pseudo-documents) provided an essential element in the formation of the Neo-Objective aesthetic. Cindy Sherman's first body of work, the *Untitled Film Stills* of 1977–80, took the form of a series of black-and-white photographs, all printed on standard 8 x 10-inch paper, that seemed at first glance to be reproductions of film stills from classic American and foreign films. The "documentary" quality of Sherman's work was so convincing that it took some time for critics to realize that she had composed the pictures herself and had in fact posed for all of them. Although the photographs varied from long shots to close-ups, they tended to fall into groups taken from a similar distance and sharing a similar point of view. What varied from one picture to the next was the role and, apparently, the identity of the "actress." In one, she poses as a cheap hooker in hotpants and a low-cut blouse, offering her wares in a window. In another, she looks like a rich man's mistress, in an Italian film, berating her inconstant lover. In a third, she seems to be an elegant New Yorker, hesitating before embarking on an evening out.

In this first reading, Sherman's pictures appeared as an exploration of the feminine image in the collective unconscious of the film world. Strangely, once Sherman's authorial role was understood, critics began to pay less attention to the individual personae enacted in her pictures, focusing instead on the significance of the fact that Sherman was playing a role for an observer, represented by the camera. The critical stress on the interaction of woman and observer corresponded to an important aspect of feminism that stressed the degree to which the roles and identities available to women were defined by the masculine gaze.[28]

These feminist critics took as their starting point the writings of Jacques Lacan, and in particular his theory that the initial formation of human identity depended on an infantile "mirror stage," in which the child adopted the self-image it received from those around it. According to this theory,

Cindy Sherman *Untitled Film Still #15, 1978*
Cindy Sherman *Untitled Film Still #7, 1978*

26. As Michael Fried noted in *Three American Painters: Kenneth Noland, Jules Olitski, Frank Stella*, exh. cat. (Cambridge, Mass.: Fogg Art Museum, 1965), the idea of the series as the basic unit of artistic enterprise was already latent in the paintings of Morris Louis and Kenneth Noland. It emerged as an important feature of Minimalism with Sol LeWitt's *Serial Project No. 1 (ABCD)*, constructed in 1966–67. This new aspect of Minimalism was noted by Mel Bochner in his essay, "The Serial Attitude," *Artforum* 6, no. 4 (December 1967), 28–33, and provided the basis for the 1968 exhibition *Serial Imagery*, curated by John Coplans for the

Pasadena Art Museum; Coplans's introduction to the catalogue was reprinted in *Artforum* 7, no. 2 (October 1968), 34–43.

27. See Howard N. Fox, *Eleanor Antin,* exh. cat. (Los Angeles: Los Angeles County Museum of Art, 1999); and Eleanor Antin, *100 Boots* (originally executed 1971–73; published New York: Running Press, 1999), a photo-narrative that clearly anticipates Sherman's work.

28. The "feminist" reading of Sherman's work is concisely summarized and criticized by Rosalind Krauss in her essay "Cindy Sherman: Untitled," in *Cindy Sherman: 1975–1993* (New York: Rizzoli, 1993), 41–61. Other important texts for this interpretation are Laura Mulvey, "Visual Pleasure and Narrative Cinema," originally published in *Screen* in 1975 and reprinted in Mulvey, *Visual and Other Pleasures* (Bloomington: University of Indiana Press, 1989); and Mulvey, "A Phantasmagoria of the Female Body: The Work of Cindy Sherman," *New Left Review*, no. 188 (July/August 1991).

human beings were fundamentally alienated from themselves because their identities depended from the outset on others, not on themselves.[29]

It seems strange, in retrospect, that feminist critics should so enthusiastically have embraced a theory that made the very identity of women hostage to the male imagination. One might have expected them, rather, to endorse the American school of ego psychology, which argued that the child's formation of a healthy self depended on the successful mastery of cognitive and other tasks. Indeed, outside the world of critical theory, feminists tended to concentrate on breaking down barriers to female achievement.

The ready acceptance of Lacanian theory by cultural critics in the 1970s and 1980s seems to have derived from several different factors. On one hand, it fit in with an increasing stress on the social rather than personal determinants of art and literature, summed up in Roland Barthes's 1967 essay, "The Death of the Author," which argued that the "author" was merely an imaginary persona, cobbled together from bits and pieces of earlier texts.[30] It also, however, corresponded to a zeitgeist dominated by a cult of celebrity rather than achievement. Horatio Alger had been replaced by movie stars who seemed to leap effortlessly from obscurity to fame. "Growing up" now seemed to mean adopting a ready-made self borrowed from the lexicon of mass culture. The "mirror stage" was not an infantile experience but an adolescent one.[31]

In fact, adolescence became increasingly the subject of Sherman's work after 1980. She had experienced (or rather created) a kind of vicarious adulthood in the *Untitled Film Stills* of the late 1970s. The women in these pictures, with their brilliantly particularized lives and moods, have little in common with the flattened images of mass culture, circling obsessively around the themes of sex, wealth, and fame. Beginning in 1980, however, when she began to work in color, Sherman seemed to adopt a simpler, more dramatic vocabulary of moods, alternating between hopeful expectation and angry despair.[32]

◎

29. See "The Mirror Stage as Formative of the Function of the I," in Jacques Lacan, *Écrits* (New York: W. W. Norton, 1977), 1–7.

30. Barthes's essay "The Death of the Author" was first published in an American journal, *Aspen*, no. 5/6 (fall-winter 1967). This was a special issue, edited by Brian O'Doherty, on Minimalism and related tendencies (it also included Sol LeWitt's "Serial Project No. 1 (ABCD)," and Susan Sontag's brilliant essay, "The Aesthetics of Silence"). Barthes's essay was subsequently retranslated and published in English in *Image/Music/Text* (New York: Hill and Wang, 1977), 142–48, where it appeared as a founding text of Postmodernism. The bibliographical note in *Image/Music/Text*, p. 216, states that "The Death of the Author" first appeared in *Mantéia* V, 1968, suggesting that Barthes himself had forgotten its first, American publication.

31. On this topic, see, for instance, Christopher Lasch, *The Culture of Narcissism: American Life in an Age of Diminishing Expectations* (New York: W. W. Norton, 1978).

32. David Salle's paintings of 1980 cover some of the same emotional and narrative territory as Sherman's early photographs. The girl washing dishes in *Untitled Film Still #3* finds a counterpart in Salle's *Archer's House*; the wistful look of the girl in *Untitled #114*, 1982, is matched by the gaze of the reclining woman on the left in Salle's *We'll Shake the Bag*, 1980.

Cindy Sherman *Untitled #114*, 1982

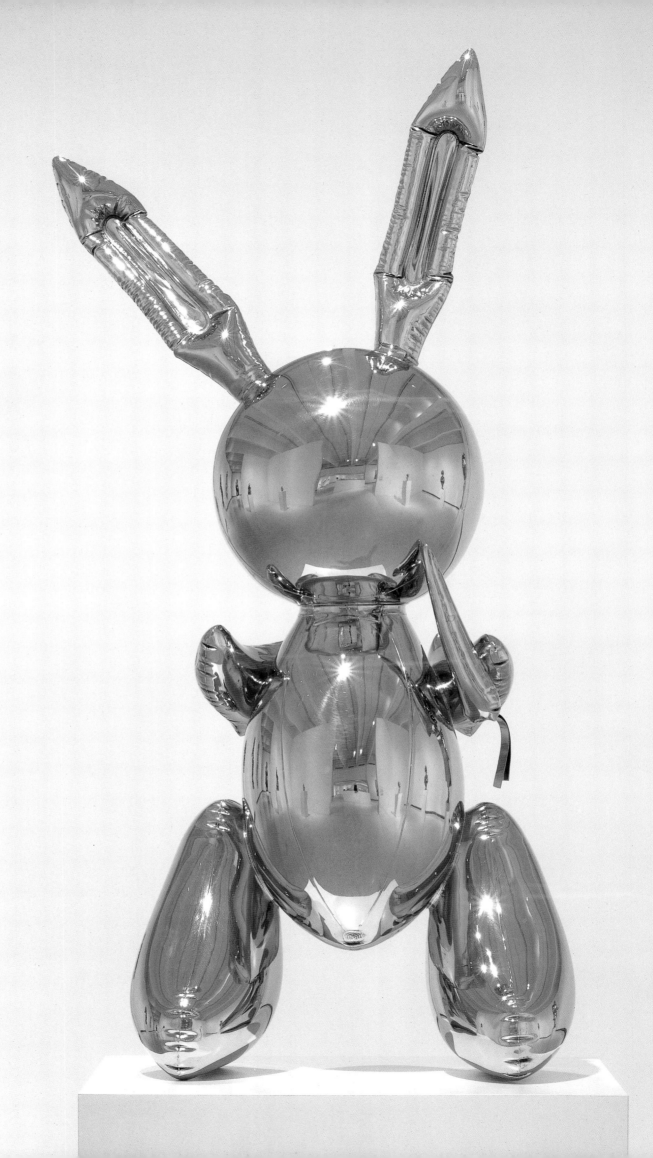

KARMEL

fig 39

fig 38

Whereas Sherman (along with Salle and Fischl) focused on the human figure, other artists turned to the inanimate object as a vehicle for exploring American culture. Allan McCollum, Robert Therrien, and Christian Eckart explored the fantasies invested in art itself by creating generic paintings or sculptures whose value seemed to depend on the quasi-religious aura attached to the work of art.[33] In addition to the basketball sculptures discussed above, Jeff Koons created a series of works that liberated the metaphoric value of mass-produced objects by reframing them or remaking them in unexpected materials. Placing industrial vacuum cleaners inside Plexiglas display cases, brilliantly illuminated by fluorescent lights, Koons forced the viewer to regard them as sculptural rather than functional objects (fig. 38). Seen in this light, they revealed unexpected erotic qualities, recalling the surreal objects in Eva Hesse's pictures of the mid-1960s (fig. 39), made before she turned to sculpture.

Other artists of the 1950s and 1960s, from Jasper Johns through Bruce Nauman, had turned to casting as a means of making the familiar strange, capturing the form of an object without inflecting it with the artist's personal touch. Koons now adopted this technique, but with an unprecedented attention to the interplay between object and material. A cast sculpture is almost invariably hollow, but traditional artists had always done their best to suppress the viewer's awareness of this fact: A bronze figure was meant to look as solid as one carved from stone. Koons, however, based many of his most successful sculptures on inflatable objects: a lifeboat or a plastic rabbit. Even though transformed into bronze or steel, the sculptures testify to the materials of their models: There are dimples or flanges where inelastic plastic or rubberized canvas resists the desire of compressed air to expand to its maximum circumference.

The visible inflation of the sculptures may recall the economic inflation of the late 1970s, or the inflated art market of the mid-1980s. And there may be a further commentary on speculative bubbles

33. The genre of the "generic painting" is represented in the Broad Collection by Robert Therrien's *No Title* of 1993–94 and Christian Eckart's *Odessey (blue and gold) #3* of 1986.

in the fact that these bronze and steel replicas will endure when every example of the original objects has vanished, condemned by the inherent impermanence of rubber and plastic. On the other hand, Koons himself has emphasized the dysfunctionality of his bronze lifeboat, noting that if you tried to use it as a lifeboat, it would do you no good whatsoever, because "it weighs over six hundred pounds and it's just going to take you right back down."[34]

◎

In a widely read 1980 essay, "Within the Context of No Context," the cultural critic George Trow complained that the "middle distance" of local community had disappeared from modern life, and Americans now lived in the yawning gap between "the grid of two hundred million and the grid of intimacy." It might be said that the borrowed imagery of Neo-Objectivism, the simulated spontaneity of Neo-Expressionism, and the anxious undercurrent of both movements were all products of this gap between mass culture and the isolated individual.[35] Other artists of the late 1970s and early 1980s reacted to this experience by trying to root their art in an imagery and experience of local community.

The most visible of these experiments was the art of Manhattan's Lower East Side. For some artists and performers, the economic and social marginality of life in Loisaida (as it was often called) provided a license to try out new identities and styles, to make art or music without worrying about whether it would be a success. An Irish bar on the Bowery was transformed, more or less by accident, into CBGB, the venue for New Wave and Punk bands like Blondie, Talking Heads, and the Ramones. Other spaces provided stages for experimental performers and artists such as Ann Magnuson, Klaus Nomi, Kenny Scharf, and Peter McDermott. Sometimes the artists and the performers worked together; other times they merely coexisted. One group of low-budget impresarios rented a space in a building owned by Ross Bleckner, telling him they were planning to open a quiet art cabaret; as soon as the lease was signed, they installed a powerful sound system and opened the Mudd Club, a downtown version of the fashionable Studio 54.[36]

A group of artists including John Ahearn, Tom Otterness, James Nares, and Jenny Holzer came together in the organization Collaborative Projects ("Colab" for short), organizing hit-and-run exhibitions such as *Manifesto*, *Income & Wealth*, and *The Real Estate Show*. Colab's political orientation made it a logical home for artists such as Ahearn, who had already begun his long-term project of documenting street life by making and painting plaster casts of its participants. Holzer was composing her "Truisms"—twisted parodies of everyday sayings—and distributing them on posters and T-shirts. Leon Golub, an older artist who had been committed to politically conscious, realist painting since the 1950s, now found himself part of a sympathetic avant-garde community.

In June 1980, Ahearn and Otterness helped organize Colab's largest, most visible exhibition, the *Times Square Show*, a sprawling, free-form installation in a former bus depot and massage parlor. The Colab members invited the participation of Fashion Moda, a community arts group based in the

fig 40

South Bronx. Several younger artists—Keith Haring, Kenny Scharf, and Jean-Michel Basquiat—also crashed the party, painting and drawing in unoccupied spaces of the building. It was in this context that a new visual sensibility, based on cartoons and graffiti, began to make a significant impact on the New York art scene.[37]

By 1980 graffiti had become a significant element in the urban experience, infuriating to the average New Yorker but offering an unexpected source of pleasure to those who did not mind the omnipresent effect of visual overload. Graffiti "artists" took walls, storefront shutters, and—above all—subway cars as their canvases, spray-painting them with complex calligraphic signatures supplemented by colorful shading and cartoon figures. Despite the efforts of well-meaning art dealers who gave shows to several of the better known "taggers," it was a style that never transferred successfully to canvas. The benefits of the movement were reaped primarily by artists who selected and refined aspects of the graffiti style, adapting them to the conventions of high modernism.[38]

fig 41

The "cartoon" aspect of the graffiti style was explored by artists such as Keith Haring and Kenny Scharf.[39] Of these, Haring seemed particularly responsive to the visual characteristics of "wild style" calligraphy, in particular its translation of conventional lettering into a pattern of broad, overlapping bands. In Haring's work (fig. 42), these bands composed simplified figures, enacting scenes from science-fiction dreams and nightmares, often with a strong erotic element. Like Jenny Holzer and other Colab artists—and like the genuine graffiti artists—Haring set out to take the city itself as his canvas. As Steve Hager writes in *Art after Midnight*, "After noticing that the city was covering unrenewed ads [in the subway] with black tarpaper, Haring began drawing on the tar paper with chalk."[40] Descending a staircase or emerging from a train, one would suddenly be confronted with a mystifying image, too strange to be an advertisement but too casual to be identified as "art." Similar bulbous figures also appeared in the work of Tom Otterness, who conferred monumental status on them by translating them into the traditional medium of cast bronze (fig. 41).

34. Koons quoted in *Jeff Koons*, 1992, n.p. [between plates 9 and 10].

35. George W. S. Trow, *Within the Context of No Context*, 1980; reprint, New York: Atlantic Monthly Press, 1997, 47. David Salle's 1985 canvas *The Cold Child (for George Trow)* alludes to pp. 54–55 of Trow's essay, and Trow's argument here, that the "cold childhood" of modern American life breeds "an interest in sadism," would offer a useful starting point for a more in-depth reading of Salle's work. Trow's essay provides an American, nontheoretical counterpart to the cultural analyses of Jean Baudrillard, discussed in note 7.

36. Steve Hager, *Art after Midnight: The East Village Scene* (New York: St. Martin's Press, 1986), 2–4, 13, 27–37, 50. Apparently derived from the tradition of drag queen cabaret, the performance pieces by Magnuson, Nomi, McDermott, etc., might be regarded as a more extreme but more ephemeral version of Cindy Sherman's experiments in alternate identities. The creation (and recording) of outrageous identities has recently become a central theme in the work of artists such as Mariko Mori, Yasumura Morimura, and the Russian team of Oleg Maslov and Victor Kiznetsov.

37. On Colab and the *Times Square Show*, see Hager, *Art after Midnight*, 14–15 and 82; Alan Moore and Marc Miller, "The ABC's of No Rio and Its Times: An Introduction," in *ABC No Rio Dinero: The Story of a Lower East Side Art Gallery* (New York: ABC No Rio with Collaborative Projects, 1985), 1–5; Walter Robinson, "Collaborative Projects and Rule C," in *ABC No Rio Dinero*, 10–11; Jeffrey Deitch, "Report from Times Square," *Art in America* 66, no. 7 (September 1980): 58–63. See also Jane Kramer's sympathetic account of John Ahearn's later career, "Whose Art Is It, Anyway?," *The New*

fig 42

fig 40 Montage of two works of graffiti in New York subway cars: *Dusty by Dust* and *Shadow by Seen*, courtesy Henry Chalfant
fig 41 **Tom Otterness** *The Doors*, 1985, pressed wood and bronze, 95½ x 60 x 5 inches (242.6 x 152.4 x 12.7 cm) overall, The Broad Art Foundation
fig 42 **Keith Haring** *Untitled*, 1983, vinyl paint on vinyl tarpaulin, 180 x 276 inches (457.2 x 701 cm), The Broad Art Foundation

Yorker, December 21, 1992; reprinted in *Whose Art Is It, Anyway?* (Durham: Duke University Press, 1994). Although not included in the present exhibition, Ahearn and Leon Golub are well represented in the Broad collections, the former by ten sculptures, the latter by twenty-two canvases, one of which, *Threnody* (1986), captures street characters comparable to those in Ahearn's work.

38. Hager, *Art after Midnight*, 40–41; Craig Castleman, *Getting Up: Subway Graffiti in New York* (Cambridge, Mass.: MIT Press, 1982); *An Exhibition of Graffiti Art by CRASH*

and DAZE (New York: Sidney Janis Gallery, 1984); Kirk Varnedoe and Adam Gopnik, *High & Low: Modern Art and Popular Culture* (New York: The Museum of Modern Art, 1991), 377–80.

39. In addition to two works by Keith Haring (one reproduced here as fig. 42), the Broad collection includes Kenny Scharf's 1984 canvas *Inside Out*.

40. Hager, *Art after Midnight*, 94.

Jean-Michel Basquiat, too, first attracted notice by intervening in the visual fabric of the city. Together with a high school friend, Albert Diaz, he invented an imaginary religion, SAMO (short for "same old shit" but also notably close to "Sambo"), and began spraying oddly poetic, apocalyptic inscriptions on downtown walls. Two downtown newspapers, *The Village Voice* and the *Soho News*, competed to see who could identify SAMO. Basquiat was the son of a successful Haitian immigrant, but his penchant for outrageous, self-destructive behavior meant that he barely managed to graduate from high school. He never attended art school; nonetheless, taking advantage of books and museums, he managed to give himself a surprisingly effective education in the language of modern art. His impromptu contribution to the *Times Square Show* attracted special notice from Jeffrey Deitch, who, writing in *Art in America*, described it as "a knock-out combination of de Kooning and subway spray-paint scribbles."[41]

The 1981 exhibition *New York/New Wave*, at P.S. 1, included a large selection of Basquiat's work, which rapidly attracted the attention of several important dealers. In very short order, Basquiat began exhibiting widely in an international array of galleries and museums. As that rara avis, a successful African-American artist, he attracted tremendous media attention, culminating in a profile in the February 10, 1985, issue of *The New York Times Magazine*, which featured him on its cover, seated in his studio, wearing an elegant but paint-spattered suit, and barefoot. With increasing prosperity came increasing drug problems, however, and Basquiat died of an overdose in August 1988, at the age of twenty-seven.[42]

Both in his lifetime and after, Basquiat's reception as an artist was shaped by his race, his youth, and his identification with the graffiti movement. Rene Ricard, the brilliant critic who had helped put Julian Schnabel on the map, made Basquiat into the centerpiece of a December 1981 article in *Artforum* announcing the emergence of a new art movement based on graffiti. Ricard stressed the social significance of Basquiat's painting:

> How does he come up with those words he puts all over everything? Their aggressively hand-made look fits his peculiarly political sensibility. He seems to have become the gutter and his world view very much that of the downtrodden and dispossessed. . . . Right now what we need is information; I want to know what is going on in people's minds and these pictures are useful.[43]

More recent writers have tended to follow Ricard's lead, reading off the inscriptions in a painting like *Horn Players* as a series of keys to Basquiat's world view—in this case, the equation between Basquiat's own achievement as a painter and the musical achievements of Charlie Parker and Dizzy Gillespie. What seems more significant, in retrospect, is Ricard's observation that Basquiat's work "looks like our expectation of art; there is observable history in his work. His touch has spontaneous erudition that comforts one as the expected does." No doubt this was, as Adam Gopnik has suggested, because he had assiduously studied the modernist masterpieces on view in the galleries and museums of New York.[44]

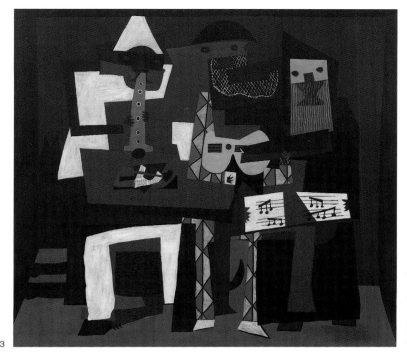

fig 43

Horn Players seems to look back, specifically, to Picasso. The masklike faces of Basquiat's musicians, the strict frontality of their arrangement, and the dark sonority of the colors (lines of white, yellow, pink, and green floating over a black and blue ground) recall the Synthetic Cubist style of the *Three Musicians* of 1921, in The Museum of Modern Art (fig. 43). In other respects, *Horn Players* marks Basquiat's engagement with an earlier phase of Cubism. The division of the picture into three tall narrow canvases, and the reduction of the musicians' bodies at left and right into vertical strips, recalls the vertical bands of Picasso's 1912–13 work. Basquiat replaces Picasso's Cubist clarinets with his own trumpets and saxophones, and substitutes his own hand-lettered inscriptions for Picasso's cut-out newspaper headlines.[45] Overall, the picture is a masterful demonstration of how a hallowed modernist style can be updated to express contemporary experience. The one radical divergence from Cubism lies in the mask-like heads, drawn with a kind of cartoon naturalism that sits uneasily with the high formalism of the rest of the picture.

Baquiat's 1981 canvas *Untitled (Skull)* reveals his struggle (successful, in this case) to reconcile cartoon imagery with more elevated artistic models. The overall contour of the "skull" resembles the caricatural head at the center of *Horn Players*, but it has been transformed by extensive reworking. Basquiat seems at first to have worked almost exclusively on the head itself, but at a later stage he used the same colors to lay in large areas of color in the surrounding areas, giving the impression that the blue and pink fields had filled the canvas *before* the imagery was superimposed on them. (Basquiat's overall palette of yellow, blue, and pink recalls de Kooning, as Jeffrey Deitch had noted in 1980.) The head itself is traversed by long lines with short crossbars, like railroad tracks or scars with visible stitches, adding to the horrific quality of the image. The head seems to be falling apart as fast as it can be stitched back together.[46]

This imagery of battered skulls and mutilated bodies becomes a regular feature of much art of the 1980s and 1990s. Cindy Sherman, for instance, produces photographs depicting a nightmare

41. On Basquiat's childhood and early career as SAMO see Hager, *Art after Midnight*, 38–46, and the chronology in Richard Marshall, ed., *Jean-Michel Basquiat* (New York: Whitney Museum of American Art, 1992), 233–38. For Deitch's response to Basquiat's contribution to the *Times Square Show*, see his "Report from Times Square," 61. Phoebe Hoban's biography, *Basquiat: A Quick Killing in Art* (New York: Viking, 1998), unfortunately devotes more attention to Basquiat's sex life and drug habits than to his formation as an artist.

42. Marshall, *Jean-Michel Basquiat*, 238–49.

43. Rene Ricard, "The Radiant Child," *Artforum* 20, no. 4 (December 1981): 41–42. Ricard also discussed the work of John Ahearn, Judy Rifka, Joe Zucker, Ronnie Cutrone, Izhar Patkin, and Keith Haring, whose cartoon of the "radiant child" provided the article's title.

44. Ricard, 40. Reviewing the Whitney's 1992 retrospective, Adam Gopnik dismissed Basquiat's image as a "primitive" artist, stressing instead his debt to the museums and to the galleries of New York; condemning the catalogue authors' analogies between Basquiat's work and bebop, Gopnik noted that "the dropping of a name (à la Charlie Parker) is supposed to magically summon up the spirit of a fully realized art." See Gopnik, "Madison Avenue Primitive," *The New Yorker*, November 9, 1992, 137–39.

45. The layering of text and image was an important feature in the work of many of Basquiat's contemporaries, ranging from Barbara Kruger (represented in the Broad collections by the iconic 1989 work *Your Body is a Battleground*) to Lari Pittman (represented by numerous works, of which *The Veneer of Order*, 1985, comes closest to Basquiat).

46. Similar lines with crossbars are visible in the head at left in Joe Zucker's *Round 14* of 1981 (reproduced in Ricard, "The Radiant Child"), where they seem unequivocally to represent scars on the face of a battered boxer.

fig 43 **Pablo Picasso** *Three Musicians*, 1921, oil on canvas, 79 x 87³⁄₄ inches (200.7 x 222.9 cm), The Museum of Modern Art, New York, Mrs. Simon Guggenheim Fund

Jean-Michel Basquiat *Untitled (Skull)* [detail], 1981

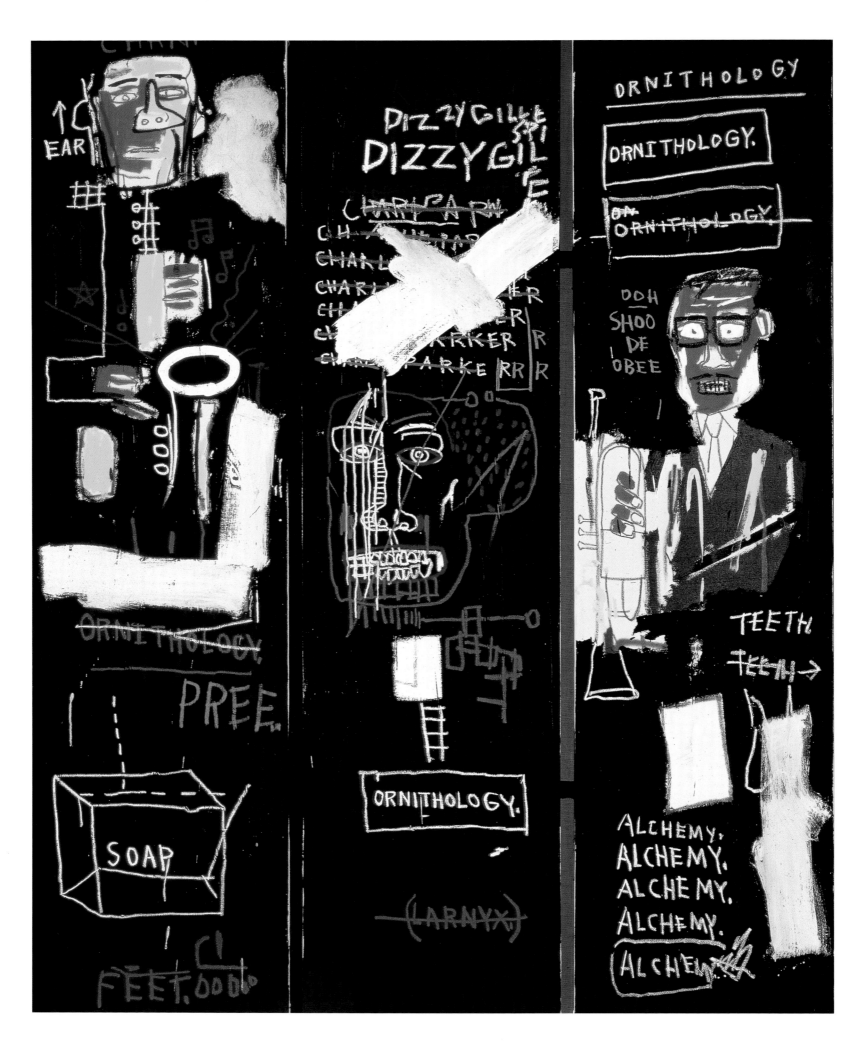

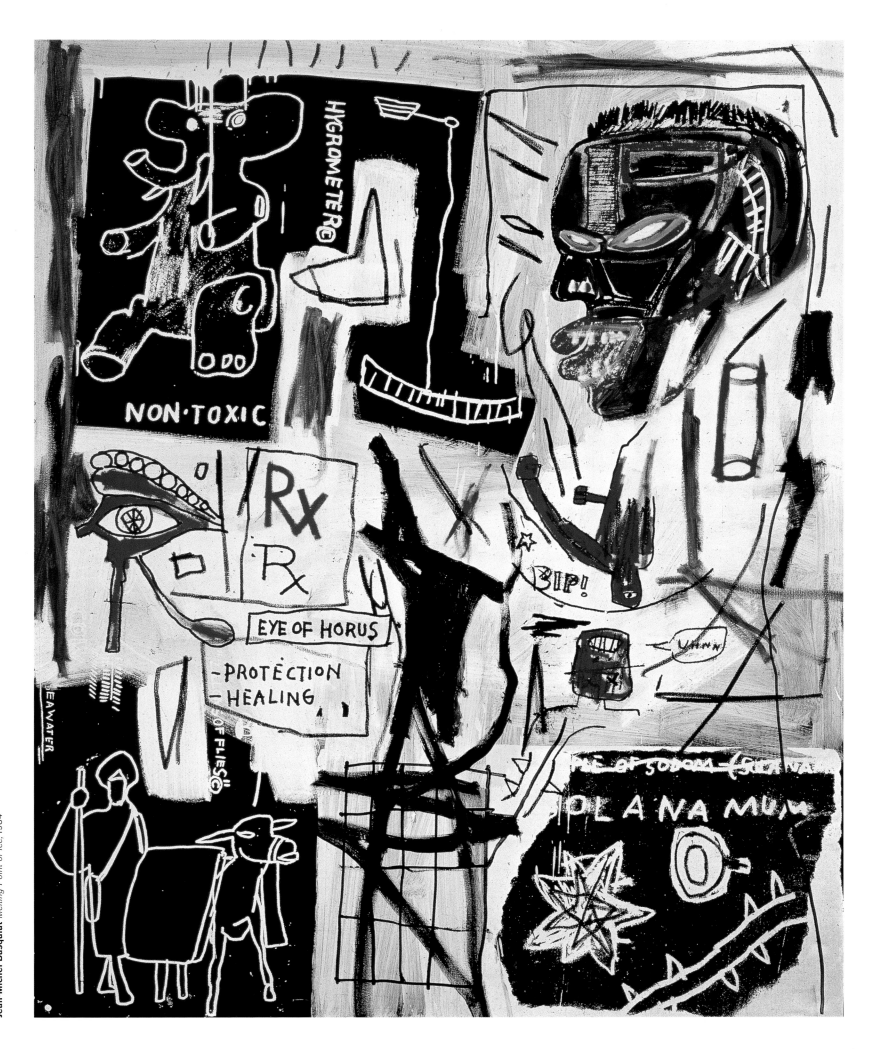

134.

face emerging from a puddle of viscera, a rotten, swollen leg, or a glistening face melting like a bar of chocolate over a fire (p. 148). The immediate sources for such imagery seem to lie in the horror comics of the 1950s, the popular horror films of more recent decades, and the violent "art" films of David Lynch, Quentin Tarantino, and the Coen brothers.[47] In a longer historical perspective, these images belong to a cultural tradition beginning with the Grand Guignol theater of the late nineteenth century and the serial novels (such as *Fantomas*) beloved by the Surrealists, who transferred the shocking scenarios of fictional melodrama into their paintings of the 1920s and 1930s.[48]

At first glance, it is hard to understand how these images could have been made by the same artist who made the understated Untitled Film Stills. One answer is simply that Cindy Sherman likes horror films: She told an interviewer that Wes Craven's *A Nightmare on Elm Street* was one of her all-time favorites, along with *The Texas Chainsaw Massacre*.[49] From a more theoretical perspective, it might be argued that Sherman's "horror" pictures demonstrate the destructive effect of the male gaze, which at its crudest reduces the female body to a series of disconnected body parts. Alternatively, it might be said that the pictures provide a literal staging of "the death of the author." To this extent, they help explain the attraction of Lacan and Barthes's assault on the idea of the self: It attracted so many adherents, not because it was true, but because it was the highbrow equivalent of a Wes Craven movie. The theory infused the play of abstract concepts with emotional drama and a sense of life-and-death urgency.

In this context, it seems virtually a cause for celebration that Sherman has turned, in her latest work, to the depiction of a cast of characters from the world of contemporary reality rather than the world of nightmare fantasy. They are women "of a certain age"—women whose aspirations to glamour have outlived the effortless good looks of adolescence. Sherman seems to regard them with a mixture of irony and affection. They are, after all, the age of her parents, twenty years ago.

◎

47. In *Untitled Film Still #13*, 1978, Sherman is standing in front of a shelf of books on art, film, and photography; the spine of one of them bears the title *Crimes of Horror: The Movies*. The horror comics of the 1950s, rather than the movies, function as a primary source for "zine" artists such as Raymond Pettibon, who achieved art world recognition in the wake of Basquiat and Sherman. Horror and melodrama also provided subject matter for more ambitious canvases, such as Robert Yarber's *Vegas Drop*, 1985, and Leon Golub's *Interrogation I*, 1980–81, both in The Broad Art Foundation.

48. In an even longer historical perspective, it might be argued that the bloody originals of Grimm's fairy tales testify to taste for the horrific deeply imbedded in folk culture.

49. Tomkins, "Her Secret Identities," 82.

Cindy Sherman *Untitled #190*, 1989

Such reconciliation is a recent development, however. The characteristic tone of the 1980s was closer to Grand Guignol than to philosophical bemusement. Robert Longo, Sherman's companion in the late 1970s, made his mark with a series of drawings based on photographs, showing men and women staggering backward or sideways, as if under the impact of a punch or an earthquake (fig. 44). Susan Rothenberg, whose early horse paintings seemed to express a comforting sense of oneness with the natural world, shifted to a new repertory of human figures bent and twisted beyond the limits of endurance. It is not clear whether her *Bone Heads* (fig. 45) are consoled or enraged by the Siamese-twin merger of their spines and torsos; a similar agony afflicts the paired heads in a contemporary sculpture by Rothenberg's husband, the artist Bruce Nauman (fig. 46).

In other pictures of the era, a sense of shock and dislocation is expressed through sexual imagery. Eric Fischl recalled that he chose the subject of his breakthrough painting *Sleepwalker*—a boy masturbating in a wading pool—because "I wanted to shock. I wanted to make something pornographic."[50] What started out as an attention-getting device, however, turned out to be a powerful tool for expressing the psychological tensions of life in the oppressive paradise of the American suburbs. The squatting woman in Fischl's *Haircut* seems at first glance to engaged in a benign moment of self-pampering. After a moment, however, the viewer begins to wonder why the cosmetics mirror is on the bathroom floor in front of her, tilted to reflect a beam of light between her thighs. What exactly is she going to do with the scissors? Maybe we don't want to know. Fischl claims never to have studied life-drawing, and there is a certain, not unattractive clumsiness to the drawing here. But he seems from the outset to have possessed an instinctive talent for composition, and the slanting beams of light, falling from a Venetian blind somewhere overhead, imbue the scene with a syncopated, unsettling rhythm, sounded out by the blunt, repeated strokes of yellow paint.

50. Donald Kuspit, "An Interview with Eric Fischl," 33.

fig 44 **Robert Longo** *Untitled (Men in the Cities: Ellen)*, 1981, charcoal and graphite on paper, 96 x 60 inches (243.8 x 152.4 cm), The Eli and Edythe L. Broad Collection
fig 45 **Susan Rothenberg** *Bone Heads*, 1989–90
fig 46 **Bruce Nauman** *Ten Heads Circle/Up and Down*, 1990, cast wax, diameter: 96 inches (243.8 cm), The Eli and Edythe L. Broad Collection

fig 44

fig 45

fig 46

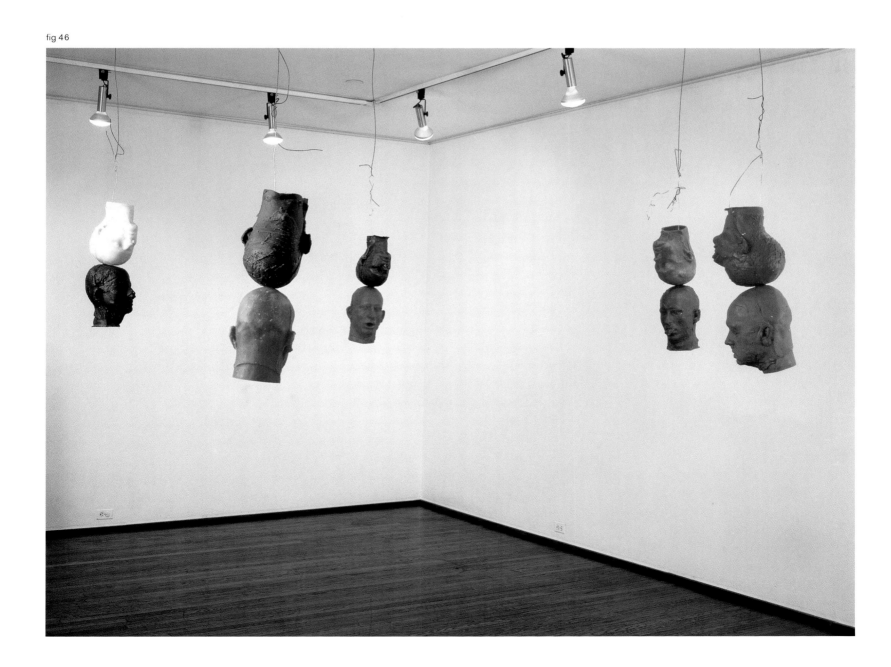

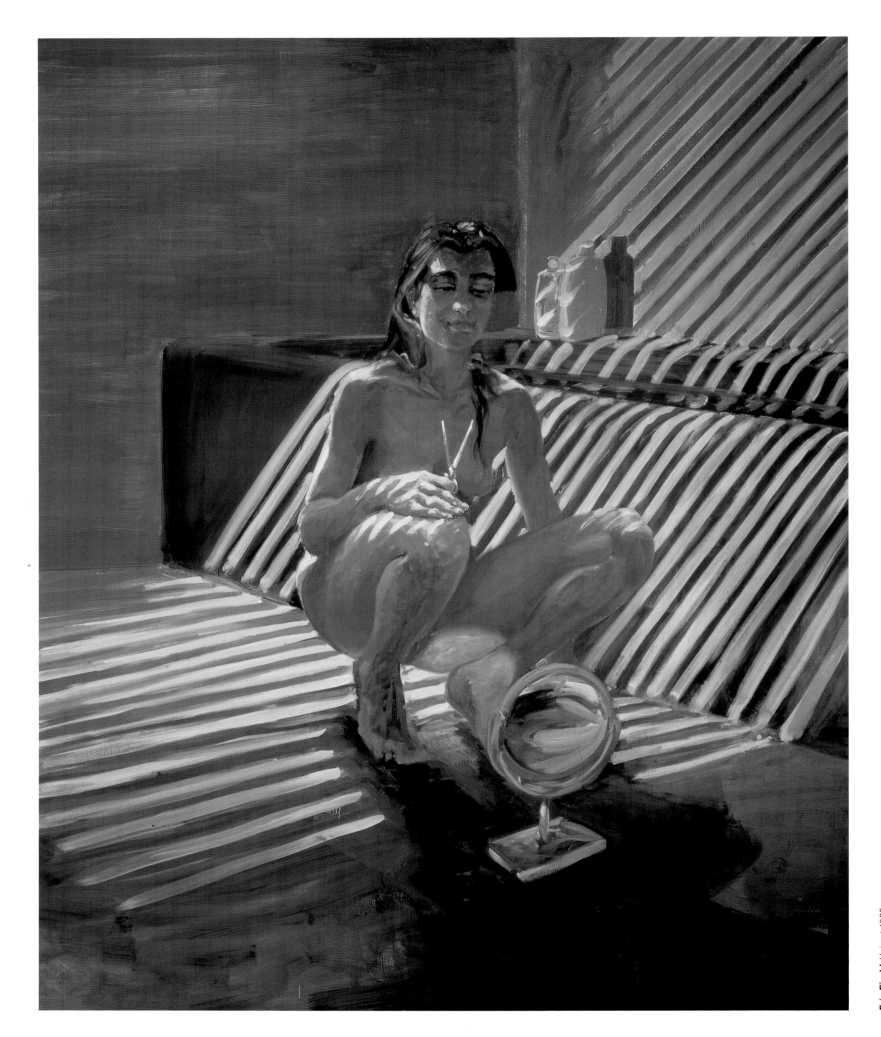

KARMEL

Eric Fischl *Haircut,* 1985
David Salle *Demonic Roland,* 1987

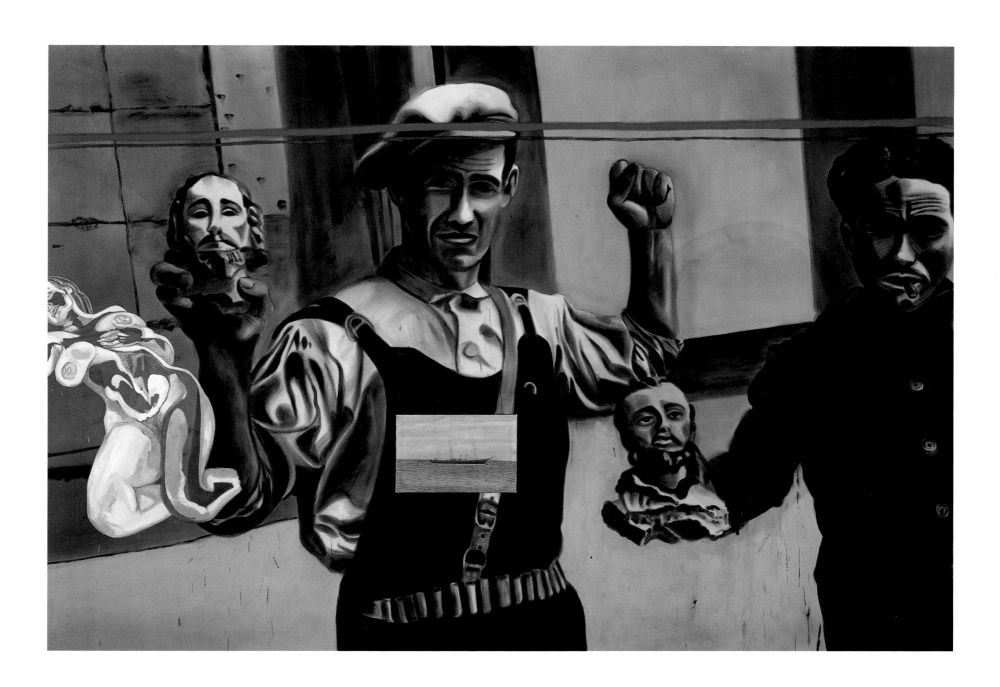

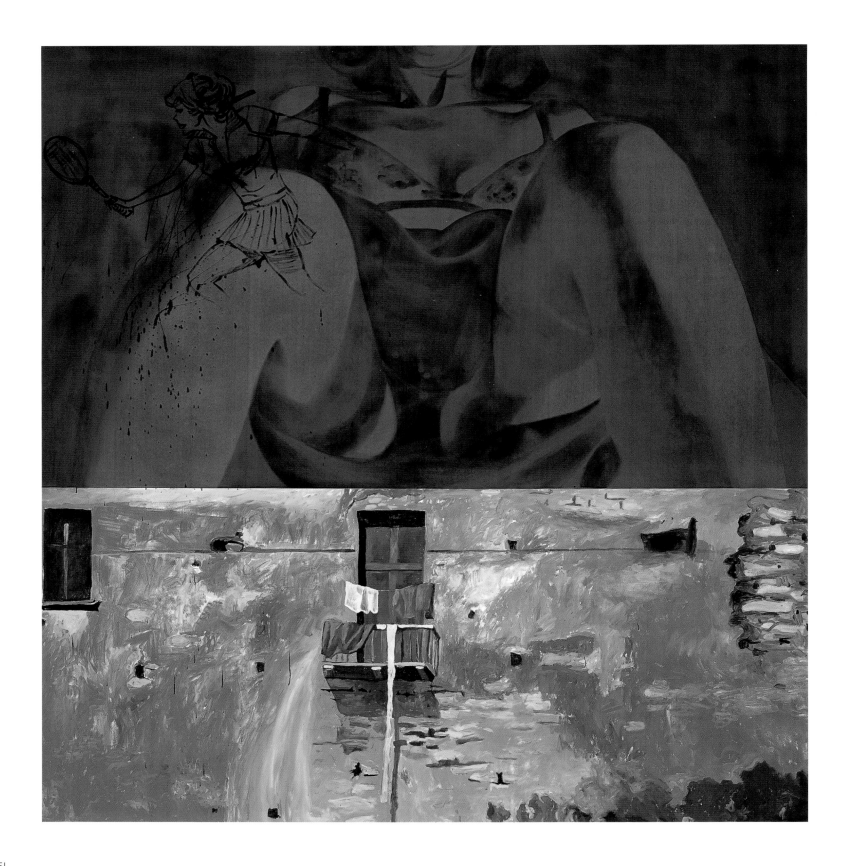

140.

Pepe Karmel is associate professor in the Department of Fine Arts, New York University. Previously, as assistant curator at The Museum of Modern Art, he helped organize the exhibitions Jackson Pollock *and* Picasso: Masterworks from The Museum of Modern Art. *He was also curator of the 1989 exhibition* Robert Morris: The Felt Works *at the Grey Art Gallery and Study Center. He has written broadly on contemporary art for publications such as* Art in America *and the* New York Times*, and is preparing a monograph on Picasso and the invention of Cubism.*

51. Thomas Jones's work had been included in The Museum of Modern Art's 1981 exhibition *Before Photography: Painting and the Invention of Photography*, organized by Peter Galassi, whose seminal catalogue essay has provoked a profound reassessment of the origins of modernism. *A Wall in Naples* was reproduced on the catalogue's cover; the original oil sketch is 6¼ inches wide; Salle's version is 100 inches wide.

An untitled canvas of 1982 (see p.18) confronts the viewer with an even more provocative image. Two women are sharing a bedroom. Are they sisters? Lovers? Bored housewives seeking diversion in an exotic affair? We don't know. One is standing in front of a large plate-glass window, drying herself with a towel. The other is sprawled on the bed, her buttocks and sex, exaggerated by perspective, thrust toward the viewer. The sense of imminent sexual contact (Between the two women? The women and an implied viewer?) is exacerbated by the picture's ominous gray-brown tonality.

These are not the "lineaments of gratified desire" that William Blake claimed as man and woman's inalienable right. In the 1980s and 1990s, arousal and anxiety seemed almost indistinguishable. In her *Untitled Film Still #6* of 1977 (see p.16), Cindy Sherman had posed as a demure pinup girl in mismatched lingerie. Fifteen years later, she returned to the idea of the pinup, only to destroy it. Combining body parts from medical mannequins, she created a nightmare version of a pornographic centerfold, with bulging plastic breasts, legs spread to reveal plastic labia, and a leather mask concealing its last vestiges of humanity (see p.148).

David Salle's 1985 painting *Clean Glasses* expresses a similar ambivalence about the instinctive drive to see and possess. The upper part of the picture consists of a large, tonal painting of a half-naked woman reclining on the floor with her skirt pushed up over her parted knees. A reddish hue permeates the image, anticipating the viewer's arousal. But the play of light and shadow becomes confused between the woman's thighs. It is not clear whether visual penetration is being permitted or denied.

The lower part of Salle's picture reproduces a late eighteenth-century sketch of a wall in Naples, by the English painter Thomas Jones. Despite its tiny dimensions, Jones's oil sketch is an important monument in the history of modern perception—a document of the moment when painters began to try to capture the direct sensation of the visible world, instead of forcing their perceptions into the Procrustean bed of classical models.[51] It marks a critical step on the road toward Impressionism, and thereby toward the wildly dissimilar art of the twentieth century. The juxtaposition of the wall in Naples with the reclining nude, above, forces the viewer to reconsider the relation between visual and sexual experience. Is the craving for visual stimulation merely a displaced version of sexual desire? Or is the sexual imagery of Salle's work an elaborate metaphor for the adult pleasures of painting, forbidden by an older generation of artists and critics? Seeking to seduce or to shock, the image-makers of the 1980s found themselves confronting the most basic questions about art itself. ◎

cindy sherman

144.

148.

i like america and america likes me

Responses from America to Contemporary German Art in the 1980s

Georg Baselitz *Trinker am Tisch* (Drinker at Table), 1983

In 1974 the German artist Joseph Beuys performed an action in New York called *I like America and America likes me*.[1] This title, an ironic comment on German-American relations, not only reflects the artist's own stance toward the United States—a clearly defined position as other, paired with ambition for acclaim in the U.S. art world—but also encapsulates West Germany's complicated, often contradictory affinity for the United States in the aftermath of National Socialism. As the most powerful Allied power present in West Germany, the United States had a major impact, not only in the political sphere. The penetration of American mass and popular culture, including blue jeans, Coca-Cola, and Hollywood movies, TV soap operas, and rock music, led many West German intellectuals to repeatedly deprecate the United States as the embodiment of a capitalist nation without high culture. This criticism, which established a regular pattern during the last five decades, didn't prevent West German intellectuals and politicians from demonstrating a strong desire for a positive perception in the United States.[2] In fact, much of West Germany's postwar identity, in everyday life as well as in politics, economics, and culture, was negotiated on the basis of its Americanization.[3] Forging this new identity also compensated Germany for the repression of its Third Reich history.

Between 1979 and 1984, after two decades of experimental avant-garde art forms such as performance, happenings, photography, video, text-based conceptual practices, and a general reduction of artistic individuality, the art worlds of Europe and the United States were overrun once again by large-scale, mostly figurative and historicist paintings. Strong colors, loose handling of paint, and a reinvestment in artistic subjectivism characterized many of these images.[4] These auratic artworks exemplify what the scholar Andreas Huyssen has called postmodernism's obsession with the past.[5] Most visible among them were German paintings and sculptures that dated back to the 1960s and examined German national narratives, monuments, and symbols. The U.S. art world's embrace of this new German art, which is often superficially labeled Neo-Expressionism,[6] sparked fervent debates that challenged Germany's dependence on a positive U.S. perception and its Americanized image. The discussion centered on Georg Baselitz, Anselm Kiefer, Markus Lüpertz, Jörg Immendorff, and A. R. Penck, as well as the following generation including Rainer Fetting, Salomé, Georg Jiri Dokoupil, Elvira Bach, and Albert Oehlen. In the course of the 1980s, however, the focus of interest in the United States shifted more and more to one single artist: Kiefer. Many of the participants in these U.S.–based debates were German art critics and scholars. This discourse, which included broader conflicts over modernist versus conservative cultural agendas, amounted to one of the last German-American dialogues on German culture before the collapse of communism and the new political sovereignty of the united Germany.[7]

In light of nonrepresentational, experimental practices that championed antiauratic, heterogeneous aesthetic perceptions and featured fragmentation and displacement as essential experiences of modernity and postmodernity, representational paintings and sculptures are often perceived as reinstating traditional aesthetic qualities such as artistic subjectivity, authenticity, and sublime experiences. These qualities signify an orientation to the past that is all the more obvious if the works treat

fig 47

historical subject matter. Thus, from a modernist point of view, with faith in historical progression, the return to traditional aesthetic modes connoted foremost a conservative artistic agenda. German Neo-Expressionism's monumentality and examination of German historical memory also abetted an understanding of this art as backward.[8]

The magazines *Art in America* and *Artforum* served as public forums for discussions of the predominantly European exhibitions that featured the new German art.[9] In the 1980 Venice Biennale, the director of Frankfurt's Städel Museum, Klaus Gallwitz, presented Georg Baselitz's *Model for a Sculpture*, 1980 (fig. 47), often regarded as a rendering of the Hitler salute, and Anselm Kiefer's *Deutschlands Geisteshelden* (Germany's Spiritual Heroes), 1973, (p. 174), which appropriated Albert Speer's Nazi architecture. The Biennale became a flash point for protest in Germany and initiated to a large extent the American debates. In the ensuing years, a series of mammoth international exhibitions increasingly stressed both the superiority and the specific Germanness of recent German art, fueling the discourse.[10]

During the 1970s a number of avant-garde German artists had won serious recognition in the United States: Joseph Beuys, the most prominent member of Fluxus; students of Beuys, such as Imi Knoebel and Blinky Palermo, who were invested in constructivist practices; and the Düsseldorf photo conceptualists Bernd and Hilla Becher, who executed serial photographs of industrial sites (see pp. 154–56). Yet these artists' work had always been part of an international discourse. In the 1980s, however, when the United States—for the first time after 1945—devoted substantial attention to contemporary German art, it was the particularly German iconography and style articulated in such works as Markus Lüpertz's *Ganymede*, 1985 (fig. 48), that triggered the interest.

At first sight, *Ganymede* recalls Expressionist polychrome wood sculptures, even though Lüpertz cast the work in bronze. Yet its monumental scale—it is more than ninety inches tall—marks

1. Joseph Beuys, performance at René Block Gallery, New York, 23–25 May 1974. The performance began at New York's Kennedy Airport, where Beuys was wrapped in felt and transported to the Manhattan gallery in an ambulance. There he spent several days in one room with copies of the *Wall Street Journal*, a felt blanket, a flashlight, a cane, and a live coyote—possibly an allusion to the spiritual meaning of coyotes for Native Americans. With this action Beuys introduced his art to America, demonstrating more than anything his otherness.

For an excellent account of German-American artistic relations after World War II see Stefan Germer, "Intersecting Visions, Shifting Perspectives: An Overview of German-American Relations," in The Froelich Foundation, *German-American Art from Beuys to Warhol*, exh. cat. (London: Tate Gallery Publishing, 1996), 9–44.

2. See Michael Ermarth, "German Unification as Self-Inflicted Americanization," in Reinhold Wagnleitner and Elaine Tyler May, eds., *"Here, There, and Everywhere": The Foreign Politics of American Popular Culture* (Hanover and London: University Press of New England, 2000), 251–69.

3. On the complex issue of Americanization see Rob Kroes, "Americanisation: What Are We Talking About?" in Kroes et al., eds., *Cultural Transmissions and Receptions: American Mass Culture in Europe* (Amsterdam: VU University Press, 1993), 302–18; Anselm Doering-Manteuffel, "Dimensionen von Amerikanisierung der deutschen Gesellschaft," in *Archiv für Sozialgeschichte* 35 (1995): 1–34;

and Alf Lüdtke et al., eds., *Amerikanisierung: Traum und Alptraum im Deutschland des 20. Jahrhunderts* (Stuttgart: Steiner, 1996).

4. International members of this movement, in addition to the German artists discussed in this essay, include Franceso Clemente, Sandro Chia, Enzo Cucchi, Eric Fischl, Julian Schnabel, and David Salle.

5. Andreas Huyssen, "Monuments and Holocaust Memory in a Media Age," in *Twilight Memories: Marking Time in a Culture of Amnesia* (New York and London: Routledge, 1995), 249–60.

fig 48

153.

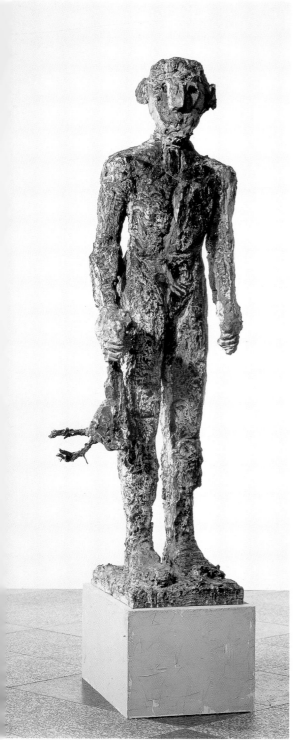

a fundamental difference from earlier Expressionist representations. Lüpertz manipulated the theme, drawn from the Greek myth in which Zeus abducts the beautiful mortal Ganymede to be his butler, and its traditional iconography (fig. 49) to suggest negotiations of postwar German identity. His Ganymede appears as a distorted yet victorious monster, alluding to Germany itself, who holds in his hand a defeated Zeus in his metamorphosis as an eagle. Lüpertz's conquered eagle—the German national symbol—clearly signifies German nationalism and questions its viability. Even though the authority of the classical narrative might partially undermine Lüpertz's fictitious appropriation, the artist clearly articulates an antinationalist position with this sculpture.

Yet this sculpture and other works that elaborate German national narratives served as signifiers of diverse and contradictory constructs of contemporary German identity. Thus, readings of single artworks can seldom illuminate the effects of Germany's unresolved past on the arts. Consider, for example, Jörg Immendorff's spectacle *Nachtmantel*, 1987, (p.158) measuring $112^{3}/16$ x $157^{1}/2$ inches, which suggests a historical and cultural unity between East and West Germany despite the reality of a divided country.[11] Compared to West Germany's official understated, modest, and often Americanized appearance in visual art, architecture, and popular culture (as evident in the Bonn government building *Langen Eugen* [fig. 50]), Immendorff's image could easily be read as a propagation of a new self-confident Germany that had "normalized" its convoluted past. Thus, artworks of the Neo-Expressionists embody highly explosive material that could potentially go off in opposite directions. At best, these monumental figurative images loaded with German historical references could be read as efforts to provoke a

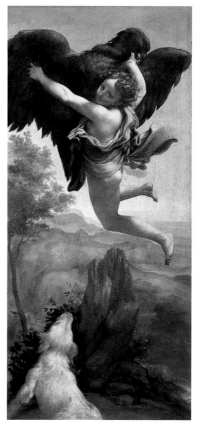

fig 49

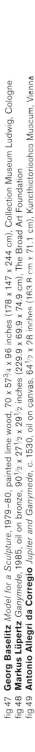
fig 47 **Georg Baselitz** *Model for a Sculpture*, 1979–80, painted lime wood, 70 x 57³/₄ x 96 inches (178 x 147 x 244 cm), Collection Museum Ludwig, Cologne
fig 48 **Markus Lüpertz** *Ganymede*, 1985, oil on bronze, 90¹/₂ x 27¹/₂ x 29¹/₂ inches (229.9 x 69.9 x 74.9 cm), The Broad Art Foundation
fig 49 **Antonio Allegri da Correggio** *Jupiter and Ganymede*, c. 1530, oil on canvas, 64¹/₂ x 28 inches (163.8 cm x 71.1 cm), Kunsthictorioohoo Muacum, Vienna

6. The term *Neo-Expressionism* is artificial; the artists did not actually continue the agenda—utopian beliefs, spiritual endeavors, and outright social protest—of German Expressionist artists such as Conrad Felixmüller, Ernst Ludwig Kirchner, Otto Mueller, Erich Heckel, Wassily Kandinsky, and Käthe Kollwitz. It is true, however, that the highly emotional qualities of the Expressionist painting style, such as distorted lines, rapid brushwork, and bold colors, find echoes in these later artists' work.

7. After the surrender in 1945, Germany did not regain its political sovereignty until 1990. On September 12 the Two-Plus-Four treaty was signed in Moscow, establishing that the united Germany would comprise the territories of the G.D.R., F.R.G., and Berlin. The rights and responsibilities of the four victorious powers would end on ratification of the treaty, and Germany would assume full sovereignty over internal and external affairs.

8. Benjamin Buchloh, "Figures of Authority, Ciphers of Regression: Notes on the Return of Representation in European Painting," *October*, no. 16 (spring 1981): 39–68. Reprinted in Brian Wallis, ed., *Art after Modernism: Rethinking Representation* (New York and Boston: The New Museum of Contemporary Art, New York, and David R. Godine, Publisher, Inc., 1984), 106–35. In 1984, Buchloh added a postscript to the reprint, in which he questioned the art-historical framework he had used to link the return to traditional aesthetics in the 1920s and the 1980s to conservative politics. For a criticism of aggressive marketing

strategies, see also Otto Karl Werckmeister, "Der größte deutsche Künstler und der Krieg am Golf," *Kunstforum International* 123 (1993); 209–19.

9. The first major American survey featuring the new German painting was mounted in 1983 by the Saint Louis Art Museum. *Expressions: New Art from Germany* featured Georg Baselitz, Jörg Immendorff, Anselm Kiefer, Markus Lüpertz, and A. R. Penck and was curated by Jack Cowart. The show traveled widely in the United States.

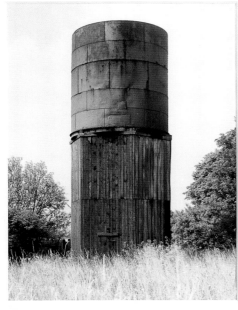
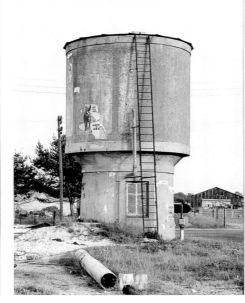
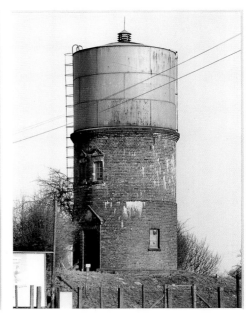
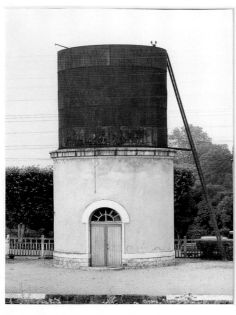
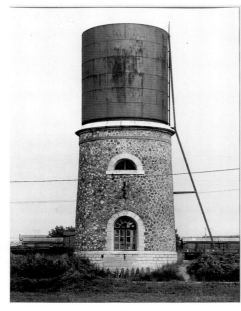

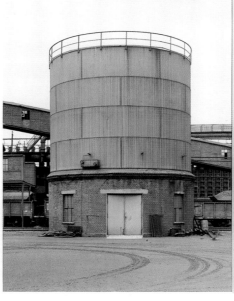
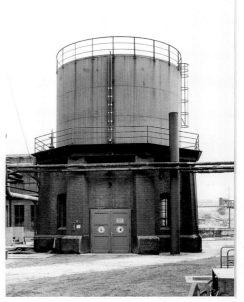

154.

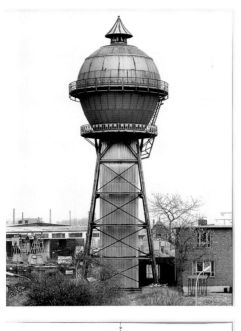
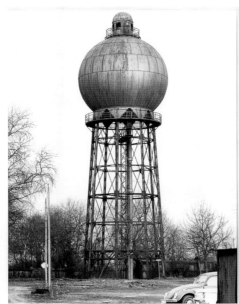
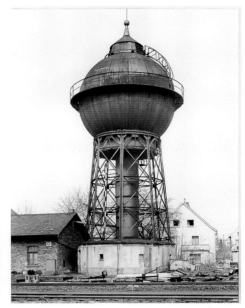

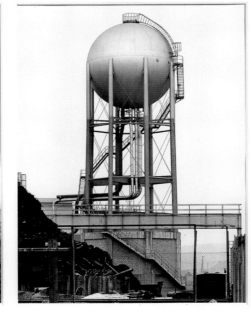
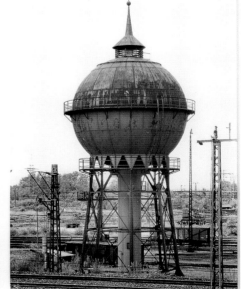

Bernd and Hilla Becher *Typology of Water Towers, 1972*
Bernd and Hilla Becher *Typology of Water Towers, 1972*

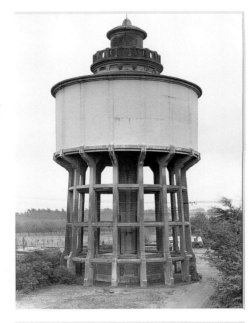 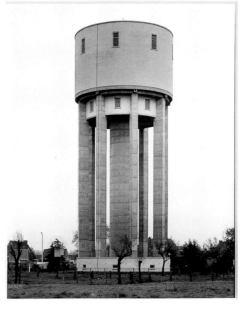 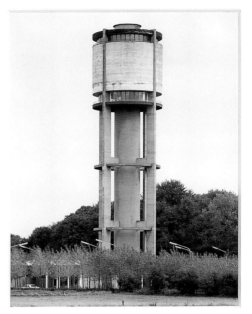

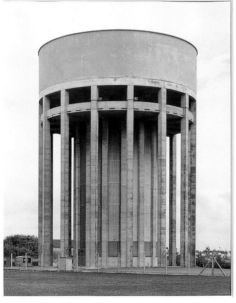 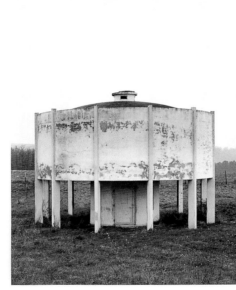 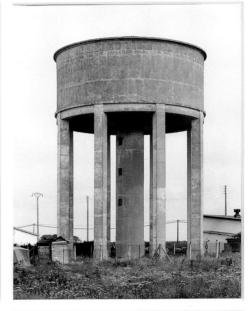

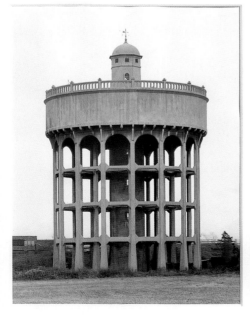 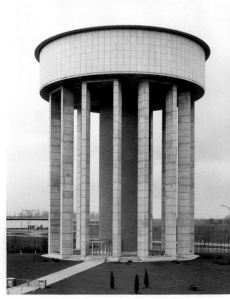 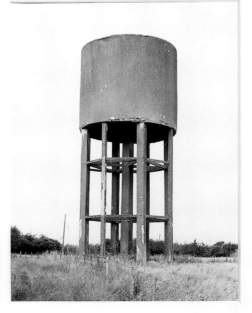

156.

fig 50

long-overdue confrontation with the taboo of Germany's Nazi past. Conversely, they could be seen as an aspect of an aggressively resurgent German nationalism appropriating the images and national narratives that had served to form a collective German identity during the Third Reich. Hence, the issues at stake reach beyond the significance of representational painting and sculpture in the 1980s; they are linked to a reappearance of a German identity that evoked for many Americans the return of the German aggressor and for Germans the painful memory of the self-inflicted trauma of the Nazi past, the Holocaust, and its afterimages.

The Return to Painting: *Zeitgeist* or *Tendenzwende*?[12]

In the spring of 1981, one year before the collapse of the social-liberal coalition in West Germany and the election of the conservative-liberal government under the leadership of Helmut Kohl, the critic and scholar Benjamin Buchloh claimed that the return "to unified pictorial presentations" as emphasized in contemporary German figurative painting and sculpture echoed "the ideological impact of growing authoritarianism."[13] Buchloh credited increased demand for art as a luxury commodity, together with the works' traditional form, for their success on the market. By confirming traditional political and cultural systems of hierarchy, including the notion of an elitist cultural sphere, Buchloh warned, the artworks of the Neo-Expressionists would provide viewers a sublime experience of past cultural values, silencing the historical consciousness of modernism. Thus he decried the avoidance of social discourse and the absence of an avant-garde utopia—and their replacement by historicist and universal narratives—in contemporary art.[14] The far-reaching impact of Buchloh's criticism was reflected in a variety of reviews on contemporary German art in the early 1980s. In her review of the 1981 London exhibition *A New Spirit in Painting*, Roberta Smith stressed the reactionary potential of representational paintings and also harshly criticized the absence of women artists in the exhibition.[15] In the same year, Nancy Marmer reproached the "new Expressionists" for refusing to engage in a critique of society and underscored the commodity character of the artworks: "Urging the idea of painting as 'salvation,' these artists have transformed a politically and esthetically reactionary stance into

10. Almost one-third of London's 1981 Royal Academy exhibition *A New Spirit in Painting,* curated by Christos Joachimides, Norman Rosenthal, and Nicholas Serota, was devoted to German art; Joachimides and Rosenthal's 1983 Berlin *Zeitgeist* exhibition centering around Joseph Beuys featured twenty German artists out of forty-five participants. The 1982 *documenta 7*, curated by Rudi Fuchs and Johannes Gachnang, was perceived "as a triumph of German nationalism." Donald Kuspit, "Acts of Aggression: German Painting Today," *Art in America,* Part I (September 1982) and Part II

(January 1983); reprinted in Kuspit, *The New Subjectivism—Art in the 1980s* (Ann Arbor: UMI Research Press), 5. In response, Kaspar König attempted to correct this one-sided nationalistic perception with his 1984 Düsseldorf *Von hier aus* exhibition. See David Galloway. "Report from Germany," *Art in America* (March 1985): 25. Three years earlier König's *Heute* (Today) section of his Cologne *Westkunst* exhibition had been a target of hostile reviews exposing nationalistic interpretations of contemporary German art.

11. For this identity construct and its connection to the Nazi past, see Brian Ladd, *The Ghosts of Berlin: Confronting German History in the Urban Landscape* (Chicago and London: The University of Chicago Press, 1997), 29–31.

12. *Zeitgeist* may be translated in English as "hitting the nerve of the time"; *Tendenzwende* means "ideological shift" with regard to the political or cultural sphere.

13. Buchloh, "Figures of Authority," in Wallis, *Art after Modernism,* 119 and 108.

14. For other *October* contributions on this issue see Douglas Crimp, "The End of Painting," *October,* no. 16 (spring 1981): 69–86. See also Thomas Lawson, "Last Exit: Painting," *Artforum* (October 1981): 40–47; and Tricia Collins and Richard Milazzo, ed., *Art at the End of the Social,* exh. cat. (Malmö, Sweden: Rooseum, 1988).

15. "The nasty message implicit in the complete absence of women painters from this show, a message which also seemed to be reflected in many of the overblown canvases, is that painting is once again a 'man's work.'" Roberta Smith, "Fresh Paint?," *Art in America* (summer 1981): 75.

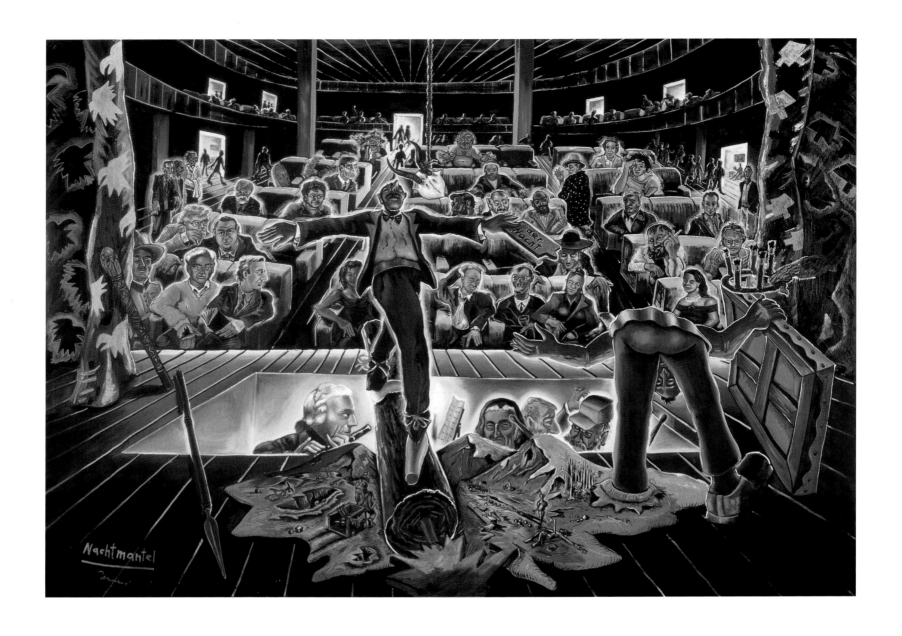

fig 51 **Key to Jörg Immendorff's *Nachtmantel***

1. Jörg Immendorff 2. Frederick the Great (1717–1786), king of Prussia, 1740–80 3. Die Hofdame (Lady of the Royal Court) 4. Markus Lüpertz, artist 5. A. R. Penck, artist 6. Immendorff's grandfather 7. Wolfgang Hahn, collector 8. Michael Werner, dealer 9. Sabine Knust, publisher 10. Rudolf Springer, dealer 11. Johannes Gachnung, publisher 12. Helen van der Meij, dealer 13. Mary Boone, dealer 14. Eric Fischl, artist 15. Harald Szeemann, curator 16. NormanRosenthal, exhibitions secretary, Royal Academy of Arts, London 17. Siegfried Gohr, former director, Ludwig Museum, Cologne 18. Rudi Fuchs, director, Stedelijk Museum, Amsterdam 19. Wouter Koutte, director, Museum van Hedengasse Kunst, Utrecht 20. Ileana Sonnabend, dealer 21. Christos Joachimides, curator 22. Lüpertz 23. Georg Baselitz, artist 24. Joseph Beuys (1921–1986), artist 25. Per Kirkeby, artist 26. David Salle, artist 27. Kasper König, director, Museum Ludwig, Cologne 28. Brigitte Klotz 29. Alfred Schmela, dealer 30. Benjamin Katz, photographer 31. Don van Vliet (a.k.a. Captain Beefheart), musician 32. Penck 33. Julian Schnabel, artist

what seems to be an eminently salable export product."[16] This association of the return to figurative painting with regression was not limited to critics. A similar warning was reflected in Hans Haacke's installation *Oelgemaelde: Hommage à Marcel Broodthaers* (Oil Painting: Homage to Marcel Brood-thaers) at the 1982 *documenta 7*, curated by Rudi Fuchs and Johannes Gachnang. In this installation, the German artist Haacke, who lives in New York and is known for his timely, pointed, political works, placed two images face-to-face across a red carpet: a realistically painted portrait of Ronald Reagan and a blown-up photograph of a 1982 German peace demonstration against Reagan.[17] The method by which the Reagan portrait is displayed works to criticize the notion of art on a pedestal as boosted at that year's *documenta*: The painting has a golden frame and a brass label and is lit from above; stanchions in front of it keep viewers at an appropriate distance.

In addition to *documenta 7*, which advanced figurative painting along with a nationalistic presentation of German art,[18] Christos Joachimides and Norman Rosenthal's 1983 exhibition *Zeitgeist* in Berlin promoted the return to representation as the trend of the time. Yet it wasn't only the 1980s phenomenon of the international mammoth exhibition, the mass-culture event, that encouraged monumental and figurative works of art. The American art critic Donald Kuspit, educated in Germany, perceived the new German painting as radically avant-garde. He described this art's critical and historical acuity as a constructive tension between past and present, ultimately leading Germany to freedom from its past.[19] He based this argument on a conviction that Buchloh's "modernist paradigm might have collapsed of its own weight" and that abstract painting and other experimental and modernist forms had lost their criticality.[20] In contrast to Buchloh, Kuspit dehistoricized the avant-garde into a broad concept determined by a subjective evaluation of the art's "newness" and its acuity. Moreover, instead of ascribing subversive political qualities to the art, Kuspit saw its relevance in effecting immediate changes within the political and social sphere, as this art would bring about a reconciliation between Germans and their Nazi past.

Other defending voices on the American scene included German intellectuals who positioned themselves within the political left. Wolfgang Max Faust and Bazon Brock, both German academics,

16. Nancy Marmer, "Isms on the Rhine," *Art in America* (November 1981): 123.

17. By contrasting the painted authoritative Reagan portrait with a photograph of German peace activists, Haacke's criticism also encompasses Reagan's conservative political agenda. (The version of the work in this exhibition shows a photograph of a protest in New York; this photograph is used whenever the installation is shown in the United States.)

18. See Annelie Pohlen, "The Dignity of the Thorn," *Artforum* (September 1982): 59–61.

19. "The historical German symbols within the new German painting show . . . double character, making them especially trenchant. They are at once abstract spectres and natural realities; on the one hand they are fatalistically accepted as irrevocable absolutes and on the other overcome by being artistically appropriated and experienced. . . . Yielding their paralyzing, hypnotic abstractness in their passage from the collective unconscious through the artist's personal consciousness, these

symbols can finally be laid to rest. . . . They suggest that art still has a redemptive power of transformation over history." Kuspit, "Flak from the 'Radicals': The American Case against Current German Painting," in Jack Cowart, ed., *Expressions: New Art from Germany*, exh. cat. (Munich and St. Louis: Prestel and Saint Louis Art Museum, 1983), 45–46.

20. Ibid., 43.

Hans Haacke *Oelgemaelde, Hommage à Marcel Broodthaers* (Oil Painting: Homage to Marcel Broodthaers), 1982 (in the installation, the two works on these pages face each other across a room)

identified the representational paintings and sculptures as avant-garde based on their freshness, originality, incomprehensibility, and expected radical contribution to confronting the German past.[21] Faust stressed the works' social and political engagement: "New German art reflects . . . an attitude toward society (with it and against it) that might be called 'productively anarchic.'"[22] Brock couched his evaluation in a critique of Germany's political culture. Typically, he claimed, Germans tend not to accept aesthetic constructs and abstract structures as mere appearances but insist on applying them literally. This fixed German particularity, he went on to say, played a major role in Nazi ideology; and "the radical hatred of the Jews in Germany arose principally from the permanent opposition of Jewish theology to any literal execution of a myth, a revelation, or a system of thought." Brock implied that artists such as Kiefer were displaying this "Jewish" trait.[23] He thereby intended to position the new avant-garde in the strongest place of opposition possible. Although he meant well, this argument is unsettling foremost because of its underlying racism: Brock assumes ahistorical and fixed typical Jewish and German qualities, which he uses to frame the Jew as other, and additionally identifies Germans with Jews, conflating perpetrator and victim—a long-standing feature of Germany's Holocaust negotiations.[24]

The arguments over the progressiveness or backwardness of contemporary German art's pictorial figuration reveal conflicting agendas: Haacke and Buchloh, arguing from a position that values art as a means to criticize capitalist structures, attacked the Neo-Expressionists for legitimizing power hierarchies. They exposed the return to representational aesthetic modes as reactionary strategies with parallels in the conservative politics of the Reagan and Kohl governments. Feminist criticism focused on the conservatism of these grand artistic gestures for the same reasons, but also because these images—almost exclusively executed by male artists—revived a male-dominated art world. By contrast, Kuspit, fascinated by the notion of artistic subjectivity, saw modernism as an empty and useless concept, ascribing avant-garde qualities of social and political relevance instead to the new German historicist art. Similarly, Faust and Brock proclaimed figurative and expressively rendered images radical, at the same time conveying their own commitment to this art. The debate, encompassing a variety of voices on the left political spectrum, also discloses the postmodernist crisis of

21. Bazon Brock, "The End of the Avant-Garde? And So the End of Tradition. Notes on the Present 'Kulturkampf' in West Germany," *Artforum* (summer 1981): 62–67. Wolfgang Max Faust, "'Du hast keine Chance. Nutze sie!'" With It and against It: Tendencies in Recent German Art," *Artforum* (September 1981): 33–39.

22. Faust, 36.

23. Brock, 67 and 63.

24. See, for example, Frank Stern, *Whitewashing the Yellow Badge: Antisemitism and Philosemitism in Postwar Germany* (Oxford and New York: University of Oxford Press, 1992).

fig 52 **Georg Baselitz** *Untitled (Held)*, 1966

fig 52

164.

representation. Aesthetic practices reflecting specific social and political circumstances and beliefs were seen as presenting evidence of diverse concepts such as artistic subjectivity, the hegemony of German art, German art's role in redeeming the German past, and historicist art as a sign of authoritarianism. The variety of uses to which the same images were put demonstrates the indeterminate relations between visual vocabulary and meaning.

What Is German? Tackling Issues of German Nationalism

In 1965, the Jewish philosopher Theodor W. Adorno warned German audiences not to identify with monolithic characteristics of Germanness.[25] He asserted that "it is uncertain whether there even is such a thing as the German person or a specifically German quality."[26] Adorno had taken this lesson from his own experiences with the National Socialist ideology of collective identity: He had been forced to flee National Socialist Germany in the 1930s and had returned to West Germany from Southern California in the late 1940s. Along with the younger generation of leftist intellectuals, among them Günther Grass and Wim Wenders, whose parents' lives had been formed by the Third Reich, Adorno is known for dismissing the concept of a German national identity. Within the visual arts, similar tendencies revealing deep-rooted skepticism about Germanness are evident in the *Helden* (hero) images Baselitz developed in the 1960s, such as his *Untitled* (Held), 1966 (fig. 52). Nevertheless, in the early 1980s, about the same time the American miniseries *Holocaust* and the German Bundestag's abolition of limitations on prosecution of Nazi crimes prompted a new wave of coming to terms with the past in Germany, the unique Germanness of recent German art was one of the foremost topics occupying the art world.

The monumentalizing presentation of a disparate array of often German histories and narratives in the new paintings, along with the aggressive strategies of the German and American art market, provoked a discourse that focused the matter of power and hegemony in the art world along nationalist(ic) lines: Would German and European art for the first time since World War II supersede American art? A 1982 editorial in *Art in America* assured its readers that "it is clearly absurd to jump

25. Adorno's lecture was broadcast on 9 May 1965 as part of a series organized by the Hessischer Rundfunk that focused on the question "What is German?" The lecture was published as "On the Question: 'What is German?'" trans. Thomas Y. Levin, *New German Critique*, no. 36 (fall 1985): 121–33. Also see Levin's introduction, "Nationalities of Language: Adorno's Fremdwörter. An Introduction to "On the Question: What is German?," 111–21.

26. Adorno, 121.

166.

Anselm Kiefer *Laßt 1000 Blumen Blühen* (Let 1000 Flowers Bloom), 1998

to the conclusion . . . that New York (and by extension U.S. art) is done for."[27] In a similar vein, Roberta Smith complained about the dominance of German artists in *A New Spirit in Painting*: "The exhibition's main goal seemed to have been to increase the visibility and appreciation of the northern expressionist tradition in current painting, and to unseat American painting's hegemony."[28] She bluntly stated her distaste for much of German figurative painting and her affinity for American art.[29] More concerned about burgeoning German nationalism was Nancy Marmer, who described the "quest for German roots" as "pro-nationalist sentiments."[30] On the other side of the debate stood critics such as Faust and Siegfried Gohr, who denied that the new German art had a national subtext and attempted to place it in an international avant-garde context—while at the same time, curiously, emphasizing its specific German qualities. In 1982, Gohr, then director of the Kunsthalle in Cologne, analyzed Georg Baselitz's early hero paintings, such as *Der Jäger (Vier Streifen)* (The Hunter [Four Stripes]), 1966, to establish a pedigree for him as a specifically German artist.[31] Simultaneously he linked Baselitz's work to Russia's early twentieth-century avant-garde movement Suprematism, thereby legitimating the specifically German artist within a progressive tradition. Others, such as Faust, first revealed contradictory, yet at last ambivalent positions in their effort to heighten the importance of German art. He criticized the 1983 *Zeitgeist* show for the dominance of German art, anxious to correct the impression that the art itself had nationalistic traits.[32] He had, however, earlier asserted German art's leadership in the international art world, claiming that "recent German art has a significance that extends beyond German borders."[33] And although he pointed to the impact of postmodern philosophers such as Gilles Deleuze, Félix Guattari, and Jean-François Lyotard, he also linked the artists to German predecessors, such as Ernst Ludwig Kirchner, Erich Heckel, and Karl Schmidt-Rottluff, and rooted much of their efforts in their search for identity as German artists in the 1980s. Both critics tied international authorities on cultural production to German art to ensure its viability, while emphasizing German national aspects.

Among American critics, the prolific Kuspit has emerged as the most aggressive defender of the New German painting committed to restoring a static German identity. Recent theories have

27. "Editorial: 'The Return' of European Art," *Art in America* (September 1982): 5.

28. Smith, 75.

29. "The work of Lüpertz, Koberling, Hödicke and Hacker in particular brought me to the same conclusion as did the Guggenheim's recent, dully historical Expressionist survey: that most of the paintings would be a lot better if they had just been worked on for a few more days—even a few more hours." and "As a group, the Americans looked the best to me." Smith, 75 and 79.

30. Marmer, 122.

31. Siegfried Gohr, "In the Absence of Heroes: The Early Work of Georg Baselitz," *Artforum* (summer 1982): 67–69.

32. Wolfgang Max Faust, "The Appearance of Zeitgeist," *Artforum* (January 1983): 89. "To see this as a new German nationalism, or as a striving toward hegemony in art, seems mistaken, for it is possible to recognize in it a general tendency to turn away from the program of internationalism. This tendency results in a regional interest in the past which reaches back

to tradition in order to criticize it in a contemporary way." See also Joan Simon, "Report from Berlin. 'Zeitgeist': The Times and the Place," *Art in America* (March 1983): 34.

33. Faust, "'Du hast keine Chance. Nutze sie!'," 36. In this article Faust focused on the younger generation artists such as Albert Oehlen, Salomé, and Rainer Fetting.

Georg Baselitz *Der Jäger (Vier Streifen)* (The Hunter [Four Stripes]), 1966

presented the formation of cultural and national identity as a complicated process that relies simultaneously on personal and collective memories, changing constructs of reality and history, and heterogeneous social and political concepts.[34] Ignoring these subtleties, Kuspit identified the new German art with stereotypes used to characterize Germanness since well before the war, centering on irrational concepts: "German originality in the visual arts will once and for all be demonstrated—an originality based on a revived elitist sense of the German spirit, the special German relationship to 'Geist.'"[35] Moreover, he described aggressiveness as a typical German quality and attributed a romantic German restlessness to the works of Lüpertz and Baselitz, drawing on cultural stereotypes that were ideologically abused during the Third Reich. In regard to the effect of this new German art, Kuspit trusted that it created a new, collective German identity finally freed from the Nazi past. "The new German painters perform an extraordinary service for the German people. They lay to rest the ghosts . . . so that the people can be authentically new. They are collectively given the mythical opportunity to create a fresh identity."[36] Thus, according to Kuspit, by appropriating German history as well as historical, political, and cultural constructs of meaning, artists could liberate these semantic systems from their past significance.

To apply this interpretation to an actual work of art, Kiefer's 1982 painting *Nürnberg* would, for example, redeem the city of Nuremberg from the burden of its Nazi past. *Nürnberg* belongs to series executed in the early 1980s, in which Kiefer negotiates images of historical memory. Several paintings in this series cite landscapes and figural scenes from Paul Celan's "Death Fugue";[37] others refer to motifs of Richard Wagner's operas, such as *Die Meistersinger von Nürnberg*.[38] While Celan's characters mediate the Nazi past, specifically the Holocaust, through the victims' eyes, Wagner's motifs communicating German nationalism, its manipulation by the Nazis, and anti-Semitism reflect the perpetrators' convictions.

Like most of Kiefer's works in this series, *Nürnberg* includes straw and burned wood glued on the canvas support, leading to immediate allusions of destruction, in particular the annihilation of the European Jewry by the Germans. He also refers to the Nazi aesthetics of vast and empty natural

34. For the most recent discourse on identity in the German context see, for example, Jeffrey Herf, *Divided Memory: The Nazi Past in the Two Germanys* (Cambridge, Massachusetts, and London: Harvard University Press, 1997); Andreas Huyssen, *Twilight Memories*; Konrad K. Jarausch, ed., *After Unity: Reconfiguring German Identities* (Providence and Oxford: Berghahn, 1997); and Rudy Koshar, *Germany's Transient Pasts: Preservation and National Memory in the Twentieth Century* (Chapel Hill and London: University of North Carolina Press, 1998).

35. Also, Kuspit particularly singles out Kiefer as an artist who is very German because of his search for the German spirit. Kuspit, *The New Subjectivism—Art in the 1980s,* 4 and 19/20.

36. Kuspit, "Flak from the Radicals," 46.

37. The Romanian-Jewish poet wrote this poem in 1947, mourning the victims of the Holocaust.

38. For a detailed reading of this series, see Sabine Schütz, *Anselm Kiefer: Geschichte als Material, Arbeiten 1969–1983* (Cologne: DuMont Press, 1999), 301–12.

Anselm Kiefer *Nürnberg* (Nuremberg), 1982

panoramas by setting the perspectival vanishing point high in the upper right of the uninhabited agricultural landscape. To the right a church and cityscape are sketched out, evoking Nuremberg as seen from Hitler's party rally grounds; the city itself is not depicted. In the upper area of the image is the handwritten inscription "Nürnberg-Festspiel-Wiese"; below is a small piece of paper with the name "Eva" written on it. The Bayreuth Festspielwiese (concert grounds) is traditionally used as the stage for the performance of Wagner's operas, *The Mastersingers of Nuremburg* is set in the medieval city of Nuremberg, and Eva is one of the main figures in the opera. The painting, by omitting the city itself, dislocates *The Mastersingers* from medieval Nuremberg to a site of Nazi history. In fact, *The Mastersingers* was staged in Nuremberg in 1935, on the occasion of the Nazi Party rally that inaugurated the anti-Semitic race laws. Kiefer's image conflates German cultural narratives and historical events: It alludes to Wagner's nationalistic celebration of German art, Hitler's political use of this representation of German culture, and the cherished medieval history and dark Third Reich history of Nuremberg. Finally, Nuremberg, as the city of the war trials, connotes the surrender of National Socialism and its afterimages. Yet it is difficult to read Kiefer's image as either an unambiguous work of mourning or one proposing redemption, as Kuspit suggests. The monumental scale of the canvas—the work measures $110^{3}/_{8}$ by $149^{7}/_{8}$ inches—and its theme advance two conflicting readings: The image is at once an iconic witness to the Nazi past and the expression of an assertive nation with the confidence to monumentalize its conflicted history. Kiefer's blended allusions to Nazi aesthetics and the Holocaust could evoke the German population's coming to terms with or, alternatively, its desire to detach itself from its past. The vacillation between forgetting, facing, and overcoming the problematic past, and thereby forging a new German identity, links Kiefer's painting to the leftist critics' ambivalence about the Germanness of German art.

This first dispute since the end of the Third Reich over contemporary German art's cultural hegemony underscored German critics' investment in demonstrating to American audiences the return of a self-confident national culture. The renegotiation of long-unheeded German particularities aimed to forge the possibility of a collective narrative of the German nation. Homi Bhabha characterized this

construct of a national identity as the pedagogical narrative of a nation.[39] The idea of a collective national identity, based on the notion of belonging, includes categories such as a common language, culture, and historical memory. The discourse outlined above testifies to the German desire for a "normal" relationship to the nation's self—a desire that evokes misgivings, particularly in light of Chancellor Kohl's "normalizing" memorial politics of the decade. Most appalling in this respect was Reagan's and Kohl's commemoration of Nazi victims and perpetrators at the Bergen Belsen concentration camp and the cemetery in Bitburg, where members of the Wehrmacht are buried. This relativization of Holocaust memory and distortion of history reinforced the Cold War division between East and West and legitimized a resurgence of West German nationalism. By contrast, German critics demonstrated remaining scars vis-à-vis a positive identification with German identity because the theme of German nationalism was at times discarded as a viable concept. American critics made it clear that the asserted superiority of contemporary German art not only threatened America's cultural hegemony but also reenacted treacherous recollections of Germany's past. Curiously, U.S. critics did not discuss Anselm Kiefer's art in these terms.

The Case of Anselm Kiefer

"Nobody noticed at the time—how could they, when so much else was happening?—but one of the best things that happened to Germany in 1945 was that Anselm Kiefer got born."[40] The American critic John Russel's surprisingly stark statement, made in 1985, illuminates crucial elements of Kiefer's reception in the United States: first, his almost unanimous celebration as one of the greatest German artists, a judgment often not even limited to the postwar period; second, his identification as a figure of national fate, especially within the context of Germany's Third Reich history; and third, American critics' refusal to engage his work in a discourse relating to contemporary issues of postmodernist art.

In contrast to Kiefer's uncontested popularity in the United States,[41] his homeland initially met his work with outrage.[42] When his monumental *Deutschlands Geisteshelden* was exhibited at the

39. Homi Bhabha, "Dissemination, Time, Narrative, and the Margins of the Modern Nation," in *The Location of Culture* (London and New York: Routledge, 1995), 146–52.

40. John Russel, "Anselm Kiefer's Paintings Are Inimitably His Own," *New York Times*, 21 April 1985, 33.

41. See, for example, ibid.; Russel, "A Kiefer Retrospective," *New York Times*, December 5, 1987, 9; Robert Hughes, "Germany's Master in the Making," *Time*, December 21, 1987, 72-73; Hilton Kramer, "The Anselm

Kiefer Retrospective," *The New Criterion* (February 1988): 1–4; Peter Schjeldahl, "Our Kiefer," *Art in America* (March 1988): 116–27.

42. For Kiefer's German reception, see Lisa Saltzmann, "Kiefer: A Painter from Germany," in *Anselm Kiefer and Art after Auschwitz* (Cambridge, England, and New York: Cambridge University Press, 1999), 97–123. For Kiefer's German and American reception, see also Schütz, "Kiefer-Rezeption in Kritik and Kunstwissenschaft," in *Anselm Kiefer: Geschichte als Material*, 60–81; and Huyssen, "Kiefer in Berlin," in *Twilight Memories*, 85–101.

German Pavilion of the 1980 Venice Biennale, German critics asserted that his images would buttress the ideology of the Third Reich, foster neo-Fascist tendencies, destabilize the democratic foundation of the F.R.G., and—most important—awaken ghosts Germany wanted to lay to rest. In Germany, this evaluation changed reluctantly, marching in step with Kiefer's increasing international success. Yet it was only after the unification of the two Germanies, a pivotal turning point in the country's postwar history and its relationship to the United States, that Kiefer's works gained wide acceptance there. (At this point in German postwall history, Kiefer, however, had left the new Germany and relocated to France.)

The contradictory reception of Kiefer in West Germany and the United States led Andreas Huyssen in 1992 to raise the question of how "Kiefer's Germanness functions differently in the U.S.?"[43] The German scholar, who lives in the United States, suggested that Kiefer's traditional German image worlds remained taboo for Germans, whereas for American audiences they signified an attempt to confront the Nazi past. Five years earlier, in 1987, Robert Hughes had told American audiences that by reading Kiefer's images as a revival of or nostalgia for the Nazi past instead of a confrontation of denied ghosts, his "German critics often got [the meaning of his art] wrong."[44]

Formalist critic Hilton Kramer also accounted for Kiefer's success in terms of his taboo-loaded subject matter. "The secret of Kiefer's immense appeal just now . . . lies, I believe, precisely in his willingness, or, if you will, his compulsion to place these subjects at the center of his art."[45] Yet Kiefer was not the first German postwar artist to address the Nazi past. Nor was he the only one to exhibit such works at prominent U.S. locations. In 1979 Joseph Beuys's *Auschwitz Installation*,

174.

fig 53

fig 54

1956–64, was a focal point of his New York Guggenheim retrospective. But unlike Kiefer, his teacher Beuys relied on experimental and abstract strategies, displaying in a glass vitrine, among other items, a crucifix attached to a plate, a small electric range, pieces of fat, rings of blood sausage, a plan of Auschwitz, small medicine containers, an aluminum plate, and a pair of glasses. To those not acquainted with Beuys's aesthetic theories and hermetic iconography, these objects do not disclose their meaning. By contrast, in *Deutschlands Geisteshelden*, 1973, Kiefer models his painting in accord with Nazi aesthetics and their ideological message, relying on representational strategies accessible to many. The spatial construction of the wooden interior room, resembling an old German loft with its deep perspective moved slightly left of center, recalls the seductive spatial power, theatricality, and emptiness of Albert Speer's architecture, such as his Berlin Reich chancellery (fig. 53). More closely it approximates Friedrich Hetzel's Karinhall (fig. 54), 1935, built for Reichsmarschall Hermann Göring as a country house, where he kept much of his art collection.[46] The burning torches allude to the fire spectacles used to provoke irrational feelings of belonging to Nazi brotherhood and mass obedience to the irresistible Führer. The inscribed names of the German-speaking cultural figures Richard Wagner, Richard Dehmel, Josef Weinheber, Caspar David Friedrich, Mechthild von Magdeburg, Robert Musil, and Joseph Beuys complicate the reading, both referring to and pointing away from National Socialist ideology. Although some of these artists—such as Weinheber—actively supported the Nazi regime, most had nothing to do with it. They were, however, except for Beuys and to some degree the mystic von Magdeburg, highly regarded by the regime. Thus, Kiefer's image illuminates Nazi aesthetics with minimal refractions and could be read as either boosting or critiquing Nazi ideology. By contrast, Baselitz's painting *Der Jäger (Vier Streifen)* conveys loathing for the nationalistic

43. Huyssen, "Kiefer in Berlin," 85.

44. Hughes, "Germany's Master in the Making," 73.

45. Kramer, "The Anselm Kiefer Retrospective," 2.

46. See also Schütz, 184–96.

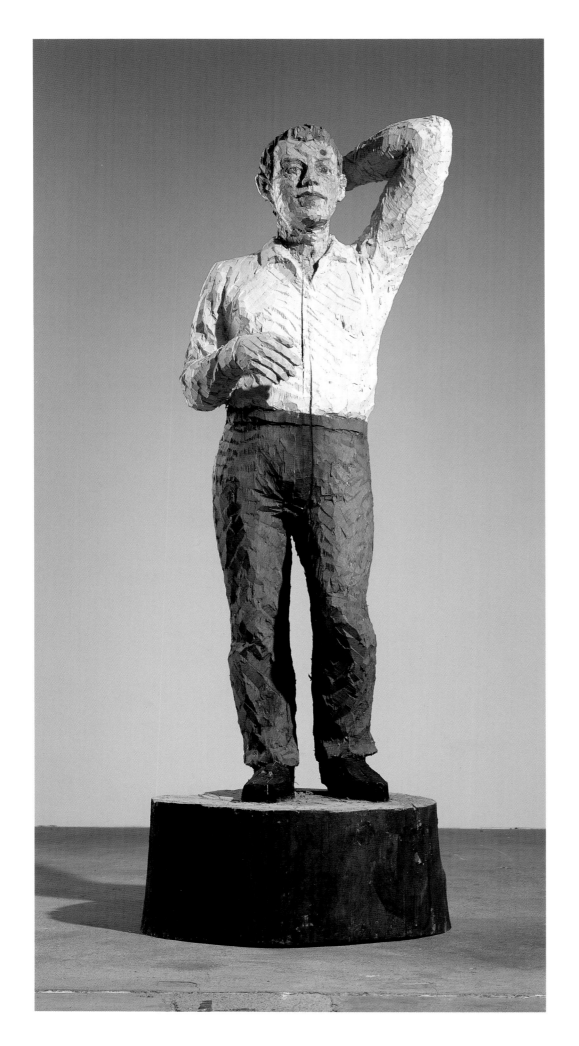

176.

ECKMANN

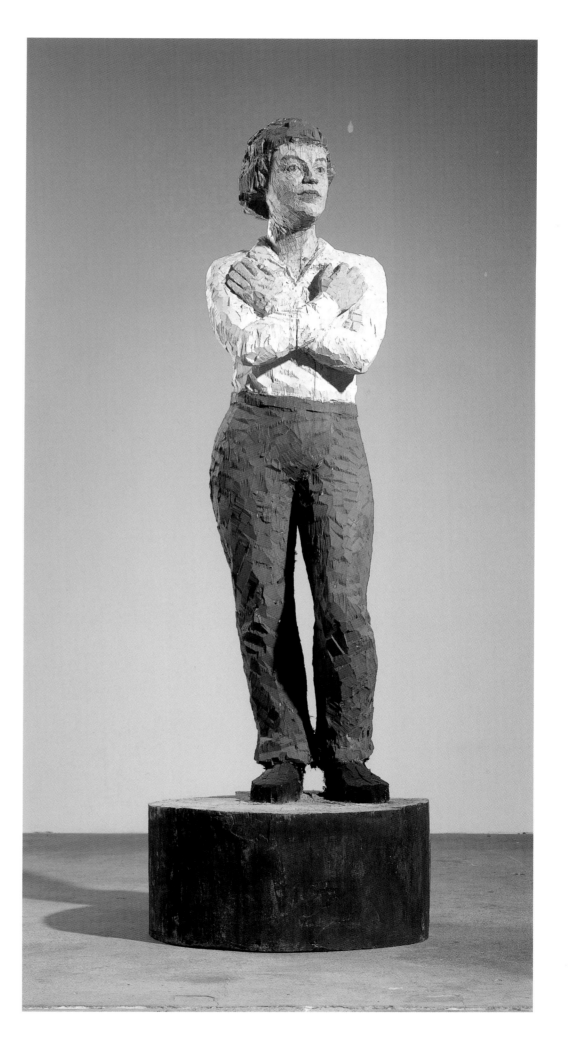

symbol of the German forest. The rendering of a German hunter, surrounded by green and brown stripes that connote a forest setting, negates the Nazi dogma of the physically beautiful body and replaces it with a distorted body reflective of mannerist and expressionist aesthetics, the latter pilloried as degenerate by the Nazis.

Kiefer's emphasis on architectural monumentalism, sublimity, and irrationality stands in stark contrast to Germany's modest postwar self-presentation. Thus, it becomes obvious why German critics, including intellectuals on the left, were appalled by Kiefer's images—in particular *Deutschlands Geisteshelden*—which presented German art internationally at the Venice Biennale. The painting communicates Germany's prewar image, the very identity West Germany since 1949 had attempted to lay to rest and replace with an international, democratic, and Americanized self-conception. Meanwhile, the Third Reich references worked for American audiences as an identification tag symbolizing old German traditions, Germany's conflicted past, and the unresolved issue of Germany's coming to terms with this past.

Above all, American critics claimed Kiefer as an "American type painter."[47] Peter Schjeldahl distinguished him as "somehow inauthentically German" in contrast to "echt-Deutsch Georg Baselitz," and also underscored Kiefer's assimilation of Jackson Pollock's art to enlist American sympathies.[48] He was not alone in making this connection: To name a few, Donald Kuspit, Mark Rosenthal, Hilton Kramer, Robert Hughes, and even Judith Russi Kirshner,[49] one of the few women and critical voices in the United States addressing Kiefer, point to the impact on him of Abstract Expressionism.[50] This acceptance of Kiefer can be attributed not only to his daunting subject matter, but also to his successful integration of Abstract Expressionism. Despite revisionist accounts,[51] it is important to recall that Abstract Expressionism is still widely regarded as America's most significant high-art movement, the one that advanced the country to the center of the art world.

Striking in Kiefer's American reception is the widespread omission of contemporary issues.[52] The criticism rarely attends to him as a contemporary painter; more often he is framed in a discourse of German nineteenth-century culture. His citations of cultural figures such as Richard Wagner and

47. Schjeldahl, "Our Kiefer," 118.

48. Ibid, 116 and 115.

49. "His paintings, particularly the more abstract landscapes, transfix American audiences with their epic proportions and ambition, yet they remain politically neutral, numbing our responses to excesses of chauvinism, imperialism, and domination." Judith Russi Kirshner, "Anselm Kiefer," *Artforum* (March 1988): 144.

50. See, among others, Mark Rosenthal, *Anselm Kiefer*, exh. cat. (Chicago, Philadelphia, and New York: The Art Institute of Chicago, Philadelphia Museum of Art, Prestel, 1987), 104.

51. See, for example, Michael Leja, *Reframing Abstract Expressionism: Subjectivity and Painting in the 1940s* (New Haven and London: Yale University Press, 1993).

52. Judith Kirshner is also an exception in this respect, in that she compares Kiefer's image world with Steven Spielberg's. Kirshner, 144.

53. Kramer, 3.

54. For an analysis of the connection between the fascination with Fascism and the unreality of contemporary culture, see Hal Foster, "Contemporary Art and Spectacle," in *Recodings: Art, Spectacle, Cultural Politics* (Seattle: Bay Press, 1985), 79–98.

fig 55 **Anselm Kiefer** *Fur René Char* (For René Char), 1988

Caspar David Friedrich are taken as literal models of his cultural identification, rather than carriers of specific cultural meanings that he negotiates. For example, Kramer points out that Kiefer's symbolic landscapes, such as *Nürnberg*, echo the German imagination in that they at times barely differentiate between culture and nature. He situates his analysis within German nineteenth-century Romanticism and Johann Wolfgang von Goethe's idealistic elaborations on cultivated nature, ignoring contemporary approaches to landscape.[53]

Yet there are many components in Kiefer's work that position his art within postmodern but also avant-garde traditions: his use of ephemeral materials such as straw and paper bits in *Nürnberg* and other paintings; the combination of photography with lead in *Fur René Char*, 1988 (fig. 55); the

combination of text and image in *Deutschlands Geisteshelden*, 1973; and the citation of past artworks, including his own, in *Am Rhein*, 1968–91 (fig. 56).

Although hardly explored, these aesthetic strategies distinguish Kiefer from his German contemporary colleagues who stuck to painting or sculpture. Certainly the artist's successful combination of traces of Abstract Expressionism and experimental forms appealed to American audiences. Finally, Kiefer's investigation of fascist aesthetics ties his work to the topical interest in Fascism evident in contemporary American works such as Jack Goldstein's *Untitled*, 1982, which alludes to Nazi aesthetics through its irrational use of light.[54]

A decade after the fall of the Berlin Wall and the unification of the two Germanies, this discourse has indeed become a phenomenon of West Germany's postwar history. Since its unification in 1990, Germany has once again been invested in reinventing a new image for itself and searching

fig 55

fig 56

Sabine Eckmann is curator of the Washington University Gallery of Art in Saint Louis, where she also holds an adjunct professorship in the Department of Art History and Archeology. Her exhibitions and publications have focused on nineteenth- and twentieth-century European art, with a particular emphasis on avant-garde art from the 1910s to the 1940s. As exhibition associate at LACMA, she co-organized the 1997 show Exiles and Emigrés: The Flight of European Artists from Hitler, which was named best exhibition outside of New York by the Association of International Critics of Art.

for a new political symbolism to present the Berlin republic. The debates of the 1980s attest to the German problem of how to forge a national identity on an international level without evasion or ambiguity about the past. In contrast to German art of the 1970s, some figurative artworks of the 1980s advanced the notion that German artists intended to confront the Nazi past openly. The traditional aesthetics made this topic more accessible. Yet collectively the figurative images also aided various and conflicting readings of German identity and Germany's coming to terms with its past, contributing to, if not fabricating, the controversy. In retrospect, it was the monumental format—rather than the subject matter and figuration—of these works of art that was problematic. The grand artistic gestures, conveying notions of visual totality, aura, and theatricality, indeed attest to a renewed German national self-assertiveness. In the 1980s the investment in issues of German national identity as it was mediated by and through the visual arts remained, however, confined to the cultural sphere. Only with Germany's unification and political sovereignty in 1990 has German identity become a highly contested discourse within the political arena.

The end of communism and increased globalism have brought about radical changes in left cultural discourses. As opposed to current debates, which locate positions of resistance *within, in between,* or in a sphere of liminality,[55] the conservative cultural and political climate of the 1980s ushered in the last Cold War dispute that pitted left radical utopias against capitalist realities. ◎

55. For the concept of liminality in anthropological studies see Victor Turner, *The Ritual Process: Structure and Anti-Structure.* (Ithaca: Cornell University Press, 1969). Postcolonial theorists such as Homi Bhabha use liminality as a category similar to hybridity—an "in-between" space that is unfixed, inclusive, and diverse. It enables an antihierarchical discourse bypassing old antithetical concepts such as socialism and capitalism. See for example Bhabha, *The Location of Culture.*

fig 56 **Anselm Kiefer** *Am Rhein* (On the Rhine), 1968–91

john baldessari

THE SPECTATOR IS COMPELLED
TO LOOK DIRECTLY DOWN THE
ROAD AND INTO THE MIDDLE OF
THE PICTURE.

TIPS FOR ARTISTS
WHO WANT TO SELL

- GENERALLY SPEAKING, PAINT-INGS WITH LIGHT COLORS SELL MORE QUICKLY THAN PAINTINGS WITH DARK COLORS.

- SUBJECTS THAT SELL WELL: MADONNA AND CHILD, LANDSCAPES, FLOWER PAINTINGS, STILL LIFES (FREE OF MORBID PROPS ___ DEAD BIRDS, ETC.), NUDES, MARINE PICTURES, ABSTRACTS AND SUR-REALISM.

- SUBJECT MATTER IS IMPOR-TANT: IT HAS BEEN SAID THAT PA-INTINGS WITH COWS AND HENS IN THEM COLLECT DUST ___ WHILE THE SAME PAINTINGS WITH BULLS AND ROOSTERS SELL.

186.

Note to the reader: This checklist includes all the works in the Broad collections by the artists represented in the exhibition. Works featured in the exhibition are indicated in orange.

John Baldessari
United States, b. 1931

The Spectator Is Compelled . . . ,
1967–68
Acrylic and photo-emulsion on canvas
59 x 45 inches (150 x 114.3 cm)
The Broad Art Foundation
p. 184

Tips for Artists, 1967–68
Acrylic on canvas
68 x 56^1/$_2$ inches (173 x 144 cm)
The Broad Art Foundation
p. 185

Black and White Decision, 1984
Two gelatin silver prints
64 x 70^3/$_4$ inches
(162.6 x 179.7 cm) overall
The Broad Art Foundation
p. 186

*Building=Guns=People: Desire,
Knowledge and Hope (with Smog),*
1985
Color photographs and black-and-
white photographs with oil tint and
vinyl paint mounted on five panels
185 x 446 inches
(470 x 1132.8 cm) overall
The Broad Art Foundation

*Green Kiss/Red Embrace
(Disjunctive)*, 1988
Four black-and-white photographs
with oil tint
156 x 192 inches (396.2 x 487.7 cm)
overall
The Broad Art Foundation

Seashells/Tridents/Frames, 1988
Five black-and-white photographs with
oil tint and vinyl paint
96 x 152 inches (243.8 x 386.1 cm)
overall
The Broad Art Foundation
p. 187

*Car Flanked by Doubleman (Splashed
Blue)*, 1990
Three color photographs with vinyl
paint and acrylic paint
52 x 72 inches (132.1 x 182.9 cm)
overall
The Broad Art Foundation

*Overlap Series: Palms (with
Cityscape) and Climbers*, 2000
Lambda prints with acrylic on sintra
79 x 60 inches (200.7 x 152.4 cm)
The Eli and Edythe L. Broad Collection
p. 183

Stephan Balkenhol
Germany, b. 1957

6 Bears, 1991
Lignum vitae wood
Height: 57 inches (144.8 cm);
installation dimensions vary
The Broad Art Foundation

Large Classical Man, 1996
Poplar wood and paint
98^1/$_2$ x 35 x 30 inches
(250.2 x 76.2 cm)
The Broad Art Foundation
p. 176

Large Woman with Green Pants,
1996
Poplar wood and paint
96^1/$_16$ x 32 x 27 5/8 inches
(244 x 81.3 x 70.2 cm)
The Broad Art Foundation
p. 177

*Small Pair (man with red shirt and
woman with black shirt)*, 1997
Wawa wood and paint
Man: 62^3/$_4$ x 13^1/$_4$ x 9^3/$_4$ inches
(159.4 x 33.7 x 24.8 cm)
Woman: 62^1/$_2$ x 13^1/$_2$ x 9^5/$_8$ inches
(158.8 x 34.3 x 24.4 cm)
The Broad Art Foundation

Four Women Group, 1998
Douglas fir wood and paint
Height: 61^1/$_2$ inches (156.2 cm);
installation dimensions vary
The Broad Art Foundation

Big Head Relief, 1999
Oak wood and paint
49^3/$_4$ x 38^3/$_4$ x 5^3/$_8$ inches
(126.4 x 98.4 x 13.7 cm)
The Broad Art Foundation

Georg Baselitz
Germany, b. 1938

Der Jäger (Vier Streifen) (The Hunter
[Four Stripes]), 1966
Oil on canvas
71 x 51 inches (180.3 x 129.5 cm)
The Eli and Edythe L. Broad Collection
p. 169

Untitled (Held), 1966
Red and black conte crayon and
pencil on paper
14^1/$_2$ x 10^1/$_4$ inches (148.6 x 26 cm)
The Eli and Edythe L. Broad Collection
p. 163

Trinker am Tisch (Drinker at Table), 1983
Oil on canvas
98^1/$_2$ x 78^3/$_4$ inches
(250.2 x 200 cm)
The Eli and Edythe L. Broad Collection
p. 150

Jean-Michel Basquiat
United States, 1960–1988

Untitled, 1981
Acrylic and mixed media on canvas
96 x 60 inches (243.8 x 152.4 cm)
The Broad Art Foundation

Untitled (Skull), 1981
Acrylic and mixed media on canvas
81 x 69^1/$_4$ inches (205.7 x 175.9 cm)
The Eli and Edythe L. Broad Collection
p. 102 and pp. 130–31

Beef Ribs Longhorn, 1982
Acrylic and mixed media on canvas
60 x 60 inches (152.4 x 152.4 cm)
The Broad Art Foundation

Obnoxious Liberals, 1982
Acrylic and oil paintstick on canvas
68 x 102 inches (172.7 x 259.1 cm)
The Eli and Edythe L. Broad Collection

Santo 2, 1982
Oil stick, mixed media, and collage
on canvas
36^1/$_4$ x 36 inches (90.6 x 91.4 cm)
The Broad Art Foundation

Eyes and Eggs, 1983
Acrylic, oil paintstick, and paper
collage on cotton dropcloth; two panels
119 x 97 inches
(302.3 x 246.4 cm) overall
The Eli and Edythe L. Broad Collection

Horn Players, 1983
Acrylic and oil paintstick on
three canvas panels
96 x 75 inches
(243.8 x 190.5 cm) overall
The Broad Art Foundation
p. 132

With Strings Part 2, 1983
Acrylic and mixed media on canvas
96 x 60 inches (243.8 x 152.4 cm)
The Broad Art Foundation

Deaf, 1984
Oil and acrylic on canvas
66 x 60 inches (167.6 x 152.4 cm)
The Broad Art Foundation

Gold Griot, 1984
Oil and oil paintstick on wood
117 x 73 inches (297.2 x 185.4 cm)
The Broad Art Foundation

Melting Point of Ice, 1984
Acrylic, oil paintstick, and silkscreen
on canvas
86 x 68 inches (218.4 x 172.7 cm)
The Broad Art Foundation
p. 133

Moon View, 1984
Acrylic and mixed media on canvas
66 x 60 inches (167.6 x 152.4 cm)
The Broad Art Foundation

Pakiderm, 1984
Oil and acrylic on canvas
86 x 68 inches (218.4 x 172.7 cm)
The Broad Art Foundation

Pink Devil, 1984
Acrylic and mixed media on canvas
66 x 60 inches (167.6 x 152.4 cm)
The Broad Art Foundation

Wicker, 1984
Oil and mixed media on canvas
86 x 98 inches (218.4 x 248.9 cm)
The Broad Art Foundation
p. 31

Bernd and Hilla Becher
Germany, b. 1931 and b. 1934

Typology of Water Towers, 1972
Suite of nine black-and-white
photographs
15³⁄₄ x 11³⁄₄ inches
(40 x 29.8 cm) each
The Eli and Edythe L. Broad Collection
p. 154

Typology of Water Towers, 1972
Suite of nine black-and-white
photographs
15³⁄₄ x 11³⁄₄ inches
(40 x 29.8 cm) each
The Eli and Edythe L. Broad Collection
p. 155

Typology of Water Towers, 1972
Suite of nine black-and-white
photographs
15³⁄₄ x 11³⁄₄ inches
(40 x 29.8 cm) each
The Eli and Edythe L. Broad Collection
p. 156

Typology of Water Towers, 1972
Suite of nine black-and-white
photographs
15³⁄₄ x 11³⁄₄ inches
(40 x 29.8 cm) each
The Eli and Edythe L. Broad Collection

Typology of Water Towers, 1972
Suite of nine black-and-white
photographs
15³⁄₄ x 11³⁄₄ inches
(40 x 29.8 cm) each
The Eli and Edythe L. Broad Collection

Typology of Water Towers, 1972
Suite of nine black-and-white
photographs
15³⁄₄ x 11³⁄₄ inches
(40 x 29.8 cm) each
The Eli and Edythe L. Broad Collection

Ross Bleckner
United States, b. 1949

Bed Flower, 1985
Oil on linen
48 x 40 inches (121.9 x 101.6 cm)
The Broad Art Foundation
p. 118

Brothers' Sword, 1986
Oil on canvas
108 x 84 inches (274.3 x 213.4 cm)
The Broad Art Foundation
p. 119

More Wreath, 1986
Oil on linen
48 x 40 inches (121.9 x 101.6 cm)
The Broad Art Foundation

Unknown Quantities of Light (Part IV),
1988
Oil on canvas
108 x 144 inches (274.3 x 365.8 cm)
The Broad Art Foundation

Us Two, 1988
Oil on canvas
108 x 60 inches (274.3 x 152.4 cm)
The Broad Art Foundation

Invisible Heaven, 1991
Oil, metallic pigment, graphite, and
modeling paste on canvas
106 x 92 inches (269.2 x 233.7 cm)
The Broad Art Foundation

Prayer (for a friend), 1993
Oil on linen
96 x 72 inches (243.8 x 182.9 cm)
The Eli and Edythe L. Broad Collection

Memorial I, 1994
Oil and wax on linen with varnish
96 x 120 inches (243.8 x 304.8 cm)
The Broad Art Foundation

Hot House, 1995
Oil on canvas
108 x 72 inches (274.32 x 182.9 cm)
The Broad Art Foundation

Hidden Law, 1996
Oil on canvas
84 x 72 inches (213.4 x 182.9 cm)
The Broad Art Foundation

In Sickness and in Health, 1996
Oil on linen
84 x 72 inches (213.4 x 182.9 cm)
The Eli and Edythe L. Broad Collection
p. 113

Map by Heart, 1996
Oil on canvas
96 x 120 inches (243.8 x 304.8 cm)
The Broad Art Foundation

Eric Fischl
United States, b. 1948

Untitled, 1982
Oil on canvas
84 x 84 inches (213.4 x 213.4 cm)
The Broad Art Foundation
p. 18

Fort Worth, 1985
Oil on four canvas panels
98 x 216 inches (248.9 x 548.6 cm)
overall
The Broad Art Foundation

Haircut, 1985
Oil on linen
104 x 84 inches (264.2 x 213.4 cm)
The Broad Art Foundation
p. 138

The Evacuation of Saigon, 1987
Oil on three linen panels
120 x 142 inches
(304.8 x 360.7 cm) overall
The Broad Art Foundation

Trance, 1988
Bronze
41 x 17 x 7 inches
(104.1 x 43.2 x 17.8 cm)
Edition 2/5
The Broad Art Foundation

Nick's Picnic, 1992
Oil on canvas
98 x 86 inches (248.9 x 218.4 cm)
The Broad Art Foundation

The Call of the Ball, 1993
Oil on linen
65 x 50 inches (165.1 x 127 cm)
The Eli and Edythe L. Broad Collection

The Travel of Romance: Scene I, 1994
Oil on linen
58 x 65 inches (147.3 x 165.1 cm)
The Broad Art Foundation

The Travel of Romance: Scene II, 1994
Oil on linen
45 x 70 inches (114.3 x 177.8 cm)
The Broad Art Foundation

The Travel of Romance: Scene III, 1994
Oil on linen
72 x 54 inches (182.9 x 137.2 cm)
The Broad Art Foundation

The Travel of Romance: Scene IV, 1994
Oil on linen
55 x 65 inches (139.7 x 165.1 cm)
The Broad Art Foundation

The Travel of Romance: Scene V, 1994
Oil on linen
70 x 54 inches (177.8 x 137.2 cm)
The Broad Art Foundation

*Once Where We Looked to Put Down
Our Dead*, 1996
Oil on linen
98 x 80 inches (248.9 x 203.2 cm)
The Eli and Edythe L. Broad Collection

The Weight, 1996
Bronze
31¹⁄₂ x 23 x 11 inches
(80 x 58.4 x 27.9 cm)
Edition 1/5
The Broad Art Foundation

Hans Haacke
Germany, b. 1936

*Oelgemaelde, Hommage à Marcel
Broodthaers* (Oil Painting: Homage to
Marcel Broodthaers), 1982
Mixed-media installation; installation
dimensions vary
Los Angeles County Museum of Art,
gift of The Broad Art Foundation
pp. 160–61

*The Saatchi Collection
(Simulations)*, 1987
Mixed-media installation
96 x 76 x 15 inches
(243.8 x 193 x 38.1 cm)
Edition of 2
The Broad Art Foundation

Jörg Immendorff
Germany, b. 1945

Nachtmantel, 1987
Oil on canvas
112³⁄₁₆ x 157¹⁄₂ inches
(285 x 398.8 cm)
The Museum of Contemporary Art,
Los Angeles, partial gift of The Broad
Art Foundation
p. 158

Raub der Sabinerin
(Rape of the Sabines), 1987–88
Linocut
48³/₄ x 8¹/₂ inches
(123.8 x 207 cm)
Edition 6/7
The Eli and Edythe L. Broad Collection

Jasper Johns
United States, b. 1930

White Flag, 1960
Oil and newspaper collage over
lithograph
22 x 29¹/₄ inches
(55.9 x 74.3 cm)
The Eli and Edythe L. Broad Collection
p. 59

Watchman, 1964
Oil on two canvas panels with objects
85 x 60¹/₄ inches
(215.9 x 153 cm)
The Eli and Edythe L. Broad Collection
p. 63

Flag, 1967
Encaustic and collage on three canvas
panels
33¹/₂ x 56¹/₄ inches
(85.1 x 142.9 cm) overall
The Eli and Edythe L. Broad Collection
p. 44

High School Days, 1969
Lead relief with mirror
23 x 17 inches (58.4 x 43.2 cm)
Edition 42/60
The Eli and Edythe L. Broad Collection

Light Bulb, 1969
Lead relief
39 x 17 inches (99.1 x 43.2 cm)
Edition 12/60
The Eli and Edythe L. Broad Collection

The Critic Smiles, 1969
Lead relief with cast gold crown and
tin relief
23 x 17 inches (58.4 x 43.2 cm)
Edition 16/60
The Eli and Edythe L. Broad Collection

Decoy, 1971
Lithograph with die cut printed in color
41³/₈ x 29⁵/₈ inches
(105.1 x 75.2 cm)
Edition 49/55
The Eli and Edythe L. Broad Collection

Flags I, 1973
Silkscreen, 31 screens,
printed in color
27¹/₂ x 35 inches (69.9 x 88.9 cm)
Edition 34/65
The Eli and Edythe L. Broad Collection

Flags II, 1973
Silkscreen, 30 screens
27¹/₂ x 35 inches (69.9 x 88.9 cm)
Edition 34/60
The Eli and Edythe L. Broad Collection

Untitled, 1975
Oil and encaustic on four canvas
panels
50¹/₈ x 50¹/₈ inches
(127.3 x 127.3 cm) overall
The Eli and Edythe L. Broad Collection
p. 64

Corpse and Mirror, 1976
Silkscreen, 36 screens,
printed in color
42¹/₄ x 53 inches
(107.3 x 134.6 cm)
Edition 41/65
The Eli and Edythe L. Broad Collection

The Dutch Wives, 1977
Silkscreen, 29 screens,
printed in color
43¹/₄ x 56¹/₄ inches
(109.2 x 142.9 cm)
Edition 67/70
The Eli and Edythe L. Broad Collection

Untitled, 1978
Watercolor, graphite, and ink on paper
18 x 17¹/₄ inches (45.7 x 43.8 cm)
The Eli and Edythe L. Broad Collection

Cicada II, 1981
Silkscreen, 18 screens, printed in color
24 x 19 inches (61 x 48.3 cm)
Edition 46/50
The Eli and Edythe L. Broad Collection

Untitled, 1984
Encaustic on canvas
63 x 76³/₄ inches (160 x 194.9 cm)
The Eli and Edythe L. Broad Collection
p. 65

*The Seasons (Spring, Summer, Fall,
Winter)*, 1987
Four intaglio prints
26 x 19 inches (66 x 48.3 cm) each
Edition 49/73
The Eli and Edythe L. Broad Collection

Target with Plaster Casts, 1990
Drypoint, etching, and aquatint
31 x 24¹/₂ inches (78.7 x 62.2 cm)
Edition 54/60
The Eli and Edythe L. Broad Collection

Untitled, 1990
Lithograph, three plates, printed in
color
10¹/₂ x 8 inches (26.7 x 20.3 cm)
Edition 232/250
The Eli and Edythe L. Broad Collection

Summer, 1991
Lithograph, two plates, printed in color
16¹/₄ x 11¹/₄ inches (41.3 x 28.6 cm)
Edition 52/225
The Eli and Edythe L. Broad Collection

Untitled, 1991
Encaustic and sand on canvas
50⁷/₈ x 35³/₈ inches (129.2 x 89.9 cm)
The Eli and Edythe L. Broad Collection
p. 66

Untitled, 1992–94
Encaustic on canvas
78¹/₂ x 118³/₈ inches
(199.4 x 300.7 cm)
The Eli and Edythe L. Broad Collection
p. 67

Flag, 1994
Acrylic on canvas
12¹¹/₁₆ x 19¹³/₁₆ inches
(32.2 x 50.3 cm)
The Eli and Edythe L. Broad Collection

Untitled, 1994
Lithograph, eight plates,
printed in color
36¹/₄ x 30¹/₂ inches
(92.1 x 77.5 cm)
H.C. AB 6/11
The Eli and Edythe L. Broad Collection

Anselm Kiefer
Germany, b. 1945

Kopf im Wald, Kopf in den Wolken
(Head in the Forest, Head in the
Clouds), 1971
Oil and fabric collage on two
canvas panels
78¹/₄ x 38¹/₄ inches
(198.8 x 97.2 cm) each
The Broad Art Foundation

Deutschlands Geisteshelden
(Germany's Spiritual Heroes), 1973
Oil and charcoal on burlap
mounted on canvas
120¹/₂ x 267³/₄ inches
(306.1 x 680.1 cm)
The Broad Art Foundation
p. 174

Nürnberg (Nuremberg), 1982
Oil, straw, and mixed media on canvas
110³/₈ x 149⁷/₈ inches
(280.4 x 380.7 cm)
The Eli and Edythe L. Broad Collection
p. 171

Dein Goldenes Haar Margarete
(Your Golden Hair Margarete), 1983
Watercolor on paper
16³/₄ x 21³/₄ inches (42.5 x 55.2 cm)
The Eli and Edythe L. Broad Collection

*Zweistromland: Mesopotamia (Tigris
& Euphrat)* (Land of Two Rivers:
Mesopotamia [Tigris and Euphrates]),
1985–87
Mixed media on two canvas panels
with applied wire and metal object
130 x 220¹/₂ inches
(330.2 x 560.1 cm) overall
The Eli and Edythe L. Broad Collection

Das Balder-Lied (The Song of Balder),
1977–88
Original photograph and mistletoe on
treated lead in a glazed steel frame
94¹/₂ x 67 inches (240 x 170.2 cm)
The Eli and Edythe L. Broad Collection

Fur René Char (For René Char), 1988
Original photograph on treated lead in
a glazed steel frame
90¹/₂ x 67 inches (229.9 x 170.2 cm)
The Broad Art Foundation
p. 179

Alarichs Grab (Alaric's Grave),
1969–89
Mixed media on treated lead mounted
on original photgraph in a glazed steel
frame
67 x 94¹/₂ inches (170.2 x 240 cm)
The Eli and Edythe L. Broad Collection

Euphrat und Tigris (Euphrates and
Tigris), 1986–89
Original photograph on treated lead in
a glazed steel frame
67 x 94¹/₂ inches (170.2 x 240 cm)
The Eli and Edythe L. Broad Collection

Am Rhein (On the Rhine), 1968–91
Photograph on treated lead in steel
frame
95 1/8 x 51 15/16 inches
(241.6 x 131.9 cm)
The Broad Art Foundation
p. 180

Maginot, 1977–93
Acrylic, emulsion, and shellac on
woodcut mounted on canvas
150 1/2 x 196 5/8 inches
(382.3 x 499.4 cm)
The Broad Art Foundation

Laßt 1000 Blumen Blühen (Let 1000
Flowers Bloom), 1998
Mixed media on canvas
74 7/8 x 220 5/8 inches
(190.2 x 560.4 cm)
The Eli and Edythe L. Broad Collection
pp. 166–67

Jeff Koons
United States, b. 1955

Lifeboat, 1985
Bronze
12 x 80 x 60 inches
(30.5 x 203.2 x 152.4 cm)
Edition 2/3
The Eli and Edythe L. Broad Collection
pp. 126–27

Three-Ball 50/50 Tank, 1985
Glass, steel, distilled water,
and three basketballs
60 1/2 x 48 3/4 x 13 1/4 inches
(153.7 x 123.8 x 33.7 cm)
Edition 2/2
The Broad Art Foundation
p. 117

Italian Woman, 1986
Stainless steel
30 x 18 x 11 inches
(76.2 x 45.7 x 27.9 cm)
Edition 2/3
The Broad Art Foundation

Jim Beam-J.B. Turner Train, 1986
Stainless steel and bourbon
11 x 114 x 6 1/2 inches
(27.9 x 289.6 x 16.5 cm)
Edition 2/3
The Broad Art Foundation
p. 224

Louis XIV, 1986
Stainless steel
46 x 27 x 15 inches
(116.8 x 68.6 x 38.1 cm)
Edition 2/3
The Broad Art Foundation

Rabbit, 1986
Stainless steel
41 x 19 x 12 inches
(104.1 x 48.3 x 30.5 cm)
A.P.
The Eli and Edythe L. Broad Collection
p. 124

*New Hoover Deluxe Shampoo
Polishers, New Shelton Wet/Dry
5-Gallon Displaced Quadradecker*,
1981–87
Vacuum cleaner, six shampoo polish-
ers, Plexiglas, and fluorescent lights
116 x 54 x 28 inches
(294.6 x 137.2 x 71.1 cm)
The Broad Art Foundation
p. 125

Michael Jackson and Bubbles, 1988
Ceramic
42 x 70 1/2 x 32 1/2 inches
(106.7 x 179.1 x 82.6 cm)
A.P.
The Broad Art Foundation
p. 29

St. John the Baptist, 1988
Porcelain
56 1/2 x 30 x 24 1/2 inches
(143.5 x 76.2 x 62.2 cm)
A.P.
The Broad Art Foundation

String of Puppies, 1988
Polychromed wood
42 x 62 x 37 inches
(106.7 x 157.5 x 94 cm)
Edition 3/3
The Broad Art Foundation
p. 116

Balloon Dog, 1994–2001
Stainless steel with transparent
color coating
121 x 143 x 45 inches
(307.3 x 363.2 x 114.3 cm)
Version 1 of 4
The Broad Art Foundation
p. 28

Cat on a Clothesline, 1994–2001
Polyethylene plastic
123 x 110 x 50 inches
(312.4 x 279.4 x 127 cm)
Version 1 of 4
The Broad Art Foundation

Party Hat, 1995–97
Ol on canvas
114 3/8 x 127 5/8 inches
(290.5 x 324.2 cm)
The Broad Art Foundation

Roy Lichtenstein
United States, 1923–1997

Live Ammo (Blang!), 1962
Oil and Magna on canvas
68 x 80 inches (172.7 x 203.2 cm)
The Eli and Edythe L. Broad Collection
p. 68

Femme d'Alger, 1963
Oil on canvas
80 x 68 inches (203.2 x 172.7 cm)
The Eli and Edythe L. Broad Collection
p. 37

Non Objective I, 1964
Oil and Magna on canvas
56 x 48 inches (142.2 x 121.9 cm)
The Eli and Edythe L. Broad Collection
p. 38

I . . . I'm Sorry, 1965–66
Oil and Magna on canvas
60 x 48 inches (152.4 x 121.9 cm)
The Eli and Edythe L. Broad Collection
p. 78

*Rouen Cathedral (Seen at Five
Different Times of the Day) Set III*,
1969
Oil and Magna on five canvas panels
63 x 42 inches (160 x 106.7 cm) each
The Eli and Edythe L. Broad Collection
pp. 40–41

Cubist Still Life, 1974
Oil, Magna, and sand on canvas
18 x 24 1/8 inches (45.7 x 61.3 cm)
The Eli and Edythe L. Broad Collection

Purist Still Life, 1975
Oil and Magna on canvas
70 x 80 inches (177.8 x 203.2 cm)
The Eli and Edythe L. Broad Collection
p. 39

Entablature, 1976
Oil and Magna on canvas
55 x 144 inches (139.7 x 365.8 cm)
The Eli and Edythe L. Broad Collection

Self Portrait II, 1976
Oil and Magna on canvas
70 x 54 inches (177.8 x 137.2 cm)
The Eli and Edythe L. Broad Collection

Female Figure, 1980
Oil and Magna on canvas
70 x 50 inches (177.8 x 127 cm)
The Eli and Edythe L. Broad Collection
p. 42

Woman in Hat and Fox Fur, 1980
Oil and Magna on canvas
75 x 44 inches (190.5 x 111.8 cm)
The Eli and Edythe L. Broad Collection

Green & Yellow Apple, 1981
Magna on canvas
24 x 24 inches (61 x 61 cm)
The Eli and Edythe L. Broad Collection

*Two Paintings: Radiator and Folded
Sheets*, 1983
Oil and Magna on canvas
70 x 64 inches (177.8 x 162.6 cm)
The Eli and Edythe L. Broad Collection
p. 43

River Valley, 1985
Oil and Magna on canvas
77 x 108 inches (195.6 x 274.3 cm)
The Eli and Edythe L. Broad Collection

Imperfect Painting, 1986
Oil and Magna on two canvas panels
111 3/4 x 168 inches overall
(283.8 x 426.7 cm)
The Broad Art Foundation

Perfect Painting, 1986
Oil and Magna on canvas
70 x 100 inches (177.8 x 254 cm)
The Broad Art Foundation

Brushstroke Chair and Ottoman,
1986–88
Paint and varnish on laminated
birch veneer
Chair: 70 11/16 x 18 x 27 1/4 inches
(179.5 x 45.7 x 69.2 cm)
Ottoman: 20 3/4 x 17 3/4 x 24 inches
(52.7 x 45.1 x 61 cm)
Edition 12/12
The Eli and Edythe L. Broad Collection

Reflections: Vip! Vip!, 1989
Oil and Magna on canvas
68 x 88 inches (172.7 x 223.5 cm)
The Eli and Edythe L. Broad Collection
p. 72

Reflections on Interior with Girl Drawing, 1990
Oil and Magna on canvas
75 x 108 inches (190.5 x 274.3 cm)
The Eli and Edythe L. Broad Collection
p. 73

Interior with African Mask, 1991
Oil and Magna on canvas
114 x 146 inches (289.6 x 370.8 cm)
The Eli and Edythe L. Broad Collection

Interior with Blue Floor Wallpaper,
1992
36-color screenprint on five panels
102 x 156 inches (259.1 x 396.2 cm)
overall
Edition 99/300
The Eli and Edythe L. Broad Collection

Red Lamp, 1992
Screenprint
21 1/2 x 24 inches (54.6 x 61 cm)
Edition 221/250
The Eli and Edythe L. Broad Collection

La Nouvelle Chute de L'Amérique,
by Allen Ginsberg
Paris, Édition du Solstice, 1992
10 aquatints
19 x 14 1/16 inches
(48.3 x 35.7 cm) each
H.C. 27/45
The Eli and Edythe L. Broad Collection

Nude with Pyramid, 1994
Oil and Magna on canvas
84 x 70 inches (213.4 x 177.8 cm)
The Eli and Edythe L. Broad Collection

Untitled Head, 1995
Lithograph
18 1/2 x 21 1/4 inches (47 x 54 cm)
Edition 6/75
The Eli and Edythe L. Broad Collection

Woman with Mirror, 1996
Patinated bronze and mirror
28 x 39 x 11 1/4 inches
(71.1 x 99.1 x 28.6 cm)
Edition 3/6
The Eli and Edythe L. Broad Collection

Interior with Painting of Bather, 1997
Oil and mineral spirits acrylic
on canvas
70 x 68 1/2 inches (177.8 x 174 cm)
The Eli and Edythe L. Broad Collection

Sharon Lockhart
United States, b. 1964

Julia Thomas, 1994
Two framed chromogenic prints
61 x 49 1/8 inches (154.9 x 124.8 cm)
each ; installed dimensions vary
Edition 2/4
The Broad Art Foundation

Untitled, 1996
Framed chromogenic print
63 1/4 x 50 1/8 inches (160.7 x 127.3 cm)
Edition 4/6
The Broad Art Foundation
p. 209

Untitled, 1996
Framed chromogenic print
73 x 109 inches (185.4 x 276.9 cm)
Edition 4/6
The Broad Art Foundation
p. 210

Untitled, 1996
Framed chromogenic print
32 x 43 inches (81.3 x 109.2 cm)
Edition 3/6
The Broad Art Foundation
p. 211

Untitled, 1996
Framed chromogenic print
73 x 49 inches (185.4 x 124.5 cm)
Edition 3/6
The Broad Art Foundation

*Goshogaoka Girls Basketball Team:
Chihiro Nishijima; Sayaka Miyamoto &
Takako Yamada; Kumiko Shirai & Eri
Hashimoto; Kumiko Kotaka*, 1997
Four framed chromogenic prints
37 1/2 x 31 inches (95.3 x 78.7 cm)
each; installed dimensions vary
Edition 8/8
The Broad Art Foundation

*Manioc Production: Elenilde Correa,
Eliane Correa, Neide Correa, Mariana
Correa, Denize Correa, and Maria
Correa, Santa Rita Community, River
Aripuana, Brazil*, 1999
Six framed chromogenic prints
24 x 19 inches (61 x 48.3 cm) each;
installed dimensions vary
Edition 1/8
The Broad Art Foundation

*Enrique Nava Enedina: Oaxaca
Exhibit Hall, National Museum of
Anthropology, Mexico City*, 1999
Three framed chromogenic prints
49 x 64 1/2 inches (124.5 x 163.8 cm)
each; installed dimensions vary
A.P. 1/2
The Broad Art Foundation
pp. 212–13

Sigmar Polke
Germany, b. 1941

Untitled, 1983
Gouache, watercolor, gold paint, and
tempera on paper
39 x 27 1/2 inches (99.1 x 69.9 cm)
The Eli and Edythe L. Broad Collection

Transparent #8, 1988
Resin on silk on two sides
51 x 43 1/4 inches (129.5 x 109.9 cm)
The Broad Art Foundation

Homme Chantant la Marseillaise,
1989
Mixed media on canvas
70 3/4 x 59 inches (179.7 x 149.9 cm)
The Eli and Edythe L. Broad Collection
p. 164

Robert Rauschenberg
United States, b. 1925

Untitled (Red Painting), 1954
Combine painting: oil, fabric, and
paper on canvas
70 3/4 x 48 inches (179.7 x 121.9 cm)
The Eli and Edythe L. Broad Collection
p. 8 and p. 46

Round Trip I, 1963
Oil and silkscreen ink on canvas
30 x 40 inches (76.2 x 101.6 cm)
The Eli and Edythe L. Broad Collection
p. 61

Golden Grebe (Scale), 1978
Solvent transfer on fabric collaged to
wooden panels with acrylic paint, col-
ored and clear mirrors
84 x 98 x 10 1/4 inches
(213.4 x 248.9 x 26 cm)
The Eli and Edythe L. Broad Collection

Charles Ray
United States, b. 1953

All My Clothes, 1973
16 Kodachrome photographs mounted
on board
9 x 60 inches (22.9 x 152.4 cm) overall
Edition 6/12
The Broad Art Foundation
pp. 200–201

Plank Piece I–II, 1973
Two black-and-white photographs
mounted on rag board
39 1/2 x 27 inches (100.3 x 68.6 cm)
each
Edition 1/7
The Broad Art Foundation
p. 203

Untitled, 1973
Black-and-white photograph mounted
on rag board
20 1/2 x 42 1/2 inches (52.1 x 108 cm)
Edition 1/7
The Broad Art Foundation
p. 202

Male Mannequin, 1990
Mixed media
73 1/2 x 15 x 14 inches
(186.7 x 38.1 x 35.6 cm)
Edition of 3
The Broad Art Foundation
p. 205

Table, 1990
Plexiglas and steel
35 5/8 x 52 3/4 x 35 3/8 inches
(90.5 x 134 x 89.9 cm)
Edition of 3
The Broad Art Foundation
p. 204

Fall '91, 1992
Mixed media
96 x 26 x 36 inches
(243.8 x 66 x 91.4 cm)
The Broad Art Foundation
p. 199

Firetruck, 1993
Painted aluminum, fiberglass,
and Plexiglas
144 x 96 x 558 inches
(365.8 x 243.8 x 1417.3 cm)
The Broad Art Foundation

Susan Rothenberg
United States, b. 1945

Double Masked Heads, 1974
Acrylic and tempera on canvas
65 1/4 x 79 inches (165.7 x 200.7 cm)
The Eli and Edythe L. Broad Collection
p. 105

Blue Body, 1980–81
Acrylic and flashe on canvas
108 x 75 inches (274.3 x 190.5 cm)
The Eli and Edythe L. Broad Collection
p. 110

Untitled #152, 1981
Charcoal on paper
28 3/4 x 22 1/2 inches (73 x 57.2 cm)
The Eli and Edythe L. Broad Collection

Elizabeth, 1984–85
Oil on canvas
71 x 54 1/2 inches (180.3 x 138.4 cm)
The Broad Art Foundation

Trumpeter, 1984–85
Oil on canvas
78 x 60 inches (198.1 x 152.4 cm)
The Eli and Edythe L. Broad Collection

A Golden Moment, 1985
Oil on canvas
54 x 48 inches (137.2 x 121.9 cm)
The Broad Art Foundation

Juggler with Shadows, 1987
Oil on canvas
72 1/4 x 124 1/4 inches
(183.5 x 315.6 cm)
The Eli and Edythe L. Broad Collection

Bone Heads, 1989–90
Oil on canvas
77 x 152 inches (195.6 x 386.1 cm)
The Broad Art Foundation
p. 137

Accident #2, 1993–94
Oil on canvas
66 x 125 inches (167.6 x 317.5 cm)
The Broad Art Foundation

Ed Ruscha
United States, b. 1937

Boss, 1961
Oil on canvas
72 x 67 inches (182.9 x 170.2 cm)
The Eli and Edythe L. Broad Collection
p. 86

Heavy Industry, 1962
Oil on canvas
67 x 71 5/8 inches (170.2 x 181.9 cm)
The Broad Art Foundation
p. 87

Norms, La Cienega, On Fire, 1964
Oil on canvas
64 1/2 x 124 1/2 inches
(163.8 x 316.2 cm)
The Broad Art Foundation
p. 90

*No End to the Things Made Out of
Human Talk*, 1977
Oil on canvas
36 x 84 inches (91.4 x 213.4 cm)
The Broad Art Foundation

*Where Are You Going, Man?
(For Sam Doyle)*, 1985
Oil and enamel on canvas
64 x 78 1/2 inches (162.6 x 199.4 cm)
The Broad Art Foundation
p. 91

Strong, Healthy, 1987
Acrylic on canvas
54 x 120 inches (137.2 x 304.8 cm)
The Eli and Edythe L. Broad Collection
p. 95

The Beer, The Girls, 1993
Acrylic on canvas
84 x 60 inches (213.4 x 152.4 cm)
The Broad Art Foundation

Bloated Empire, 1996–97
Acrylic on canvas
77 1/2 x 77 1/2 inches (196.9 x 196.9 cm)
The Eli and Edythe L. Broad Collection

Sunset-Gardner Cross, 1998–99
Acrylic on canvas
60 x 112 inches (152.4 x 284.5 cm)
The Broad Art Foundation
p. 7

David Salle
United States, b. 1952

Savagery and Misrepresentation, 1981
Acrylic on canvas
80 x 51 inches (203.2 x 129.5 cm)
The Eli and Edythe L. Broad Collection

Before No Walk, 1982
Acrylic and oil on two canvas panels
86 x 168 inches (218.4 x 426.7 cm)
overall
The Broad Art Foundation
p. 106

Clean Glasses, 1985
Acrylic and oil on two canvas panels
105 x 100 inches (266.7 x 254 cm)
overall
The Broad Art Foundation
p. 140

Dusting Powders, 1986
Acrylic and oil on two canvas panels
with wooden chair
108 x 156 inches
(274.3 x 396.2 cm) overall
The Broad Art Foundation

Pound Notes, 1986
Acrylic, fabric, oil, and silkscreen on
three canvas panels
60 x 116 1/2 inches
(152.4 x 295.9 cm) overall
The Eli and Edythe L. Broad Collection

The Loneliness of Clothes, 1986
Acrylic on canvas with two
blue lightbulbs
108 x 90 inches (274.3 x 228.6 cm)
The Broad Art Foundation

Cataluna Ground, 1987
Acrylic and oil on two canvas panels
120 x 150 inches (304.8 x 381 cm)
overall
The Broad Art Foundation

Demonic Roland, 1987
Acrylic and oil on canvas
94 x 136 inches (238.8 x 345.4 cm)
The Eli and Edythe L. Broad Collection
p. 139

Symphony Concertante I, 1987
Oil and acrylic on canvas
110 x 96 inches (279.4 x 243.8 cm)
The Broad Art Foundation

Searching Out Buddha, 1988
Acrylic and oil on two canvas panels
78 x 96 inches (198.1 x 243.8 cm)
overall
The Eli and Edythe L. Broad Collection

False Aire, 1990
Oil and acrylic on canvas
85 x 75 inches (215.9 x 190.5 cm)
The Broad Art Foundation

Tragedy, 1995
Oil and acrylic on two canvas panels
96 x 144 inches
(243.8 x 365.8 cm) overall
The Broad Art Foundation

Lemon and Stars, 1997
Acrylic, oil, and photo-sensitized linen
on two canvas panels
96 x 144 inches (243.8 x 265.8 cm)
overall
The Broad Art Foundation

Untitled (Watermelon), 1999
Oil and acrylic on two linen panels
75 x 125 inches (190.5 x 317.5 cm)
overall
The Broad Art Foundation

Julian Schnabel
United States, b. 1951

Receivership, 1980
Oil on canvas
90 x 84 inches (228.6 x 213.4 cm)
The Broad Art Foundation

Bob and Joe, 1984
Oil and modeling paste on velvet
120 x 108 inches (304.8 x 274.3 cm)
The Broad Art Foundation

Trachea of the Alder Fly, 1984
Fiberglass and oil on tarpaulin
114 1/4 x 156 inches
(290.2 x 396.2 cm)
The Broad Art Foundation

The Walk Home, 1984–85
Oil, plates, copper, bronze, fiberglass,
and Bondo on six wood panels
112 x 232 x 6 inches overall
(284.5 x 589.3 x 15.2 cm)
The Broad Art Foundation
p. 112

*The Death of Franco . . . all the
judges sent gifts*, 1986
Oil and modeling paste on wool
139 x 204 1/4 inches
(353.1 x 518.8 cm)
The Broad Art Foundation

The Goddess of Reason, 1987
Oil on tarpaulin
132 x 228 inches (335.3 x 579.1 cm)
The Broad Art Foundation

Self-Portrait in Andy's Shadow, 1987
Oil, plates, and Bondo on two wood
panels
103 x 72 x 10 inches overall
(261.6 x 182.9 x 25.4 cm)
The Eli and Edythe L. Broad Collection

Anh in a Spanish Landscape, 1988
Oil, plates, and Bondo on three wood
panels
114 x 125 x 12 inches overall
(289.6 x 317.5 x 30.5 cm)
The Broad Art Foundation

St. S, 1988
Oil and velvet on tarpaulin with
photograph
132 x 228 inches (335.3 x 579.1 cm)
The Broad Art Foundation

Cindy Sherman
United States, b. 1954

Untitled Film Still #6, 1977
Black-and-white photograph
10 x 8 inches (25.4 x 20.3 cm)
Edition 5/10
The Broad Art Foundation
p. 16

Untitled Film Still #7, 1978
Black-and-white photograph
10 x 8 inches (25.4 x 20.3 cm)
Edition 8/10
The Broad Art Foundation
p. 120

Untitled Film Still #13, 1978
Black-and-white photograph
10 x 8 inches (25.4 x 20.3 cm)
Edition 9/10
The Broad Art Foundation

Untitled Film Still #15, 1978
Black-and-white photograph
10 x 8 inches (25.4 x 20.3 cm)
Edition 6/10
The Broad Art Foundation
p. 120

Untitled Film Still #16, 1978
Black-and-white photograph
10 x 8 inches (25.4 x 20.3 cm)
Edition 3/10
The Broad Art Foundation

Untitled Film Still #27, 1979
Black-and-white photograph
10 x 8 inches (25.4 x 20.3 cm)
Edition 9/10
The Broad Art Foundation

Untitled Film Still #34, 1979
Black-and-white photograph
10 x 8 inches (25.4 x 20.3 cm)
Edition 2/10
The Broad Art Foundation

Untitled Film Still #35, 1979
Black-and-white photograph
10 x 8 inches (25.4 x 20.3 cm)
Edition 5/10
The Broad Art Foundation
p. 143

Untitled Film Still #37, 1979
Black-and-white photograph
10 x 8 inches (25.4 x 20.3 cm)
Edition 6/10
The Broad Art Foundation

Untitled Film Still #43, 1979
Black-and-white photograph
8 x 10 inches (20.3 x 25.4 cm)
Edition 3/10
The Broad Art Foundation
p. 143

Untitled Film Still #47, 1979
Black-and-white photograph
8 x 10 inches (20.3 x 25.4 cm)
Edition 4/10
The Broad Art Foundation

Untitled Film Still #52, 1979
Black-and-white photograph
8 x 10 inches (20.3 x 25.4 cm)
Edition 1/10
The Broad Art Foundation

Untitled Film Still #54, 1980
Black-and-white photograph
8 x 10 inches (20.3 x 25.4 cm)
Edition 6/10
The Broad Art Foundation
p. 109

Untitled Film Still #58, 1980
Black-and-white photograph
8 x 10 inches (20.3 x 25.4 cm)
Edition 1/10
The Broad Art Foundation

Untitled, 1980
Two color photographs
20 x 24 inches (50.8 x 61 cm) each
A.P. 1/2
The Broad Art Foundation

Untitled #70, 1980
Color photograph
20 x 24 inches (50.8 x 61 cm)
Edition 3/5
The Broad Art Foundation

Untitled #85, 1981
Color photograph
24 x 48 inches (61 x 121.9 cm)
Edition 6/10
The Eli and Edythe L. Broad Collection

Untitled #86, 1981
Color photograph
24 x 48 inches (61 x 121.9 cm)
Edition 10/10
The Eli and Edythe L. Broad Collection

Untitled #92, 1981
Color photograph
24 x 48 inches (61 x 121.9 cm)
Edition 10/10
The Eli and Edythe L. Broad Collection

Untitled #94, 1981
Color photograph
24 x 48 inches (61 x 121.9 cm)
Edition 10/10
The Broad Art Foundation
p. 19

Untitled #97, 1982
Color photograph
45 x 30 inches (114.3 x 76.2 cm)
Edition 10/10
The Eli and Edythe L. Broad Collection
p. 144

Untitled #98, 1982
Color photograph
45 x 30 inches (114.3 x 76.2 cm)
Edition 10/10
The Eli and Edythe L. Broad Collection

Untitled #99, 1982
Color photograph
45 x 30 inches (114.3 x 76.2 cm)
Edition 10/10
The Eli and Edythe L. Broad Collection

Untitled #100, 1982
Color photograph
45 x 30 inches (114.3 x 76.2 cm)
Edition 10/10
The Eli and Edythe L. Broad Collection

Untitled #112, 1982
Color photograph
45 x 30¹/₂ inches (114.3 x 77.5 cm)
Edition 1/10
The Broad Art Foundation

Untitled #114, 1982
Color photograph
49 x 30 inches (124.5 x 76.2 cm)
Edition 7/10
The Broad Art Foundation
p. 123

Untitled #116, 1982
Color photograph
45¹/₄ x 30 inches (114.9 x 76.2 cm)
Edition 1/10
The Broad Art Foundation

Untitled #117, 1983
Color photograph
24¹/₂ x 34³/₄ inches (62.2 x 88.3 cm)
Edition 14/18
The Broad Art Foundation

Untitled #118, 1983
Color photograph
34¹/₂ x 23¹/₄ inches (87.6 x 59.1 cm)
Edition 14/18
The Broad Art Foundation

Untitled #119, 1983
Color photograph
17¹/₂ x 36 inches (44.5 x 91.4 cm)
Edition 14/18
The Eli and Edythe L. Broad Collection

Untitled #120, 1983
Color photograph
34¹/₂ x 21³/₄ inches (87 x 55.2 cm)
Edition 14/18
The Broad Art Foundation

Untitled #122, 1983
Color photograph
35¹/₄ x 21¹/₄ inches (89.5 x 54 cm)
Edition 14/18
The Broad Art Foundation

Untitled #124, 1983
Color photograph
24¹/₂ x 33 inches (62.2 x 83.8 cm)
Edition 14/18
The Broad Art Foundation

Untitled #125, 1983
Color photograph
19¹/₄ x 36 inches (48.9 x 91.4 cm)
Edition 14/18
The Broad Art Foundation

Untitled #126, 1983
Color photograph
34¹/₂ x 22¹/₂ inches (87.6 x 57.2 cm)
Edition 14/18
The Eli and Edythe L. Broad Collection

Untitled #128, 1983
Color photograph
36¹/₄ x 23¹/₄ inches (92.1 x 59.1 cm)
Edition 14/18
The Broad Art Foundation

Untitled #129, 1983
Color photograph
34³/₄ x 23¹/₂ inches (88.3 x 59.7 cm)
Edition 14/18
The Broad Art Foundation

Untitled #131, 1983
Color photograph
34³/₄ x 16¹/₂ inches (88.3 x 41.9 cm)
Edition 14/18
The Broad Art Foundation

Untitled #135, 1984
Color photograph
69³/₄ x 47³/₄ inches (177.2 x 121.3 cm)
Edition 1/5
The Broad Art Foundation

Untitled #136, 1984
Color photograph
72 x 47¹/₂ inches (182.9 x 120.7 cm)
Edition 1/5
The Broad Art Foundation

Untitled #137, 1984
Color photograph
70¹/₂ x 47³/₄ inches (179.1 x 121.3 cm)
Edition 1/5
The Broad Art Foundation

Untitled #138, 1984
Color photograph
71 x 48¹/₂ inches (180.3 x 123.2 cm)
Edition 4/5
The Broad Art Foundation

Untitled #139, 1984
Color photograph
72 x 48¹/₂ inches (182.9 x 123.2 cm)
Edition 2/5
The Broad Art Foundation

Untitled #143, 1985
Color photograph
51³/₄ x 49³/₈ inches
(131.4 x 125.4 cm)
Edition 1/6
The Broad Art Foundation
p. 145

Untitled #146, 1985
Color photograph
72¹/₂ x 49³/₈ inches (184.2 x 125.4)
Edition 6/6
The Broad Art Foundation

Untitled #167, 1986
Color photograph
60 x 90 inches (152.4 x 228.6 cm)
Edition 1/6
The Broad Art Foundation

Untitled #168, 1987
Color photograph
85 x 60 inches
Edition 1/6
The Broad Art Foundation

Untitled #180, 1987
Color photograph (2 panels)
96 x 120 inches overall
Edition 4/6
The Broad Art Foundation

Untitled #190, 1989
Color photograph (2 panels)
96¹/₂ x 73 inches overall
Edition 4/6
The Broad Art Foundation
p. 134

Untitled #191, 1989
Color photograph
90 x 60 inches
Edition 3/6
The Broad Art Foundation

Untitled #193, 1989
Color photograph
48⁷/₈ x 41¹⁵/₁₆ inches
Edition 2/6
The Broad Art Foundation

Untitled #196, 1989
Color photograph
66 x 44 inches
Edition 2/6
The Broad Art Foundation

Untitled #198, 1989
Color photograph
38³/₈ x 27⁷/₈ inches
Edition 2/6
The Broad Art Foundation

Untitled #199, 1989
Color photograph
25 x 18 inches
Edition 2/6
The Broad Art Foundation

Untitled #200, 1989
Color photograph
30¹⁵/₁₆ x 20⁷/₈ inches (78.6 x 53 cm)
Edition 2/6
The Broad Art Foundation

Untitled #201, 1989
Color photograph
52⁷/₈ x 35⁷/₈ inches (134.3 x 91.1 cm)
Edition 2/6
The Broad Art Foundation

Untitled #205, 1989
Color photograph
53¹/₂ x 40¹/₂ inches
(135.9 x 102.9 cm)
Edition 3/6
The Broad Art Foundation

Untitled #207, 1989
Color photograph
65¹/₂ x 49¹/₂ inches
(166.4 x 62.2 cm)
Edition 3/6
The Broad Art Foundation

Untitled #209, 1989
Color photograph
57 x 41 inches (144.8 x 104.1 cm)
Edition 3/6
The Eli and Edythe L. Broad Collection

Untitled #211, 1989
Color photograph
37 x 31 inches (94 x 78.7 cm)
Edition 3/6
The Eli and Edythe L. Broad Collection

Untitled #214, 1989
Color photograph
29¹/₂ x 24 inches (74.9 x 61 cm)
Edition 3/6
The Eli and Edythe L. Broad Collection

Untitled #215, 1989
Color photograph
74¹/₄ x 51 inches (188.6 x 129.5 cm)
Edition 3/6
The Eli and Edythe L. Broad Collection

Untitled #216, 1989
Color photograph
87 x 56 inches (221 x 142.2 cm)
Edition 2/6
The Broad Art Foundation

Untitled, 1990
Color photograph
13 x 10 inches (33 x 25.4 cm)
Unlimited edition
The Broad Art Foundation

Untitled #225, 1990
Color photograph
48 x 33 inches (121.9 x 83.8 cm)
Edition 4/6
The Broad Art Foundation
p. 146

Untitled #228, 1990
Color photograph
82 x 48 inches (208.3 x 121.9 cm)
Edition 5/6
The Broad Art Foundation
p. 147

Untitled #243, 1991
Color photograph
49 x 72 inches (124.5 x 182.9 cm)
Edition 1/6
The Broad Art Foundation

Untitled #264, 1992
Color photograph
50 x 75 inches (127 x 190.5 cm)
Edition 4/6
The Broad Art Foundation
p. 148

Untitled, 1993
Color photograph
5 x 7 inches (12.7 x 17.8 cm)
Unlimited edition
The Broad Art Foundation

Untitled #276, 1993
Color photograph
80¹/₂ x 61 inches (204.5 x 154.9 cm)
Edition 5/6
The Broad Art Foundation
p. 19

Untitled #278, 1993
Color photograph
73 x 49 inches (185.4 x 124.5 cm)
Edition 4/6
The Broad Art Foundation

Untitled #296, 1994
Color photograph
65¹/₄ x 45¹/₄ inches
(165.7 x 114.9 cm)
Edition 5/6
The Broad Art Foundation

Untitled #297, 1994
Color photograph
50 x 33 inches (127 x 83.8 cm)
Edition 2/6
The Broad Art Foundation

Untitled #304, 1994
Color photograph
61 x 41 inches (154.9 x 104.1 cm)
Edition 4/6
The Broad Art Foundation

Untitled #311, 1994
Cibachrome photograph
76 x 51 inches (193 x 129.5 cm)
Edition 5/6
The Broad Art Foundation

Untitled #315, 1995
Cibachrome photograph
60 x 40 inches (152.4 x 101.6 cm)
Edition 5/6
The Broad Art Foundation

Untitled #321, 1996
Cibachrome photograph
57¹/₂ x 38¹/₂ inches
(146.1 x 97.8 cm)
Edition 1/6
The Broad Art Foundation

Untitled #324, 1996
Cibachrome photograph
57³/₄ x 39 inches (146.7 x 99.1 cm)
Edition 1/6
The Broad Art Foundation
p. 148

Untitled #330, 1996
Cibachrome photograph
56⁷/₈ x 38 inches (144.5 x 96.5 cm)
Edition 1/6
The Broad Art Foundation

Untitled #332, 1999
Black-and-white photograph
38¹/₂ x 25¹/₂ inches (97.8 x 64.8 cm)
Edition 4/10
The Broad Art Foundation

Untitled #334, 1999
Black-and-white photograph
47¹/₂ x 31¹/₂ inches (120.7 x 80 cm)
Edition 9/10
The Broad Art Foundation

Untitled #339, 1999
Black-and-white photograph
35¹/₂ x 23¹/₂ inches (90.2 x 59.7 cm)
Edition 9/10
The Broad Art Foundation

Untitled #353, 2000
Color photograph
36 x 24 inches (91.4 x 61 cm)
Edition 4/6
The Broad Art Foundation

Untitled #354, 2000
Color photograph
36 x 24 inches (91.4 x 61 cm)
Edition 4/6
The Broad Art Foundation

Untitled #355, 2000
Color photograph
36 x 24 inches (91.4 x 61 cm)
Edition 4/6
The Broad Art Foundation
p. 149

Untitled #356, 2000
Color photograph
30 x 20 inches (76.2 x 50.8 cm)
Edition 4/6
The Broad Art Foundation
p. 149

Untitled #357, 2000
Color photograph
30 x 20 inches (76.2 x 50.8 cm)
Edition 4/6
The Broad Art Foundation

Untitled #361, 2000
Color photograph
36 x 24 inches (91.4 x 61 cm)
Edition 4/6
The Broad Art Foundation

Untitled #363, 1976/2000
Black-and-white photograph
7³/₁₆ x 5 inches (18.3 x 12.7 cm)
Edition 8/20
The Broad Art Foundation

Untitled #364, 1976/2000
Black-and-white photograph
7³/₁₆ x 5 inches (18.3 x 12.7 cm)
Edition 8/20
The Broad Art Foundation

Untitled #365, 1976/2000
Black-and-white photograph
7³/₁₆ x 5 inches (18.3 x 12.7 cm)
Edition 8/20
The Broad Art Foundation

Untitled #366, 1976/2000
Black-and-white photograph
7³/₁₆ x 5 inches (18.3 x 12.7 cm)
Edition 8/20
The Broad Art Foundation

Untitled #367, 1976/2000
Black-and-white photograph
7³/₁₆ x 5 inches (18.3 x 12.7 cm)
Edition 8/20
The Broad Art Foundation

Untitled #368, 1976/2000
Black-and-white photograph
7³/₁₆ x 5 inches (18.3 x 12.7 cm)
Edition 8/20
The Broad Art Foundation

Untitled #369, 1976/2000
Black-and-white photograph
7³/₁₆ x 5 inches (18.3 x 12.7 cm)
Edition 8/20
The Broad Art Foundation

Untitled #370, 1976/2000
Black-and-white photograph
7³/₁₆ x 5 inches (18.3 x 12.7 cm)
Edition 8/20
The Broad Art Foundation

Untitled #371, 1976/2000
Black-and-white photograph
7³/₁₆ x 5 inches (18.3 x 12.7 cm)
Edition 8/20
The Broad Art Foundation

Untitled #372, 1976/2000
Black-and-white photograph
7³/₁₆ x 5 inches (18.3 x 12.7 cm)
Edition 8/20
The Broad Art Foundation

Untitled #373, 1976/2000
Black-and-white photograph
7³/₁₆ x 5 inches (18.3 x 12.7 cm)
Edition 8/20
The Broad Art Foundation

Untitled #374, 1976/2000
Black-and-white photograph
7³/₁₆ x 5 inches (18.3 x 12.7 cm)
Edition 8/20
The Broad Art Foundation

Untitled #375, 1976/2000
Black-and-white photograph
7³/₁₆ x 5 inches (18.3 x 12.7 cm)
Edition 8/20
The Broad Art Foundation

Untitled #376, 1976/2000
Black-and-white photograph
7³/₁₆ x 5 inches (18.3 x 12.7 cm)
Edition 8/20
The Broad Art Foundation

Untitled #377, 1976/2000
Black-and-white photograph
7³/₁₆ x 5 inches (18.3 x 12.7 cm)
Edition 8/20
The Broad Art Foundation

Untitled #396, 2000
Color photograph
36 x 24 inches (91.4 x 61 cm)
Edition 1/6
The Broad Art Foundation

Untitled #397, 2000
Color photograph
36 x 24 inches (91.4 x 61 cm)
Edition 1/6
The Broad Art Foundation

Untitled #403, 2000
Color photograph
22 x 15 inches (55.9 x 38.1 cm)
Edition 1/6
The Broad Art Foundation

Untitled #404, 2000
Color photograph
32¹/₂ x 22 inches (82.6 x 55.9 cm)
Edition 1/6
The Broad Art Foundation

Untitled #405, 2000
Color photograph
33 x 22 inches (83.8 x 55.9 cm)
Edition 1/6
The Broad Art Foundation

Robert Therrien
United States, b. 1947

No Title, 1977
Enamel and wax on wood
96 x 30 x 4 inches
(243.8 x 76.2 x 10.2 cm)
The Eli and Edythe L. Broad Collection

No Title, 1982
Oil and wax on wood
15 x 27³/₄ x 35¹/₂ inches
(38.1 x 70.5 x 90.2 cm)
The Broad Art Foundation

No Title, 1983
Lacquer and wax on wood
90 x 36 x 4 inches
(228.6 x 91.4 x 10.2 cm)
The Broad Art Foundation

No Title, 1983
Bronze
97 x 5¹/₄ x 5 inches
(246.4 x 13.3 x 12.7 cm)
The Eli and Edythe L. Broad Collection

No Title, 1984
Oil and mixed media on wood
144 x 3¹/₂ inches (365.8 x 8.9 cm)
The Broad Art Foundation

No Title, 1984–85
Enamel on bronze and wood
50 x 12¹/₂ x 5¹/₂ inches
(127 x 31.8 x 14 cm)
The Broad Art Foundation

No Title, 1985
Oil on canvas mounted on wood
64 x 96 inches (162.6 x 243.8 cm)
The Broad Art Foundation

No Title, 1985
Oil on canvas mounted on wood
48 x 72 inches (121.9 x 182.9 cm)
The Broad Art Foundation

No Title, 1985
Tin on bronze
74⁵/₈ x 35¹/₄ x 35¹/₄ inches
(189.5 x 89.5 x 89.5)
The Broad Art Foundation

No Title, 1987
Dye on wood
5¹/₈ x 1³/₄ x ³/₄ inches
(13 x 4.4 x 1.9 cm)
The Eli and Edythe L. Broad Collection

No Title, 1987
Brass and enamel on aluminum
27¹/₄ x 22⁵/₈ x 1¹/₂ inches
(69.2 x 57.5 x 3.8 cm)
The Eli and Edythe L. Broad Collection

No Title, 1986–87
Zinc on bronze
21 x 10 x 10 inches
(129.5 x 25.4 x 25.4 cm)
The Eli and Edythe L. Broad Collection
p. 25

No Title, 1991
Enamel and paper and wood
111 x 41 x 7³/₄ inches
(281.9 x 104.1 x 19.7 cm)
The Broad Art Foundation

No Title, 1993
Ceramic epoxy on fiberglass
94 x 60 x 60 inches
(228.6 x 152.4 x 152.4 cm)
The Broad Art Foundation
p. 26

No Title, 1993–94
Tempera and silver-plated bronze
84$\frac{1}{2}$ x 70$\frac{1}{2}$ x 4 inches
(214.6 x 179.1 x 10.2 cm)
The Broad Art Foundation

Under the Table, 1994
Wood and metal
117 x 312 x 216 inches
(291.2 x 792.5 x 548.6 cm) overall
The Broad Art Foundation
p. 27

No Title, 1982–98
Plaster
36 x 16 x 16 inches
(91.4 x 40.6 x 40.6 cm)
The Eli and Edythe L. Broad Collection

Cy Twombly
United States, b. 1928

Untitled, 1955
Oil-based house paint and
lead pencil on canvas
43$\frac{1}{4}$ x 50$\frac{3}{4}$ inches
(109.9 x 128.9 cm)
The Eli and Edythe L. Broad Collection
p. 55

Ilium (One Morning Ten Years Later),
1964 [Part 1]
Oil paint, lead pencil, and wax crayon
on canvas
78$\frac{3}{4}$ x 82$\frac{3}{4}$ inches
(200 x 210.2 cm)
The Eli and Edythe L. Broad Collection
p. 47

Untitled, 1969
Oil-based house paint, wax crayon,
lead, and colored pencil on canvas
78$\frac{3}{4}$ x 94$\frac{5}{8}$ inches
(200 x 240.3 cm)
The Eli and Edythe L. Broad Collection
Photography credit:
Douglas M. Parker Studio
p. 48

Nini's Painting, 1971
Oil-based house paint, wax crayon,
and lead pencil on canvas
102$\frac{3}{4}$ x 118$\frac{1}{4}$ inches
(260.1 x 300.3 cm)
The Eli and Edythe L. Broad Collection
p. 49

Untitled, 1972
Oil paint, wax crayon, and lead pencil
on canvas
79$\frac{5}{8}$ x 102$\frac{1}{2}$ inches
(202.2 x 260.3 cm)
The Eli and Edythe L. Broad Collection
p. 57

Untitled, 1973
Mixed media on paper
35 x 30 inches (88.9 x 76.2 cm)
The Eli and Edythe L. Broad Collection

By the Ionian Sea, 1988
Bronze and oil-based paint
12$\frac{1}{8}$ x 22$\frac{7}{8}$ x 19$\frac{5}{8}$ inches
(30.8 x 58.1 x 49.8 cm)
Edition 1/6
The Eli and Edythe L. Broad Collection
Photography credit:
Douglas M. Parker Studio
p. 54

Andy Warhol
United States, 1928–1987

Dollar Bill, 1962
Pencil, crayon, and gouache on paper
30 x 40 inches (76.2 x 101.6 cm)
The Eli and Edythe L. Broad Collection
p. 98

Two Marilyns, 1962
Silkscreen ink, acrylic, and pencil on
canvas
20$\frac{1}{8}$ x 27 inches (51.1 x 68.6 cm)
The Eli and Edythe L. Broad Collection
p. 97

Ambulance Disaster, 1963
Screenprint on Strathmore
Drawing paper
40 x 30$\frac{1}{8}$ inches (101.6 x 76.5 cm)
The Eli and Edythe L. Broad Collection

Elvis, 1963
Silkscreen ink and spray paint on linen
103$\frac{1}{2}$ x 49$\frac{1}{4}$ inches
(262.9 x 125.1 cm)
The Eli and Edythe L. Broad Collection
p. 84

The Kiss (Bela Lugosi), c. 1963
Screenprint on paper
30 x 40 inches (76.2 x 101.6 cm)
The Eli and Edythe L. Broad Collection
p. 100

Race Riot, 1963
Screenprint on Strathmore
Drawing paper
30$\frac{1}{8}$ x 40 inches (76.5 x 101.6 cm)
The Eli and Edythe L. Broad Collection
p. 99

*Most Wanted Men No. 6, Thomas
Francis C.*, 1964
Silkscreen ink and synthetic polymer
paint on two canvas panels
48 x 78 inches
(121.9 x 198.1 cm) overall
The Eli and Edythe L. Broad Collection
p. 83

Nine Blue Jackies, 1964
Acrylic and silkscreen on canvas
59$\frac{7}{8}$ x 47$\frac{5}{8}$ inches (152.1 x 121 cm)
The Eli and Edythe L. Broad Collection
p. 20

Self Portrait, 1966
Silkscreened synthetic polymer paint
and enamel, pencil, and ballpoint pen
on six canvas panels
22$\frac{5}{8}$ x 22$\frac{5}{8}$ inches
(57.6 x 57.6 cm) each
The Eli and Edythe L. Broad Collection
p. 21

Big Electric Chair, 1967
Silkscreen ink and synthetic polymer
paint on canvas
53$\frac{3}{4}$ x 73$\frac{1}{4}$ inches
(136.5 x 186.1 cm)
The Eli and Edythe L. Broad Collection
frontis page and p. 82

Mao-Tse-Tung, 1973
Acrylic and silkscreen on canvas
26 x 22 inches (66 x 55.9 cm)
The Eli and Edythe L. Broad Collection

40 Gold Marilyns, 1980
Silkscreen ink and synthetic polymer
paint on canvas
80 x 111 inches (203.2 x 281.9 cm)
The Eli and Edythe L. Broad Collection
p. 101

charles ray

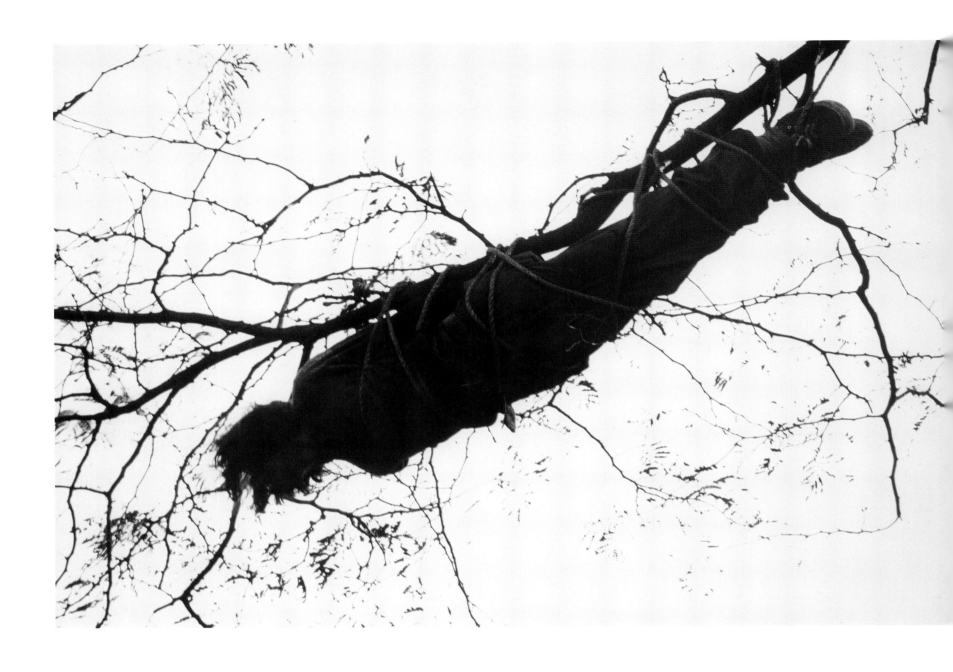

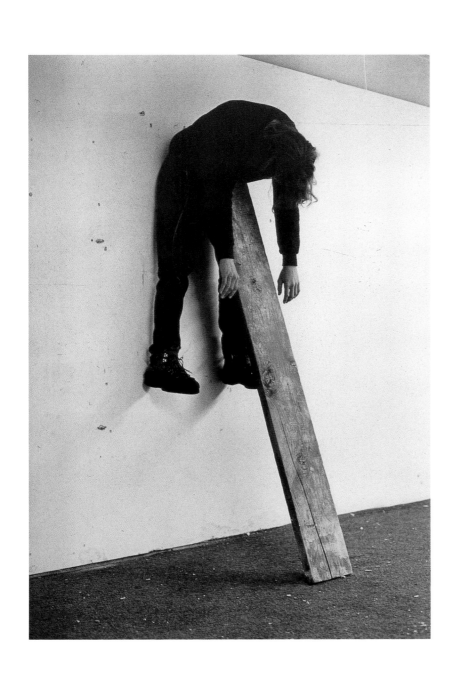

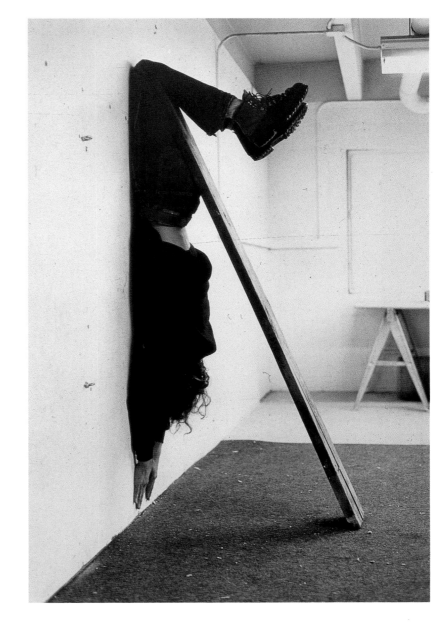

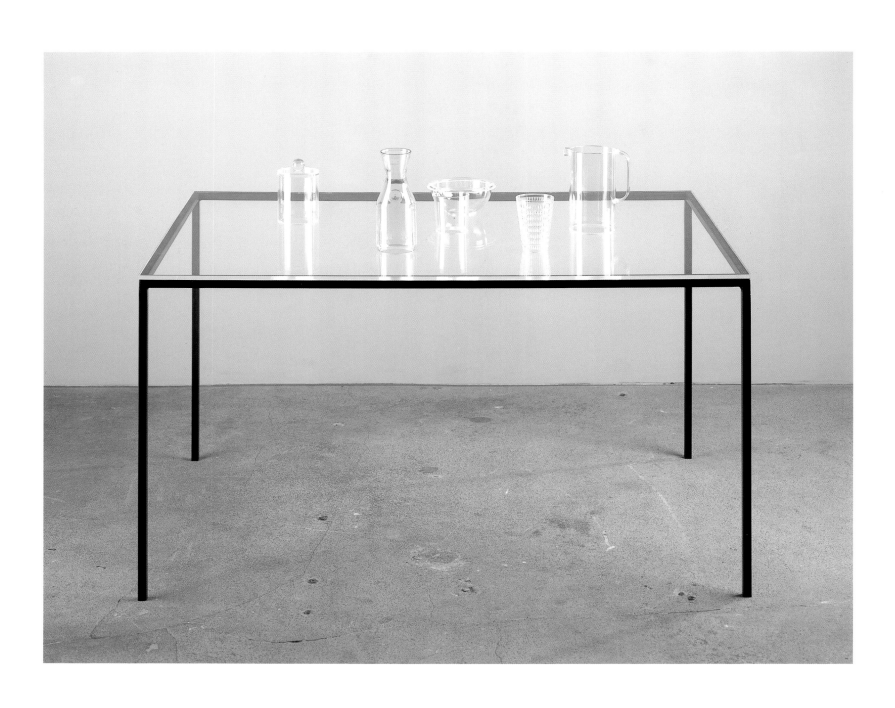

Artists in The Broad Art Foundation

Amy Adler, John Ahearn, Richard Artschwager, Donald Baechler, John Baldessari, Stephan Balkenhol, Jean-Michel Basquiat, Vanessa Beecroft, Ashley Bickerton, Ross Bleckner, Jonathan Borofsky, Richard Bosman, John Bowman, Cecily Brown, James Brown, Richmond Burton, St. Clair Cemin, Louisa Chase, Sue Coe, Robbie Conal, George Condo, Gregory Crewdson, Ronnie Cutrone, David Deutsch, John Duff, Tim Ebner, Christian Eckart, R. M. Fischer, Eric Fischl, Günther Förg, Roy Fowler, Ellen Gallagher, Charles Garabedian, Jill Giegerich, Jack Goldstein, Leon Golub, Tracy Grayson, Robert Greene, Timothy Greenfield-Sanders, Andreas Gursky, Hans Haacke, Peter Halley, Keith Haring, Jenny Holzer, Brian Hunt, Jörg Immendorff, Lee Jaffe, Bill Jensen, Mike Kelley, Toba Khedoori, Anselm Kiefer, Imi Knoebel, Jeff Koons, Barbara Kruger, Cheryl Laemmle, Jonathan Lasker, Annette Lemieux, Sherrie Levine, Roy Lichtenstein, Glenn Ligon, Sharon Lockhart, Robert Longo, Markus Lüpertz, David McDermott & Peter McGough, Will Mentor, Robert Morris, Shirin Neshat, Cady Noland, Albert Oehlen, Tom Otterness, Joel Otterson, Tony Oursler, Lari Pittman, Sigmar Polke, Richard Prince, Charles Ray, Susan Rothenberg, Ed Ruscha, David Salle, Italo Scanga, Kenny Scharf, Julian Schnabel, Peter Schuyff, Cindy Sherman, Kiki Smith, Ray Smith, Frank Stella, Gary Stephan, Donald Sultan, Philip Taaffe, Mark Tansey, Robert Therrien, John Torreano, David True, Meyer Vaisman, Kara Walker, Sue Williams, Terry Winters, David Wojnarowicz, Christopher Wool, Robert Yarber, Michele Zalopany

Artists in The Eli and Edythe L. Broad Collection

Carl Andre, Richard Artschwager, John Baldessari, Georg Baselitz, Jean-Michel Basquiat, Bernd and Hilla Becher, Ross Bleckner, Jonathan Borofsky, Georges Braque, Scott Burton, Alexander Calder, Chuck Close, Salvador Dalí, Willem de Kooning, Richard Deacon, David Deutsch, Philip-Lorca diCorcia, Richard Diebenkorn, Tim Ebner, Christian Eckart, Eric Fischl, Sam Francis, Alberto Giacometti, Jill Giegerich, Leon Golub, Timothy Greenfield-Sanders, Irving Greines, Peter Halley, Keith Haring, Jenny Holzer, Bryan Hunt, Jörg Immendorff, Robert Indiana, Mark Innerst, Robert Irwin, Neil Jenney, Bill Jensen, Jasper Johns, Donald Judd, Ellsworth Kelly, Anselm Kiefer, Jeff Koons, Annette Lemieux, Julian Lethbridge, Sherrie Levine, Roy Lichtenstein, Robert Longo, Andrew Lord, Robert Mapplethorpe, Brice Marden, Henri Matisse, John McLaughlin, Will Mentor, Joan Miró, Henry Moore, Malcolm Morley, Robert Moskowitz, Elizabeth Murray, Bruce Nauman, Kenneth Noland, Tom Otterness, Pablo Picasso, Sigmar Polke, Robert Rauschenberg, Gerhard Richter, George Rickey, Susan Rothenberg, Ed Ruscha, David Salle, Adrian Saxe, Julian Schnabel, George Schneeman, Sean Scully, George Segal, Richard Serra, Joel Shapiro, Cindy Sherman, Laurie Simmons, David Smith, Frank Stella, Hiroshi Sugimoto, Donald Sultan, Philip Taaffe, Mark Tansey, Robert Therrien, Henri de Toulouse-Lautrec, Cy Twombly, Andy Warhol, Christopher Williams, Terry Winters, Christopher Wool

sharon lockhart

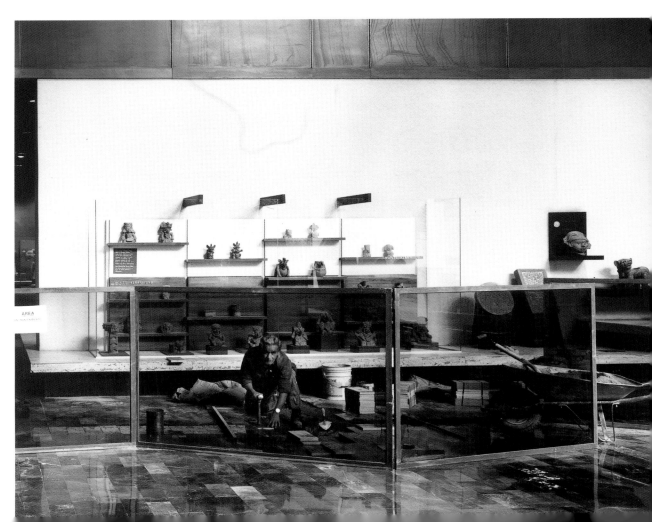

John Baldessari

Bruggen, Coosje van. *John Baldessari.* Exh. cat. Los Angeles: The Museum of Contemporary Art, 1990.

Davies, Hugh M., and Andrea Hales, eds. *John Baldessari: National City.* Exh. cat. San Diego: Museum of Contemporary Art, 1996.

John Baldessari. Exh. cat. Eindhoven, The Netherlands: Van Abbemuseum; Essen, Germany: Museum Folkwang, 1981.

John Baldessari. Exh. cat. Santiago de Compostela, Spain: Casa da Parra,1992.

Not Even So: John Baldessari. Exh. cat. Madrid: Centro de Arte Reina Sofia, 1989.

Stephan Balkenhol

Benezra, Neal. *Stephan Balkenhol: Sculptures and Drawings.* Exh. cat. Washington, D.C.: Hirshhorn Museum and Sculpture Garden, Smithsonian Institution in association with Cantz Publishers, Stuttgart, 1996.

Kent, Sarah. *Stephan Balkenhol: Sculptures 1988–1996 in the Saatchi Collection.* Exh. cat. London: The Saatchi Gallery, 1996.

Stephan Balkenhol. Exh. cat. [Basel]: Kunsthalle Basel, 1989.

Stephan Balkenhol. Exh. cat. Dublin: Irish Museum of Modern Art, 1991.

Stephan Balkenhol Skulpturen. Exh. cat. Wuppertal, Germany: Von der Heydt-Museum; Bielefeld: Kerber, 1998.

Stephan Balkenhol: Über Menschen und Skulpturen/About Men and Sculpture. Exh. cat. Rotterdam, The Netherlands: Witte de With Center for Contemporary Art; Stuttgart: Edition Cantz, 1992.

Georg Baselitz

Barron, Stephanie. *Georg Baselitz: Skulpturen und Zeichnungen 1979–1987.* Exh. cat. Hannover: Kestner-Gesellschaft, 1987.

Franzke, Andreas. *Georg Baselitz.* Trans. David Britt. Munich: Prestel, 1989.

Fuchs, Rudi. *Georg Baselitz: Reise in die Niederlande.* Exh. cat. Amsterdam: Stedelijk Museum, 1999.

Georg Baselitz. Texts by Siegfried Gohr, Emil Maurer, and Diane Waldman. Cologne: Benedikt Taschen, 1990.

Gohr, Siegfried. *Georg Baselitz: Prints 1963–1983.* Exh. cat. Munich: Prestel, 1984.

Joachimides, Christos M., ed. *Georg Baselitz: Dipinti 1965–1987.* Milan: Electa, 1988.

Waldman, Diane. *Georg Baselitz.* Exh. cat. New York: Solomon R. Guggenheim Museum, 1995.

Jean-Michel Basquiat

Haenlein, Carl. *Jean-Michel Basquiat: Das zeichnerische Werk.* Exh. cat. Hannover: Kestner-Gesellschaft, 1989.

——, ed. *Jean-Michel Basquiat.* Exh. cat. Hannover: Kestner-Gesellschaft, 1987.

Jean Michel-Basquiat. Exh. cat. Seville: Junta de Andalucia, Consejería de Cultura, Centro Andaluz de Arte Contemporáneo, 1996.

Marshall, Richard. *Jean-Michel Basquiat.* Exh. cat. New York: Whitney Museum of American Art, 1992.

Warsh, Larry, ed. *Jean-Michel Basquiat: The Notebooks.* New York: Art and Knowledge, 1993.

Bernd and Hilla Becher

Bernd and Hilla Becher: Framework Houses of the Siegen Industrial Region. Munich: Schirmer/Mosel, 1977.

Bernd and Hilla Becher: Tipologie=Typologien=Typologies. Exh. cat. Münster: Klaus Bussmann im Auftrag des Auswärtigen Amtes Bonn, 1990.

Bernd and Hilla Becher: Water Towers. Cambridge, Mass.: MIT Press, 1988.

Bernhard und Hilla Becher: Typologien industrieller Bauten 1963–1975: XIV. Bienal International de São Paolo. Exh. cat. São Paolo, Brazil: Bienal Internacional, República Federal da Alemanha, 1977.

Lange, Susanne. *Bernd und Hilla Becher: Häuser und Hallen.* Frankfurt: Museum für Moderne Kunst, 1992.

Ross Bleckner

Currents 14: Ross Bleckner. Exh. cat. Milwaukee: Milwaukee Art Museum, 1989.

Dennison, Lisa. *Ross Bleckner.* Exh. cat. New York: Guggenheim Museum, 1995.

Rosenberg, Barry A. *The City Influence: Ross Bleckner, Peter Halley, Jonathan Lasker.* Exh. cat. Dayton, Ohio: Dayton Art Institute, Museum of Contemporary Art at Wright State University, 1992.

Ross Bleckner: Watercolor. Santa Fe: Arena Editions, 1998.

Tsuzuki, Kyoichi, ed. *Ross Bleckner.* Kyoto: Sashin Kaguku Co., Ltd., 1990.

Eric Fischl

Danto, Arthur C. *Eric Fischl 1970–2000.* New York: Monacelli Press, 2000.

Eric Fischl. Exh. cat. New York: Mary Boone Michael Werner Gallery, 1988.

Ferguson, Bruce W., Jean-Christophe Ammann, and Donald B. Kuspit. *Eric Fischl Paintings.* Exh. cat. Saskatoon, Canada: Mendel Art Gallery, 1985.

Sørensen, Jens Erik, ed. *Eric Fischl.* Exh. cat. Aarhus, Denmark: Aarhus Kunstmuseum; [Humlebæk, Denmark]: Louisiana Museum for Moderne Kunst, 1991.

Whitney, David, ed. *Eric Fischl.* Essay by Peter Schjeldahl. New York: Art in America, Stewart, Tabori & Chang, 1988.

Hans Haacke

Bußmann, Klaus, and Florian Matzner, eds. *Hans Haacke, Bodenlos: Biennale Venedig, Deutsche Pavillon.* Exh. cat. Stuttgart: Edition Cantz, 1993.

Haacke, Hans. *AnsichtsSachen=ViewingMatters.* Exh. cat. Rotterdam: Museums Boijmans van Beuningen; Dusseldorf: Richter, 1999

Hans Haacke, Artfairismes. Exh. cat. Paris: Centre Georges Pompidou, Musée national d'art moderne, galeries contemporain, 1989.

"Obra Social" Hans Haacke. Exh. cat. Barcelona: Fundació Antoni Tàpies, 1995.

Wallis, Brian, ed. *Hans Haacke: Unfinished Business.* Exh. cat. New York: New Museum of Contemporary Art; Cambridge, Mass.: MIT Press, 1986.

Jörg Immendorff

Elliott, David, and Harald Szeemann. *Jörg Immendorff: Café Deutschland and Related Works.* Exh. cat. Oxford: Museum of Modern Art, 1984.

Haenlein, Carl Albrecht, ed. *Jörg Immendorff: Bilder und Zeichnungen (Paintings and Drawings).* Hannover: Kestner Gesellschaft, 2000

Immendorff. Essays by Rudi Fuchs, Karel Schampars, and Siegfried Gohr. Exh. cat. Rotterdam, The Netherlands: Museum Boymans-van Beuningen; Den Haag: Haags Gemeentemuseum, 1992.

Immendorff: The Rake's Progress. Exh. cat. London: Barbican Art Gallery, 1995.

Tolnay, Alexander, ed. *Immendorff: Malerei, 1983–1990.* Esslingen, Germany: Galerie der Stadt Esslingen, 1991.

Jasper Johns

Bernstein, Roberta. *Jasper Johns.* Rizzoli art series. New York: Rizzoli International Publications, 1992.

Boudaille, Georges. *Jasper Johns.* New York: Rizzoli, 1989.

Crichton, Michael. *Jasper Johns.* Exh. cat. New York: Whitney Museum of American Art and Harry N. Abrams, 1977.

Field, Richard S. *The Prints of Jasper Johns 1960–1993: A Catalogue Raisonné.* West Islip, N.Y.: Universal Limited Art Editions, Inc., 1994.

Francis, Richard. *Jasper Johns.* New York: Abbeville Press, 1984.

Jasper Johns Flags, 1955–1994. Exh. cat. London: Anthony d'Offay Gallery, 1996.

Jasper Johns: Loans from the Artist. Exh. cat. Basel: Fondation Beyeler, 1997.

Kozloff, Max. *Jasper Johns.* New York: Harry N. Abrams, Inc. 1972.

Orton, Fred. *Figuring Jasper Johns.* Cambridge, Mass.: Harvard University Press, 1994.

Rosenthal, Mark. *Jasper Johns: Work since 1974.* Exh. cat. Philadelphia: Philadelphia Museum of Art, 1989.

Varnedoe, Kirk. *Jasper Johns: A Retrospective.* Exh. cat. New York: The Museum of Modern Art, 1996.

Anselm Kiefer

Anselm Kiefer. Exh. cat. Essen, Germany: Museum Folkwang; London: Whitechapel Art Gallery, 1981.

Anselm Kiefer. Texts by Rudi H. Fuchs, Suzanne Pagé, and Jürgen Harten. Exh. cat. Dusseldorf: Städtische Kunsthalle, 1984.

Anselm Kiefer. Exh. cat. [Berlin]: Nationalgalerie Berlin Staatlich Museen Prussischen Kulturbesitz, 1991.

Anselm Kiefer. Texts by Massimo Cacciari and Germano Celant. Milan: Edizioni Charta, 1997.

Anselm Kiefer: Bilder 1986–1980. Exh. cat. Amsterdam: Stedelijk Museum, 1987.

Harten, Jürgen. *A Book by Anselm Kiefer: Transition from Cool to Warm.* New York: George Braziller in association with the Boston Museum of Fine Arts, 1988.

López-Pedraza, Rafael. *Anselm Kiefer: The Psychology of "After the Catastrophe."* New York: George Braziller, 1996.

Rosenthal, Mark, and A. James Speyer. *Anselm Kiefer.* Exh. cat. Chicago: Art Institute of Chicago; Philadelphia: Philadelphia Museum of Art, 1987.

Jeff Koons

Danoff, I. Michael. *Jeff Koons.* Exh. cat. Chicago: Museum of Contemporary Art, 1988.

Jeff Koons. Exh. cat. San Francisco: San Francisco Museum of Modern Art, 1992.

Jeff Koons. Exh. cat. Amsterdam: Stedelijk Museum, 1993.

The Jeff Koons Handbook. London: Anthony d'Offay Gallery, 1992.

Muthesius, Angelika, ed. *Jeff Koons.* Cologne: Benedikt Taschen, 1992.

Roy Lichtenstein

Alloway, Lawrence. *Roy Lichtenstein.* New York: Abbeville Press, 1983.

Fitzpatrick, Robert, and Dorothy Lichtenstein. *Roy Lichtenstein: Interiors.* Chicago: Museum of Contemporary Art, 1999.

Hendrickson, Janis. *Lichtenstein.* Cologne: Benedikt Taschen, 1988.

Roy Lichtenstein. Essays by Robert Rosenblum and Sarat Maharaj. Exh. cat. London: The Tate Gallery, 1993.

Roy Lichtenstein. Essay by Jack Cowart. Exh. cat. Basel: Fondation Beyeler, 1998.

Waldman, Diane. *Roy Lichtenstein.* New York: Solomon R. Guggenheim Foundation, 1969.

——. *Roy Lichtenstein.* New York: Harry N. Abrams, 1971.

——. *Roy Lichtenstein.* New York: Solomon R. Guggenheim Foundation, 1993.

Sharon Lockhart

Sharon Lockhart: Goshogaoka Girls Basketball Team. Exh. cat. Santa Monica: Blum and Poe Gallery, 1998.

Sharon Lockhart: Teatros Amazonas. Exh. cat. Rotterdam: NAi Publishers, Museum Boijmans van Beuningen, 1999.

Sigmar Polke

Schimmel, Paul. *Sigmar Polke: Photoworks, When Pictures Vanish.* Exh. cat. Los Angeles: The Museum of Contemporary Art, 1995.

Sigmar Polke. Exh. cat. Rotterdam: Museum Boymans-van Beuningen, [1983].

Sigmar Polke. Exh. cat. Cologne: Josef-Haubrich-Kunsthalle, 1984.

Sigmar Polke. Exh. cat. San Francisco: San Francisco Museum of Modern Art, 1990.

Sigmar Polke. Exh. cat. Amsterdam: Stedelijk Museum, 1992.

Sigmar Polke: Join the Dots. Exh. cat. London: Tate Gallery Publications, 1995.

Sigmar Polke: Transit. Exh. cat. Osfildern-Ruit, Germany: Cantz, 1996.

Robert Rauschenberg

Forge, Andrew. *Rauschenberg.* New York: Abrams, 1969.

Hopps, Walter. *Robert Rauschenberg: The Early 1950s.* Exh. cat. Houston: The Menil Collection; Houston Fine Art Press, 1991.

Hopps, Walter, and Susan Davidson. *Robert Rauschenberg: A Retrospective.* Exh. cat. New York: Guggenheim Museum, 1997.

Robert Rauschenberg. Exh. cat. Washington, D.C.: National Collection of Fine Arts, Smithsonian Institution, [1976].

Robert Rauschenberg: Werke 1950–1980. Exh. cat. Berlin: Staatliche Kunsthalle, 1980.

Zweite, Armin, ed. *Robert Rauschenberg.* Exh. cat. Düsseldorf: Kunstsammlung Nordrhein-Westfalen; Cologne: DuMont, 1994.

Charles Ray

Barnes, Lucinda, ed. *Charles Ray.* Exh. cat. Newport Beach, Calif.: Newport Harbor Art Museum, 1990.

Ferguson, Bruce W. *Charles Ray.* Exh. cat. Mälmo, Sweden: Rooseum Center for Contemporary Art, 1994.

Schimmel, Paul, and Lisa Phillips. *Charles Ray.* Exh. cat. Los Angeles: The Museum of Contemporary Art, 1998.

Susan Rothenberg

Grevenstein, Alexander van. *Susan Rothenberg: recente schilderijen (Recent Paintings).* Exh. cat. Amsterdam: Stedelijk Museum, 1982.

Hickey, Dave, and Michael Auping. *Susan Rothenberg.* Exh. cat. New York: Rizzoli in association with Albright-Knox Art Gallery, Buffalo, 1992.

Nittve, Lars, ed. *Susan Rothenberg: 15 Years, A Survey.* Exh. cat. Malmö, Sweden: Rooseum, 1990.

Simon, Joan. *Susan Rothenberg.* New York: Abrams, 1991.

Susan Rothenberg: Paintings from the Nineties. Exh. cat. New York: Rizzoli in association with Museum of Fine Arts, Boston, 1999.

Ed Ruscha

Benezra, Neal, and Kerry Brougher. *Ed Ruscha.* Exh. cat. Washington, D.C.: Hirshhorn Museum and Sculpture Garden, Smithsonian Institution, 2000.

Edward Ruscha. Exh. cat. Nagoya, Japan: Institute of Contemporary Arts, 1988.

Edward Ruscha Paintings. Exh. cat. Rotterdam: Museum Boymans-van Beuningen, 1990.

Edward Ruscha: Words without Thoughts Never to Heaven Go. Exh. cat. Lake Worth, Fla.: Lannan Museum, 1988.

Heaven: Edward Ruscha Editions 1959–1999: Catalogue Raisonné. Exh. cat. Minneapolis: Walker Art Center and Art Publishers, 1999.

I Don't Want No Retrospective: The Works of Ed Ruscha. Exh. cat. San Francisco: San Francisco Museum of Modern Art, 1982.

David Salle

David Salle. Exh. cat. Milan: Edizioni Charta, 1997.

David Salle: Painting and Works on Paper: 1981–1991. Exh. cat. Monterrey, Mexico: Museo de Arte Contemporáneo de Monterrey, 2000.

David Salle: 20 Years of Painting. Exh. cat. Amsterdam: Stedelijk Museum; Ghent, Belgium: Ludion, 1999.

Schjeldahl, Peter. *Salle [An Interview with David Salle].* Elizabeth Avedon Editions/Vintage Contemporary Artists. New York: Vintage Books, 1987.

Whitney, David, ed. *David Salle.* New York: Rizzoli, 1994.

Julian Schnabel

Barzel, Amnon. *Julian Schnabel.* Exh. cat. Prato, Italy: Centro per l'arte contemporanea Luigi Pecci, Museo d'arte contemporanea, 1989.

Eccher, Danilo. *Julian Schnabel.* Exh. cat. Bologna and Turin: Galleria d'art moderna and Hopefulmonster, 1996.

López Garmendia, Olatz. *Julian Schnabel: Retrospectiva.* Exh. cat. Monterrey, Mexico: Museo de Monterrey, 1994.

Schnabel, Julian. *C.V.J.: Nicknames of Maitre D's & Other Excerpts from Life.* New York: Random House, 1987.

Serota, Nicholas, and Joanna Skipwith, eds. *Julian Schnabel: Paintings, 1975–1987.* Exh. cat. London: Whitechapel Art Gallery, 1987.

Cindy Sherman

Cindy Sherman. Essays by Peter Schjeldahl and Lisa Phillips. Exh. cat. New York: Whitney Museum of American Art, 1987.

Cindy Sherman: Retrospective. Essays by Amada Cruz, Elizabeth A. T. Smith, and Amelia Jones. Exh. cat. New York: Thames and Hudson, 1997.

Cindy Sherman: Untitled Film Stills. Essay by Arthur C. Danto. New York: Rizzoli, 1990.

Danto, Arthur C. *Cindy Sherman: History Portraits.* New York: Rizzoli, 1991.

Felix, Zdenek, and Martin Schwander, eds. *Cindy Sherman: Photographic Work 1975–1995.* Exh. cat. London: Schirmer Art Books, 1995.

Krauss, Rosalind, and Norman Bryson. *Cindy Sherman 1975–1993.* New York: Rizzoli, 1993.

Robert Therrien

Brown, Julia. *Robert Therrien.* Exh. cat. Los Angeles: The Museum of Contemporary Art, 1984.

Rowell, Margit. *Robert Therrien.* Exh. cat. Madrid: Museo Nacional Centro de Arte Reina Sofia, 1991.

Zelevansky, Lynn. *Robert Therrien.* Exh. cat. Los Angeles: Los Angeles County Museum of Art, 2000.

Cy Twombly

Bastian, Heiner. *Cy Twombly: Bilder/Paintings 1952–1976.* Berlin-Wien: Propylaem Verlag, 1978.

Bastian, Heiner, ed. *Catalogue Raisonné of the Paintings, 1948–1995.* 4 vols. Munich: Schirmer Mosel, 1992–95.

Del Roscio, Nicola, and Arthur Danto. *Cy Twombly: Catalogue Raisonné of Sculpture.* Munich: Planco, 1997.

Schmidt, Katharina. *Cy Twombly: die Skulptur.* Exh. cat. Ostfildern-Ruit, Germany: Hatje Cantz, 2000.

Varnedoe, Kirk. *Cy Twombly: A Retrospective.* Exh. cat. New York: The Museum of Modern Art and Harry N. Abrams, 1994.

Andy Warhol

Andy Warhol 1960–1986. Exh. cat. Barcelona: Fundació Joan Miró, 1996.

Andy Warhol: Death and Disasters. Essays by Neil Printz and Remo Guidieri. Houston: The Menil Collection and Houston Fine Arts Press, 1988.

Feldman, Frayda, and Jörg Schellmann. *Andy Warhol Prints: A Catalogue Raisonné 1962–1987.* New York: D.A.P./Distributed Art Publishers in association with Ronald Feldman Fine Arts, 1997.

McShine, Kynaston, ed. *Andy Warhol: A Retrospective.* Exh. cat. New York: The Museum of Modern Art; Boston: Bullfinch Press/Little, Brown and Company, 1989.

Shanes, Eric. *Warhol.* London: Studio Editions, 1993.

Smith, Patrick S. *Andy Warhol's Art and Films.* Ann Arbor: UMI Research Press, 1986.

Warhol, Andy, and Pat Hackett. *Popism: The Warhol Sixties.* New York: Harcourt Brace Jovanovich, 1980.

Broad Collection Exhibition Publications

The Assertive Image: Artists of the Eighties from the Eli Broad Family Foundation. [Los Angeles]: UCLA at the Armand Hammer Museum of Art and Cultural Center, June 7–October 9, 1994.

Compassion and Protest: Recent Social and Political Art from the Eli Broad Family Foundation Collection. Exh. cat. San Jose Museum of Art, June 1–August 25, 1991. New York: Cross River Press, 1991.

Cindy Sherman: Una Selección de las Colecciones de la Eli Broad Family Foundation. Caracas, Venezuela: Fundación Muséo de Bellas Avdes, 1997.

The Mediated Object: Selections from the Eli Broad Collections. Essay by Jessica Morgan. [Boston:] Fogg Art Museum and the President and Fellows of Harvard University, 1996.

Compiled by Kristin Walker

First and foremost, gratitude for this exhibition must go to LACMA trustee Eli Broad and his wife, Edye, collectors who have been extraordinarily generous in sharing their wonderful paintings, photographs, and sculptures with the public. They have been unfailingly gracious and helpful to all of us at LACMA who have had the pleasure of working on this exhibition and its related publication. We would particularly like to thank Eli and Edye for candidly sharing with us the reminiscences and insights that form the interview found in this volume.

Joanne Heyler, Curator of The Broad Art Foundation, has not only contributed a fine essay to the catalogue, but has also worked with us on every aspect of the show. Her professionalism and sound advice have been invaluable. To the staff of The Broad Art Foundation, Juliana Hanner, Jeannine Guido, and Renée Coppola, and the staff of the Chairman's Department at SunAmerica Inc., including Sharon McQueen, Yolande Mavity, and Rachel Smookler, go our thanks for their contributions to this project. Michele De Angeles, former curator of the Broad collections, shared with us discerning comments about the early days of the Broads' collecting activities, for which we are grateful.

We would like to thank the three other catalogue authors, Thomas Crow, Sabine Eckmann, and Pepe Karmel, for their perceptive essays. It was our ambition to create a scholarly book that grappled with the larger art-historical issues raised by the collections, and they have contributed greatly to the realization of that goal. Garrett White, LACMA's Director of Publications, Stephanie Emerson, Managing Editor, and Margaret Gray, Associate Editor, worked closely with the authors and us to produce this book. Freelance designer Tracey Shiffman, who had an immediate understanding of the collection, has designed this handsome volume.

Exhibitions are by nature collaborative, and this one is no exception. It has engaged many departments within the museum. We are grateful to Kristin Walker, Exhibition Associate, who kept track of endless details, worked closely with the Foundation staff, and provided assistance with virtually every element of the project. Her work on the exhibition design was particularly helpful, and we are most appreciative of her efforts. To Irene Martin, Deputy Director for Exhibitions, and Christine Lazzaretto, Exhibitions Coordinator, we owe thanks particularly for organizing the tour to the Corcoran Gallery of Art, Washington, D.C., and the Museum of Fine Arts, Boston. Melody Kanschat, Senior Vice President for External Affairs, and her division brought their customary administrative abilities to this exhibition and its related activities. Jane Burrell, Chief, Art Museum Education, and her staff dealt capably and enthusiastically with the educational aspects of the project.

Finally, our thanks go to the artists, whose works we are delighted to present to audiences in Los Angeles, Washington, and Boston. It is gratifying indeed to be able to bring these remarkable paintings, sculptures, and photographs from private spaces to the public arena.

Stephanie Barron
Senior Curator, Modern and Contemporary Art, and Vice President, Education and Public Programs

Lynn Zelevansky
Curator and Department Head, Modern and Contemporary Art

Unless otherwise noted, all works by John Baldessari © John Baldessari; Stephen Balkenhol © Stephan Balkenhol; Georg Baselitz © Georg Baselitz; Jean-Michel Basquiat © The Estate of Jean-Michel Basquiat; Bernd and Hilla Becher © Bernd and Hilla Becher; Ross Bleckner © Ross Bleckner; Eric Fischl © Eric Fischl; Jasper Johns © 2001 Jasper Johns/VAGA, New York, NY; Anselm Kiefer © Anselm Kiefer; Jeff Koons © Jeff Koons; Roy Lichtenstein © Estate of Roy Lichtenstein; Robert Rauschenberg © 2001 Robert Rauschenberg/VAGA, New York; Charles Ray © Charles Ray; Susan Rothenberg © 2001 Susan Rothenberg/VAGA, New York; Ed Ruscha © Ed Ruscha; David Salle © 2001 David Salle/VAGA, New York; Cindy Sherman courtesy the artist and Metro Pictures; Robert Therrien © 2001 Robert Therrien/Artists Rights Society (ARS), New York; Cy Twombly © Cy Twombly; Andy Warhol © 2001 Andy Warhol Foundation for the Visual Arts/ARS, New York.

Cover, right; page 17, fig. 5; 25; 31; 33, figs. 8–9; 37; 48; 54; 57; 64; 65; 68; 78; 83; 102; 105; 106; 110; 118–19; 124; 130–31; 132–33; 138; 140; 154–56; 166–67; 169; 171; 174; 176–77; 186; 200–202; 204: Photographs by Douglas M. Parker Studio

13, fig. 2: Photograph by David A. Loggie

14, fig. 3: © Joan Miro/Artists Rights Society (ARS), New York

14, fig. 4: © Henri Matisse/Artist Rights Society (ARS), New York; photograph by Douglas M. Parker Studio

24, fig. 6: © Richard Serra; photograph by Douglas M. Parker Studio

25, fig. 7: Photograph by Bob Swanson/Swanson Images

28: Photograph by William Nettles, Los Angeles

35, figs. 10–11 © The Estate of Robert Mapplethorpe

46, fig. 12: Photograph © 2001 The Museum of Modern Art, New York.

50, fig. 13: © The Estate of John Kane

52, fig. 14; 53, fig 14.1 (detail); 108, fig. 34: Photographs by Squidds & Nunns

56, fig. 16: Photograph by Paula Goldman

58, fig. 17: Photograph by Hickey-Robertson, Houston

60, fig. 18: Photograph by Allan Grant/TimePix

60, fig. 19: © 2001 Robert Rauschenberg/VAGA, New York

60, fig. 20: Photograph © Dan Budnik/Woodfin Camp & Associates, New York

63: Photograph by Robert McKeever

66–67: Photographs by Dorothy Zeidman

72–73: Photographs by Nic Tenwiggenhorn

79, fig. 26: Photograph © D.T.M./Woodfin Camp & Associates, New York

80, fig. 27: Photograph © 2001 Museum Associates/LACMA

80, fig. 28: Photograph by Robert P. Ruschak

81, fig. 29: © 2001 Marcel Duchamp/Artists Rights Society (ARS), New York/ADAGP, Paris

89, fig. 32: © Jack Laxer

92, fig. 33: © 2001 Ellsworth Kelly; photograph © The Solomon R. Guggenheim Foundation, David Heald

95: Photograph by James Isberner Photography

101: Photograph by Robert McKeever

111, fig. 35: © Louisa Chase; photograph by Douglas M. Parker Studio

111, fig. 36: © 2001 Alberto Giacometti/Artists Rights Society (ARS), New York/ADAGP, Paris

112: © Julian Schnabel

113: Photograph by Zindman/Fremont

114, fig. 37: © 2001 Tony Smith Estate/Artists Rights Society (ARS), New York

117: Photograph by William Nettles, Los Angeles

125, fig. 39: Reproduced with permission of the Estate of Eva Hesse; photograph © Allen Memorial Art Museum, Oberlin College, Ohio. Gift of Helen Hesse Charash, 1981

128, fig. 40: Photograph © Henry Chalfant

128, fig. 41: © Tom Otterness; photo-graph by Douglas M. Parker Studio

129, fig. 42: © 2001 The Estate of Keith Haring; photograph by Douglas M. Parker Studio

131, fig. 43: © 2001 Succession Pablo Picasso/Artists Rights Society (ARS); photograph © 2001 The Museum of Modern Art, New York.

137: © Bruce Nauman/Artists Rights Society, New York

152, fig. 47: Photograph © J. Littkemann, courtesy Michael Werner Gallery, New York and Cologne

153, fig. 48: © Markus Lüpertz

157, fig. 50: Photograph by The German Information Center

158: © Jörg Immendorff

158, fig. 51: Originally created for *Why Cologne?* by Lucie Beyer and Karen Marta, **Art in America**, Brant Publications, December 1988

160–61: © Hans Haacke

164: © Sigmar Polke; photograph by Photo Kleinefenn

175, fig. 53: Photograph © Léon Krier

This publication is typeset in the German Realist typeface Akzidenz Grotesk, issued by the Berthold Foundry, Berlin, in 1898. It is the immediate ancestor to Franklin Gothic (1903) and Helvetica (1952). The paper used is Satin Kinfuji 209 gsm. The endpapers are Tanto 100 kg. The hardcover edition is bound in Hikari Nashiki.